INSIDE**SAHARA**

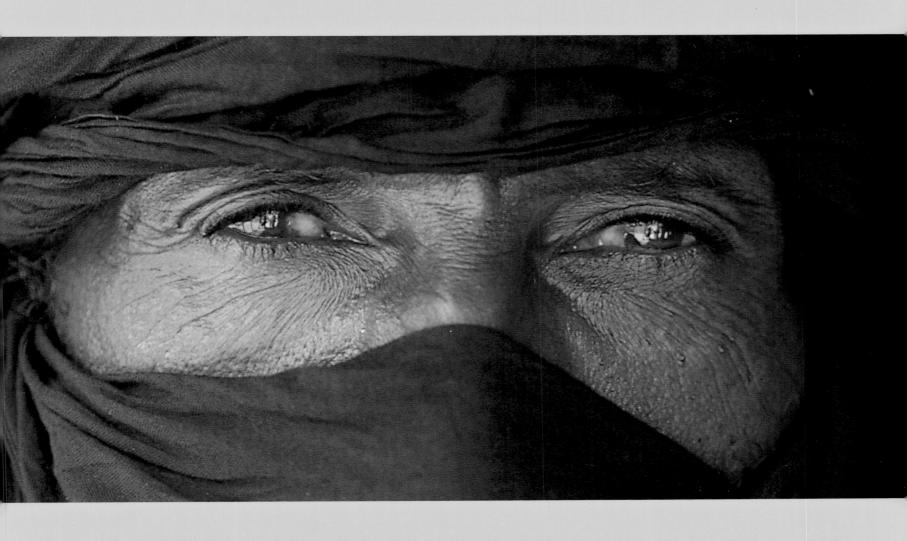

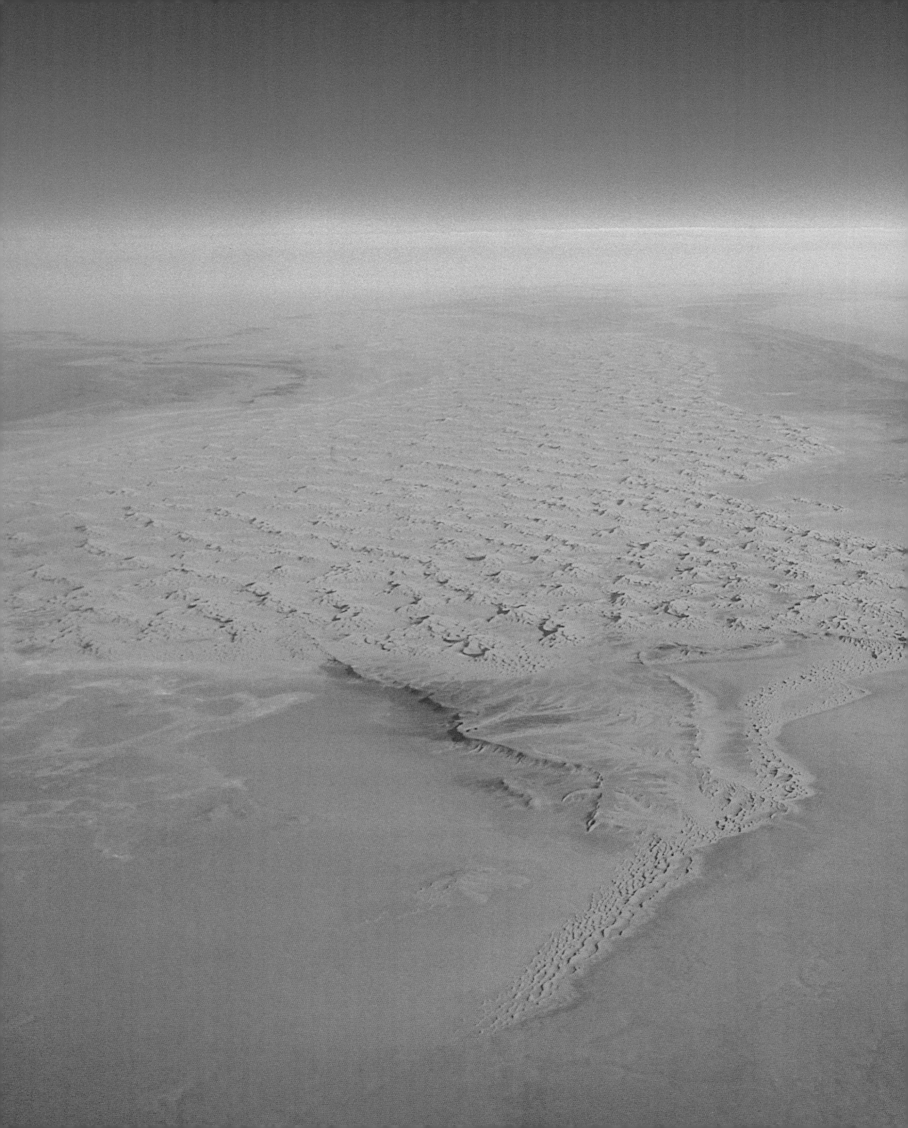

INSIDE**SAHARA** PHOTOGRAPHS BY BASIL PAO
INTRODUCTION BY MICHAEL PALIN

WEIDENFELD & NICOLSON

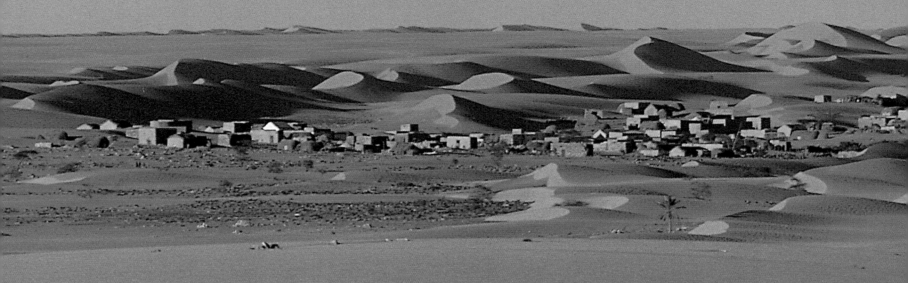

SAHARA WITH MICHAEL PALIN
A PROMINENT TELEVISION PRODUCTION FOR THE BBC

❖

THE TEAM ON THE ROAD

THE EXECUTIVE BRANCH (THE BRAINS)

SERIES PRODUCER/DIRECTOR **ROGER MILLS** (MOROCCO, POLISARIO, MAURITANIA, ALGERIA, LIBYA)
PRODUCER/DIRECTOR **JOHN PAUL DAVIDSON** (SENEGAL, MALI, NIGER, TUNISIA)
LOCATION MANAGERS **VANESSA COURTNEY** (MOROCCO, POLISARIO, MAURITANIA, LIBYA)
DUDU DOUGLAS-HAMILTON (SENEGAL, MALI) **JANE CHABLANI** (NIGER) **CLAIRE HOUDRET** (TUNISIA)

THE BOYS (BRAINS OPTIONAL)

PRESENTER **MICHAEL PALIN** CAMERAMAN **NIGEL MEAKIN** SOUND **JOHN PRITCHARD**
ASSISTANT CAMERAMAN **PETER JUNIOR MEAKIN** STILLS GUY **BASIL PAO**

STUCK IN THE OFFICE

EXECUTIVE PRODUCER **ANNE JAMES**
PRODUCTION MANAGER **JANINA STAMPS** (MOROCCO, POLISARIO, SENEGAL, MALI, LIBYA) **GINA HOBSON** (NIGER, ALGERIA, TUNISIA)
EDITOR **ALEX RICHARDSON** MUSIC **ELIZABETH PARKER** GRAPHICS **BERNARD HEYES**
PRODUCTION ASSISTANTS **NATALIA FERNANDEZ, PAUL BIRD** PRODUCTION ACCOUNTANT **LYN DOUGHERTY**

❖

FIRST PUBLISHED IN THE UNITED KINGDOM IN 2002 BY **WEIDENFELD & NICOLSON**
TEXT COPYRIGHT © **MICHAEL PALIN & BASIL PAO** 2002. PHOTOGRAPHS COPYRIGHT © **BASIL PAO** 2002
DESIGN AND LAYOUT COPYRIGHT © **WEIDENFELD & NICOLSON** 2002

THE MORAL RIGHT OF **BASIL PAO** TO BE IDENTIFIED AS THE AUTHOR OF THIS WORK HAS BEEN ASSERTED IN ACCORDANCE
WITH THE COPYRIGHT, DESIGN AND PATENTS ACT OF 1988.

TEXT QUOTATION ON P147 FROM MAJOR POEMS, JOSE MARTI,
EDITED BY PHILIP S. FONER, HOLMES & MEIER PUBLISHERS INC.

ISBN 0 297 84304 4

ART DIRECTION & DESIGN **BASIL PAO** ASSOCIATE DESIGNER & QUARK GODDESS **STELLA LAI**
PRINTED AND BOUND IN ITALY BY **PRINTER TRENTO**

WEIDENFELD & NICOLSON, THE ORION PUBLISHING GROUP, WELLINGTON HOUSE, 125 STRAND, LONDON WC2R 0BB

FOR MY PARENTS,
PAT, SONIA AND ED

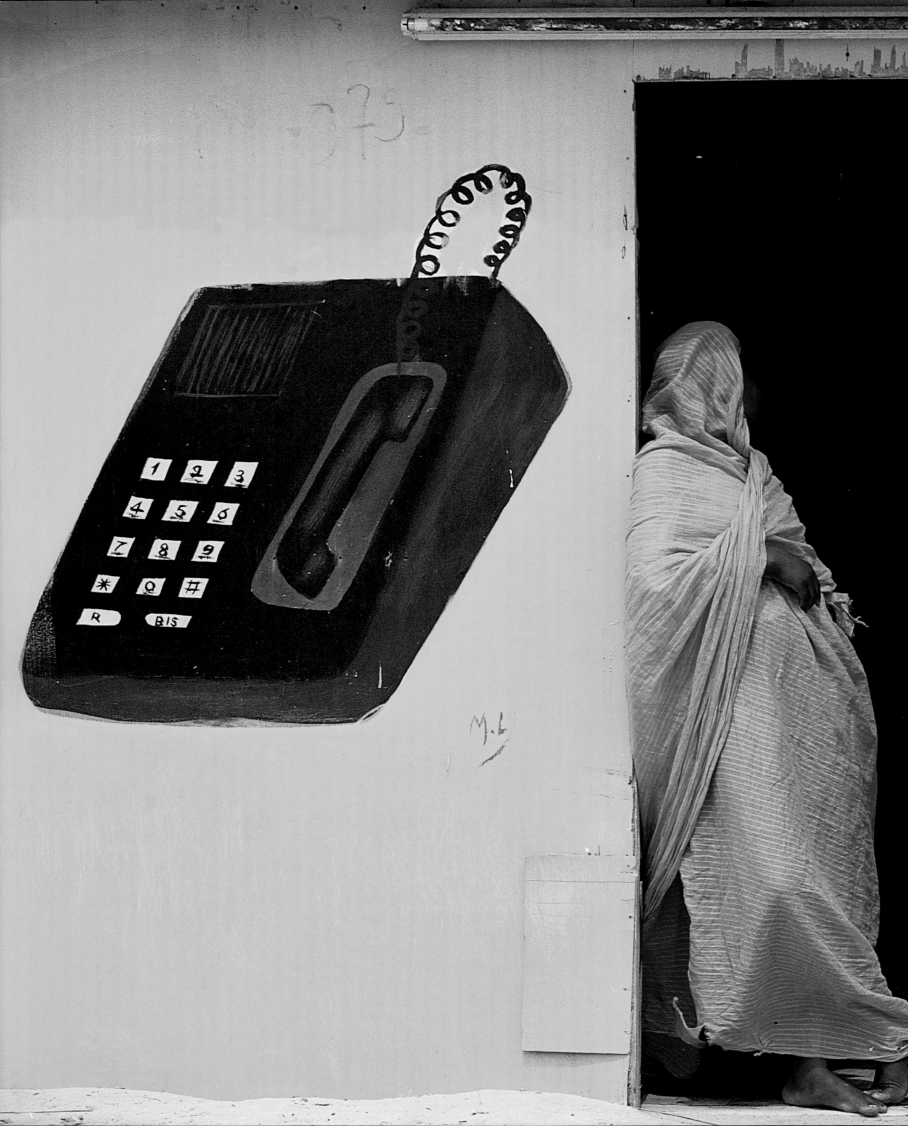

CONTENTS

❖

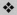

HOT, DIRTY AND DROWSY WITH A LOW-GRADE FATIGUE. Going for miles to nowhere from yesterday's no-man's-land. The car hits a nasty patch on the *piste* and lands hard. My eyes snap open as everything inside the car goes flying. I pull off my headphones. Springsteen's *Born to Run* plays on unconcerned, quickly melting away into the squeal of shifting gears as I look for my Mini Disc player on the floor. Mike is staring out the window, mesmerised by the miles of yellow sand peppered with tiny sharp rocks stretching endlessly across the horizon. 'Pity...Pitiless...' He rolls the word around, almost tasting it. Then he holds the Dictaphone up to his mouth and whispers into it, 'The pitiless desert...' 'What's the matter?' I ask. 'Running out of adjectives?' Mike returns from some far away place; his tired face opens up into a big grin. We laugh.

The scene is at once so familiar and yet feels so totally alien. This sort of banter has by now taken place across six continents and over great stretches of the world's waters. It is our way to try to stay jolly and alert, no matter how bad things get. To fill the gaps in those empty hours when the terrain is too rough to read or write, or waste film taking nothing pictures out the window as we bounce along into the unknown. But this is different; we are in the heart of the Sahara now. Out in the middle of the Ténéré Desert, searching for a Touareg camel train somewhere in the Aïr mountains, just three days after hearing about September 11th on the radio in the little town of Agadez. I can't remember another moment when our obstacles seemed as insurmountable, our future less certain, or a time when life itself seemed more fragile.

Two small children, mere silhouettes in the harsh light, emerge from a small hut of twigs and rags in the distance. They start running towards the car as we pass. I will miss my daughter's birthday again. Sonia, who was born almost the very hour when Michael boarded the Orient Express at the start of *Around the World in 80 Days*, will be thirteen in a few days. Her birthday has always been a milestone for how long I've been tagging along as the 'Stills Guy' on Michael Palin's Excellent Adventures. And as we watch her grow into a teenager, she is a constant reminder of the blinding speed of the passage of time, and how much more there is still left to see in the world.

In the distance, a complete skeleton of a camel sits in the vast emptiness, bleached white and shimmering in the midday sun. It is so perfectly preserved, with its skull resting comfortably on the sand, and its spine articulated so sharply against the ruler-straight horizon, that it could have been a sculpture placed there by design. My instinct says, stop the car and take the shot, you will never see a more perfect specimen, or a more potent symbol of flesh and blood beaten to submission by the great Sahara. But I keep silent and just let the silvery ghost etch itself onto my memory as the car hurries on. All the years of travelling with a film crew have taught me to sublimate those impulses. Not that it ever gets any easier or any less frustrating, but I have learned through previous journeys that this is a television series with a tight filming schedule, and the priority has to be getting from A to B and completing the required sequences. The director can stop the car, and the cameraman can stop if he sees something very special, but it is really not my place to hold up the convoy. Except perhaps for desperate bodily needs. The skeleton disappears into the dust cloud of our rear wheels. 'There will be another one,' I tell myself, 'in better light. The light was real dirt-bag anyway...'

I crack open the window an inch to let in some air, only to be greeted by a blast of scalding wind. As on most of this journey so far, it is often a choice between roasting in the drowsy stifling heat with all the windows up, or being barbecued and sandblasted by letting the full fury of the 130°F desert in. A few miles further on, we see far in the distance that the camera car has stopped. As we get a little closer, we can just make out that it may be a flat tyre situation. I find myself cursing them for not getting the puncture earlier.

The driver is kicking all the tyres. Nigel is walking away from the car into the desert, in search of that elusive bit of privacy. Nigel, our ace cameraman, has worked on every one of Michael's journeys. He is a gentle soul and a closet perfectionist; I see him as a kindred spirit and my hairy English brother. We started working together on *Pole to Pole*. During which, on one fateful night in Lusaka, Zambia, I gave him the nickname 'Quasi' – after Quasimodo, the Hunchback of Notre Dame – when he destroyed a hotel elevator that was rude to him with a single kick. Unfortunately, the name stuck. And now, eleven years on, the name has evolved into a verb, 'to quasi', meaning any act of wanton violence against inanimate objects, and an association, in which his son Peter, our assistant cameraman, and I are currently trainee Quasies.

I can see John, our sound recordist, hovering over the driver, eager to help, or perhaps just trying to annoy him with his irony. John joined the team on *Hemingway* and is by far my favourite Sound Department. Partly because he tolerates the occasional and inevitable intrusion of my noisy shutters when it is clear that Mike's actions in front of the camera will never be repeated again. A true English gentleman in many ways, unflappable and blessed with an extra dry sense of humour, he is also cursed with a peculiar passion for 'tidying up', especially if an unfinished bottle of wine is involved. He blames his obsession on the time spent working with the not very tidy Camera Department, but we all think it's probably a genetic thing. We like to refer to him as our '*Multi* award-winning acoustician.'

We pull up beside them. 'Everything OK?' I ask. 'Oh fine, fine. And how's the Wordsmith and the Master of the Static Frame?' says John. Pete walks over and offers me a cigarette. 'Care for a puncture moment?' Nigel returns from his stroll, clearly relieved but looking more than a little weary. 'How are you guys doing?' he says, smiling. These stops, unscheduled or otherwise, have become almost ritualistic. We gather, exchange greetings and offer up a variety of treats for parched throats or snacks for energy. And as the drivers face Mecca and pray, we stretch our legs and head for the nearest bush. Nothing really special ever happens on these stops, but I look forward to them. Because each time it is like a mini reunion, a confirmation that we have all made it in one piece, a kind of affirmation that our luck is holding, and that we have just gotten a little further down the line on this epic journey.

Nothing extraordinary happened at that stop either. In fact, nothing happened at all. Just a bunch of guys milling around aimlessly in the middle of one of the most inhospitable spots on earth, waiting for a tyre to be changed. But it was right there, beside the punctured tyre, that I had one of those 'defining moments' that you read about in self-help books. I came to the realisation that I am no longer concerned about becoming a 'Great Photographer'; I am happy just to be one of the luckiest. Because I get to go on the road with my very own dysfunctional family, and home feels like it's only as far as the next tent. At the end of the day, that means much more to me than having the luxury of waiting for the right light, or the respect that comes with being considered a serious photojournalist. Plus I get to help drag Quasi's thirty-eight cases of pig iron all around the world, and life simply doesn't get any better than that.

It is on their behalf that I present to you this book, a kind of family album on the journey we took together, the places we saw and the people we met along the way. And as John and I were fond of saying to our illustrious leaders whenever we arrived at another shit hole, 'Thank you for bringing us here.'

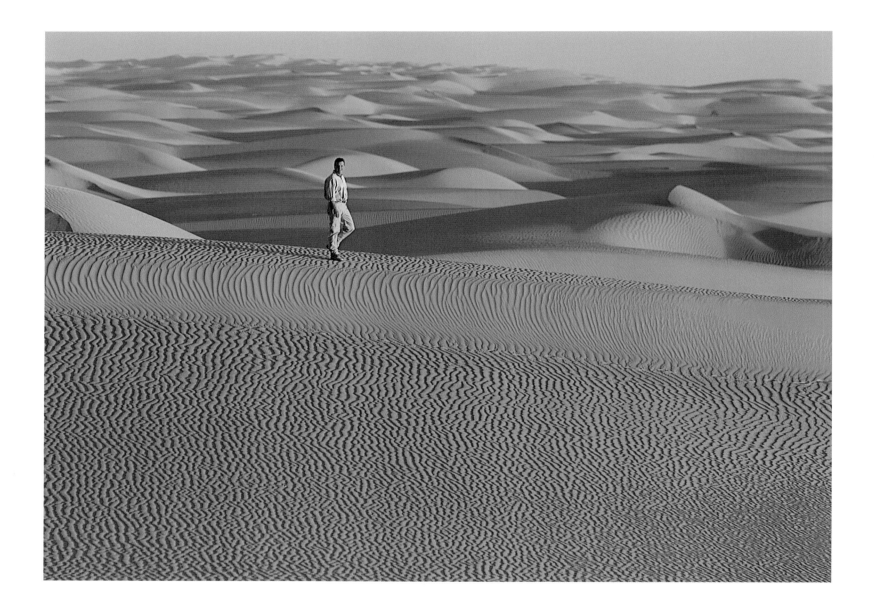

ANYONE WHO'S FOLLOWED OUR PREVIOUS JOURNEYS, up, down, round and across the world, will know that my working relationship with The Master Of the Static Frame is a bit too much like two old friends having a good time to warrant any more appreciations. My praise for Basil's work has been slavish and unstinting. Now, like all of us, he's becoming increasingly old and eccentric, and it's time for the truth. Unfortunately, I'm writing this in the lap of luxury at the Pao family home, so the truth will just have to wait. What I can reveal is that, in little ways which his natural modesty may forbid him to share with you, being inside the Sahara was far from a picnic for Basil.

The Sahara is no gourmet's paradise and Basil likes his food. He eats well, cooks well and expects high standards from the kitchen, but with few exceptions, the desert menu is quite severely limited. Camel, couscous, chicken, rice and salad basically saw us through the Sahara, with goat and mutton on a good day. Bas, however, was not to be defeated by dietary deprivation and produced from his voluminous and elegantly matching set of bags, a seemingly endless supply of lip-smacking delicacies, all neatly zip-locked and miraculously unaffected by sand, sun and international customs controls. Smoked mussels, beef, pork and salmon jerky, smoked eels, clams and oysters. Even kimchi tuna from South Korea made a brief appearance on the straw mats that were our dining rooms. We may have been in the middle of nowhere, but thanks to Mr Ziploc we could be anywhere in the world.

If there's one thing more scarce than a menu in the Sahara, it's a wine list. These are Islamic countries, and if there was alcohol at all, it was usually no more than a beer, or if you were really lucky, a cold beer. Basil, a firm friend of the cocktail hour, was thus deprived, at a stroke, of the only tried and tested method of recovering from a hard day's work.

And if there's one thing more scarce than a menu or a wine list in the Sahara, it's a hotel. All too frequently, the only accommodation available was the humble tent. Not the Bedouin tent, half as wide as a ballroom, but the individual, easy to carry, put it up yourself, polypropylene tent, which a true Bedouin wouldn't be seen dead in. Some people are natural campers, scurrying in and out of their little cocoons like hamsters when the winter's coming on. Basil is not amongst them. He likes certain comforts when he's out on the road, and one of them is being able to stand upright. The air was full of dark mutterings as he crawled in at night and crawled out in the morning and crawled off in the hours in between to answer the call of the wild.

The other thing that didn't help him much was the amount of sand in the Sahara. I tend to forget, as I sally forth in the morning, armed only with notebook and Dictaphone, that taking photographs involves being

Continues overleaf

weighed down like a pack mule. Basil had eight cameras on the shoot, and at any given time three of these would be hanging round his neck alongside an armoury of fancy lenses, some the size of a small tree. Not only were they heavy, they were also precision instruments. Now nature may abhor a vacuum but she loves a precision instrument, and to show her affection she not only provided a constant supply of grit and sand, but also arranged for a more or less constant wind to blow it into any aperture, human or mechanical.

As if this weren't enough, Basil was much vexed by the lack of appreciation of his work on the part of small, predominantly elderly, Berber ladies. Whether they had been previously let down by Mario Testino or had been promised contact sheets from Helmut Newton which never showed up I don't know, but these doughty mountain matrons seemed to have a thing about stills photographers, and all their pent-up resentments spilled onto Basil like a dam bursting. At one border crossing, the discreet attentions of his Canon Eos1, with a 17-35/F 2.8, drove one of these colourful old ladies into a positive paroxysm of protest. Shrieking like a banshee, she threatened to redirect his lens into somewhere quite painful. For sheer unprovoked ferocity it was quite without parallel, until the morning Bas chose to record the wares on a juju stall in downtown Bamako. This time, young, enraged men, probably tipped off by Berber ladies from the north, sprang out of the crowd and would have dragged him out of the minibus by his lens, if less photophobic locals hadn't intervened. Bearing all this in mind, it's pretty extraordinary that we have this book at all.

So, what was in the Sahara for Basil? Well, I think, like all of us, he had never seen anything to rival the space and scale and immensity of the place, and, like all of us, he knew that the same reasons that made it so hard going made it hugely memorable and rewarding. To penetrate to the heart of the Sahara, as well as into largely closed countries like Libya and Algeria, was an achievement on everyone's part, an achievement secured at times by a mixture of cussedness, dogged determination and much-needed communal grumbling. Communal is the key word here. It's the reason, I think, why Basil not only survived but also produced some of his finest work. On these journeys time is rarely on his side. He, like all of us, has to be a team player, going with the flow, even when it's taking you rapidly in the wrong direction. To do this, and deliver the goods at the same time, requires a combination of quick thinking, mutual tolerance, natural talent and a hefty sense of humour.

Which is why, though this may have been the least comfortable journey I've made with Basil, I hope it won't, be the last. There's much grumbling still to be done.

MICHAEL PALIN. MARCH 2002

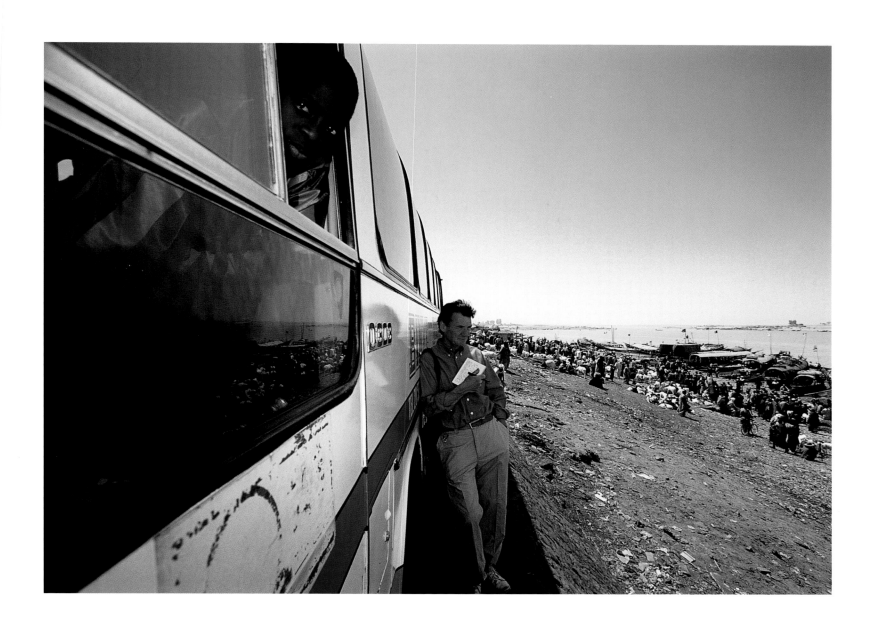

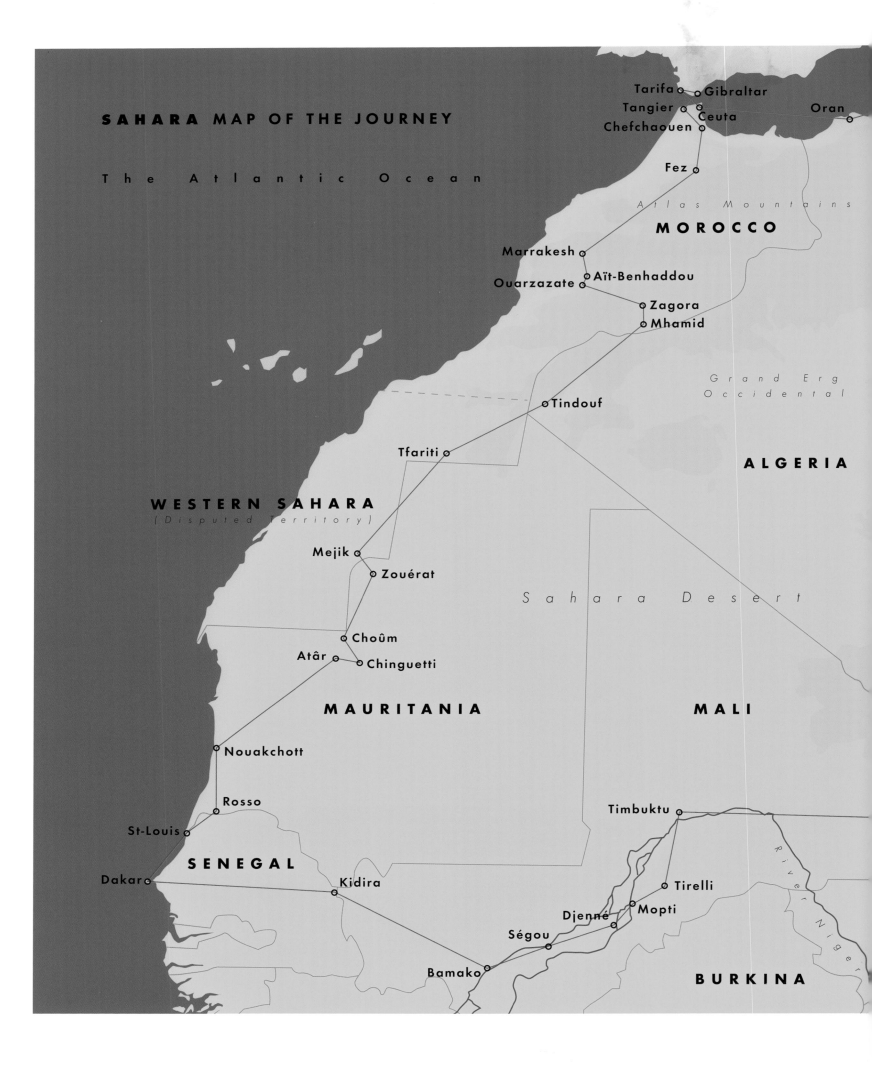

SAHARA MAP OF THE JOURNEY

The Atlantic Ocean

Tarifa ○ ○ Gibraltar
Tangier ○ Ceuta
Chefchaouen ○ Oran

Fez ○

Atlas Mountains

MOROCCO

Marrakesh ○
Aït-Benhaddou ○
Ouarzazate ○
Zagora ○
Mhamid ○

Grand Erg
Occidental

Tindouf ○

ALGERIA

Tfariti ○

WESTERN SAHARA
(Disputed Territory)

Sahara Desert

Mejik ○
Zouérat ○

Choûm ○
Atâr ○ ○ Chinguetti

MAURITANIA

MALI

Nouakchott ○

Rosso ○

Timbuktu ○

St-Louis ○

SENEGAL

Dakar ○ Kidira ○

Tirelli ○

Djenné ○ Mopti ○
Ségou ○

River Niger

Bamako ○

BURKINA

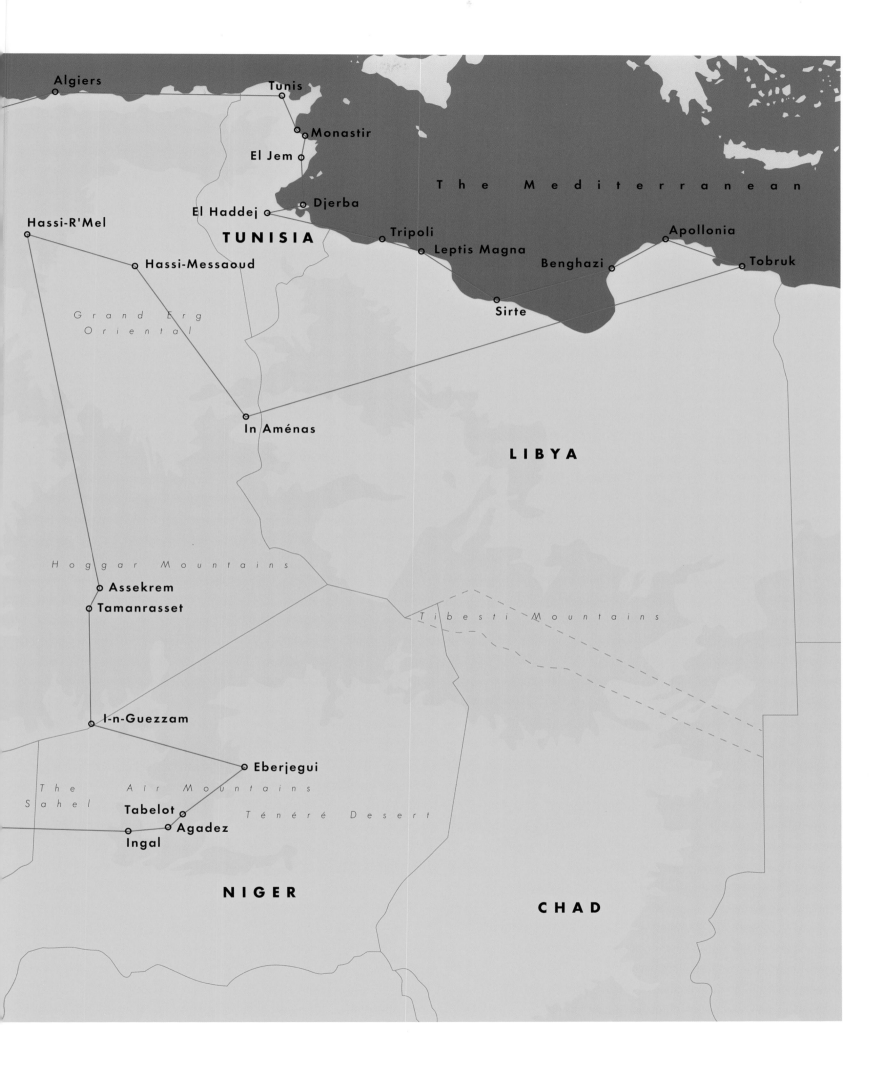

Algiers

Tunis

Monastir

El Jem

El Haddej Djerba

Hassi-R'Mel **TUNISIA**

Tripoli Apollonia

Leptis Magna Tobruk

Hassi-Messaoud Benghazi

Sirte

Grand Erg Oriental

The Mediterranean

In Aménas

LIBYA

Hoggar Mountains

Assekrem

Tamanrasset

Tibesti Mountains

I-n-Guezzam

Eberjegui

The Aïr Mountains

The Sahel

Tabelot

Ténéré Desert

Agadez

Ingal

NIGER

CHAD

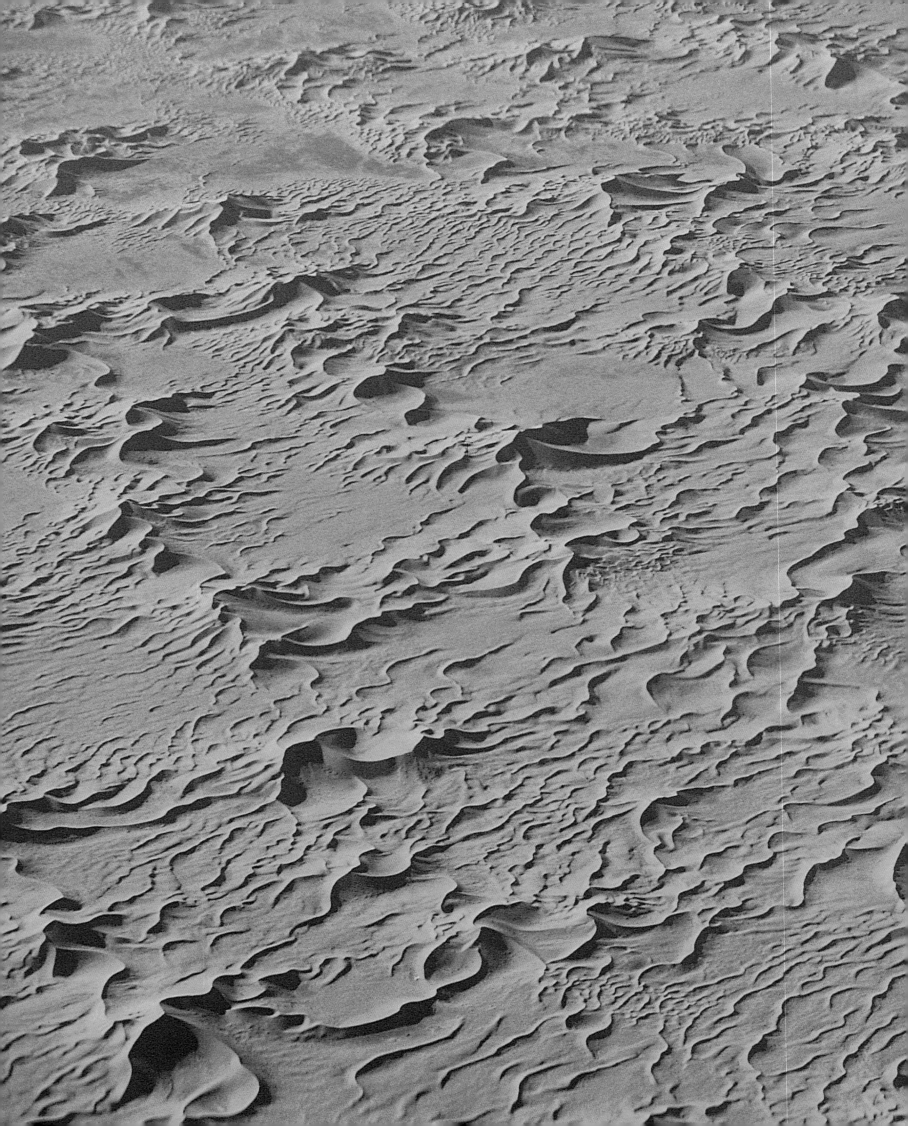

THE**WEST**

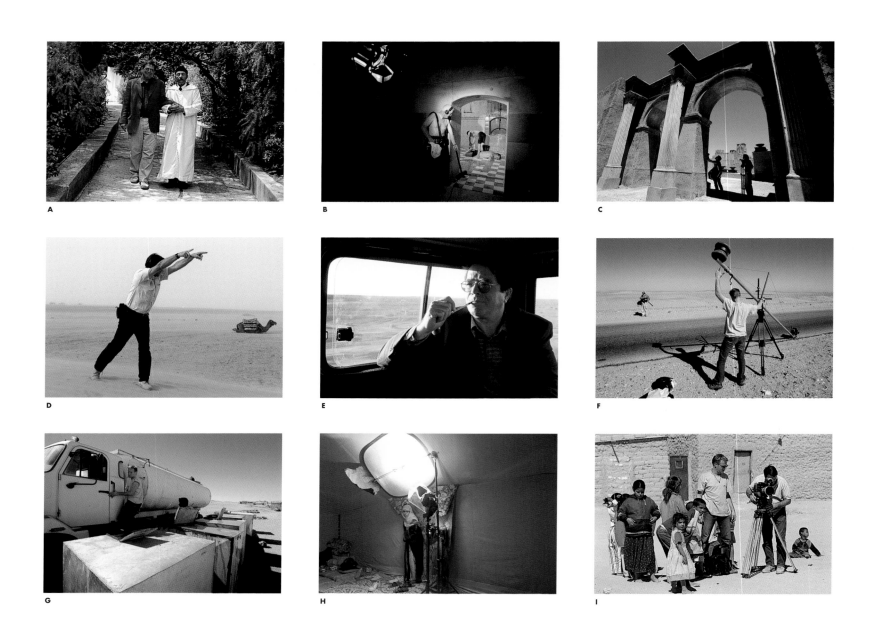

MOROCCO (A) Roger and his new best friend Mustapha, the caretaker, walking down the garden path of St Andrew's, an Anglican church in Tangier. **(B)** John recording the sound of pain in the hammam in Chefchaouen. **(C)** Pete and Alan look in vain for a real wall on the Jerusalem set. **(D)** Nigel directing traffic in Mhamid, as walkie-talkies do not like sandstorms. **ALGERIA (E)** Generalissimo Roger Edwin Mills – Portrait of Power, in Tindouf. **(F)** Pete balancing his jib arm,

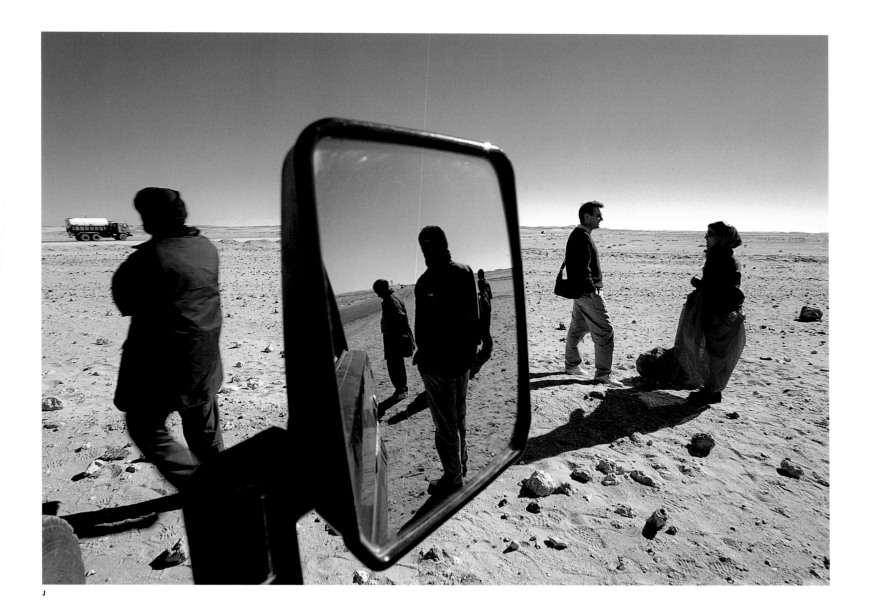

J

the ultra-light crane, for the water tanker passing shot. **(G)** Junior takes time out for Quasi-training, climbing all over the water tanker for no reason at all. **(H)** Bachir's daughter, surprised by the new lighting arrangement in the family tent. **(I)** The Meakins with their Smara camp fan club. **(J)** Michael chats with our guide, Metou, while Bachir (in the rear-view mirror) and the drivers watch the water tankers being filmed.

A

B

G

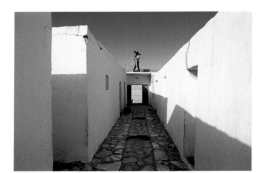
C

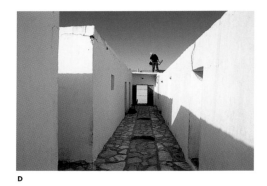
D

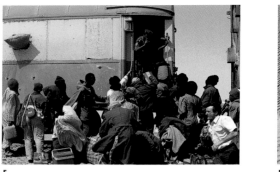
E

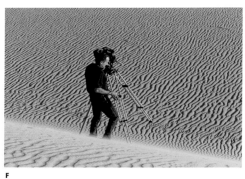
F

H

WESTERN SAHARA (A) Nigel and Bachir instructing the drivers on a car to car sequence along a hard crusted stretch of desert floor in Western Sahara. **(B)** Nigel stands on top of the Polisario army's 4th division headquarters to film General Mills' tank manoeuvres. **(C)** Nigel drags his pig iron across the roof of the Mejik barracks... **(D)** while John listens for the convoy from across the border. **MAURITANIA (E)** Nigel rushes in to ruin yet another one of my shots at Arrêt TFM. **(F)** Quasi attempting to discipline his tripod in Chinguetti. **(G)** Do not be fooled by the graceful limp-wristed action into thinking that Quasi has lost his grip on his title, it is in fact one of Nigel's trademark movements, where he switches off the camera with an elegant flourish whenever he is pleased with a take. It's particularly significant here, as he had just filmed

J

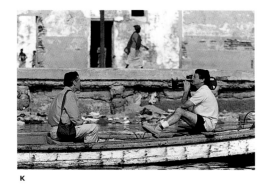

K

L

M

I

N

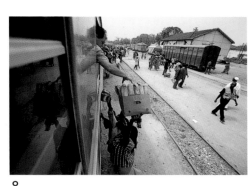

O

the loading of iron ore at the Guelb mine in Zouérat during a blistering sandstorm. **(H)** John recording the high wind that swept across the dunes of Chinguetti. **(I)** Vanessa the tourist. **(J)** Vanessa photographing the crew at Chinguetti, complete with Bob Watt, our fixer, and Abdallahi, our man from the Ministry of Communications. **SENEGAL (K)** Two men and a camera on a boat in St-Louis. **(L)** John was not tempted in the least by this nubile young lady in a Dakar high school; his preference for far more substantial womanhood in the tradition of R Crumb is well known. **(M)** John dutifully recording the rustling of silk in sync with Nigel's probing lens. **(N)** Dudu at the *la lutte* – wrestling matches in Dakar. **(O)** JP picking up more bread to supplement the Dakar-Bamako train menu.

BESIDES ITS FAME as the birthplace of *The Sheltering Sky* and other classic literary works by writers like Paul Bowles and William Burroughs, Tangier is renowned for the quality of its light, attracting artists from Delacroix to Matisse to Francis Bacon. And just down the lane from Café Tingis **(ABOVE)**, I found great 'bounce' light from a Moroccan pizza. **(RIGHT)** This equestrian was good news for me but a holy terror for the local population playing on Town Beach. When he saw me pointing the camera, he decided it was time to show off his horsemanship.

THE SCENIC OLD TOWN of Chefchaouen, up in the Jebala Mountains, was created by the Moors and Jews as a refuge from the encroachment of Catholicism in the fifteenth century. Its appearance has remained largely unchanged to this day. The houses on its steep winding streets are all painted in a beautiful pale blue, almost exactly like the blue city of Jodhpur in Rajasthan. **(ABOVE & RIGHT)** These inhabitants I encountered look like they could have been there since the beginning.

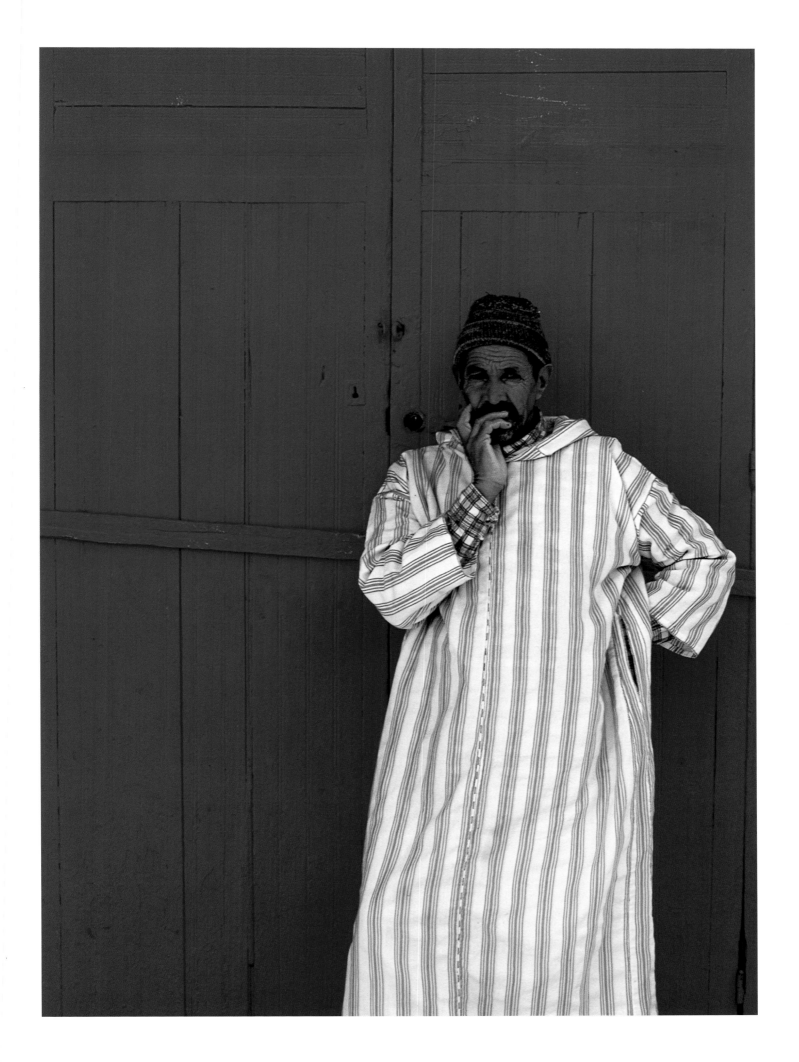

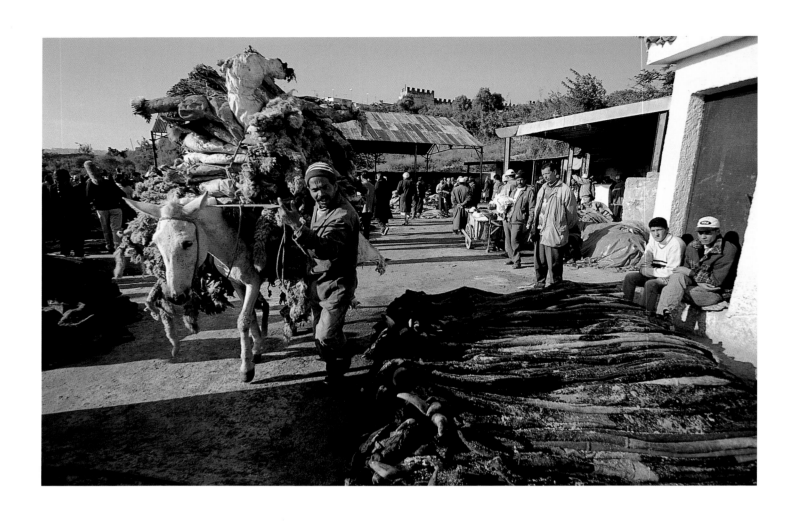

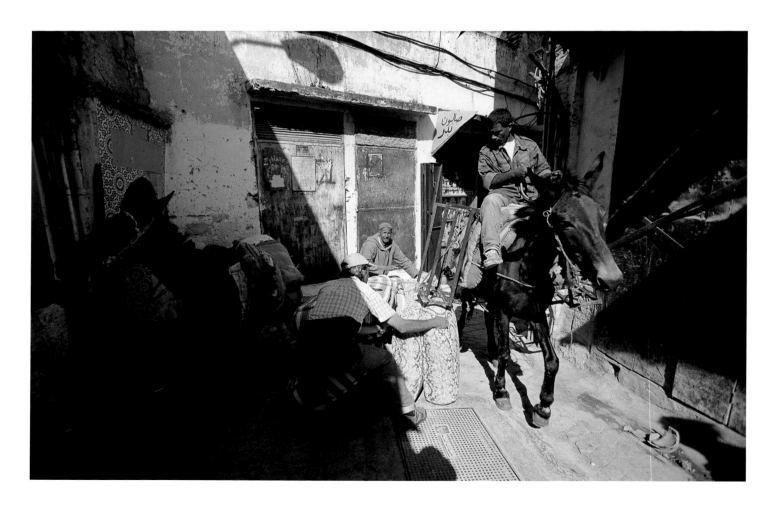

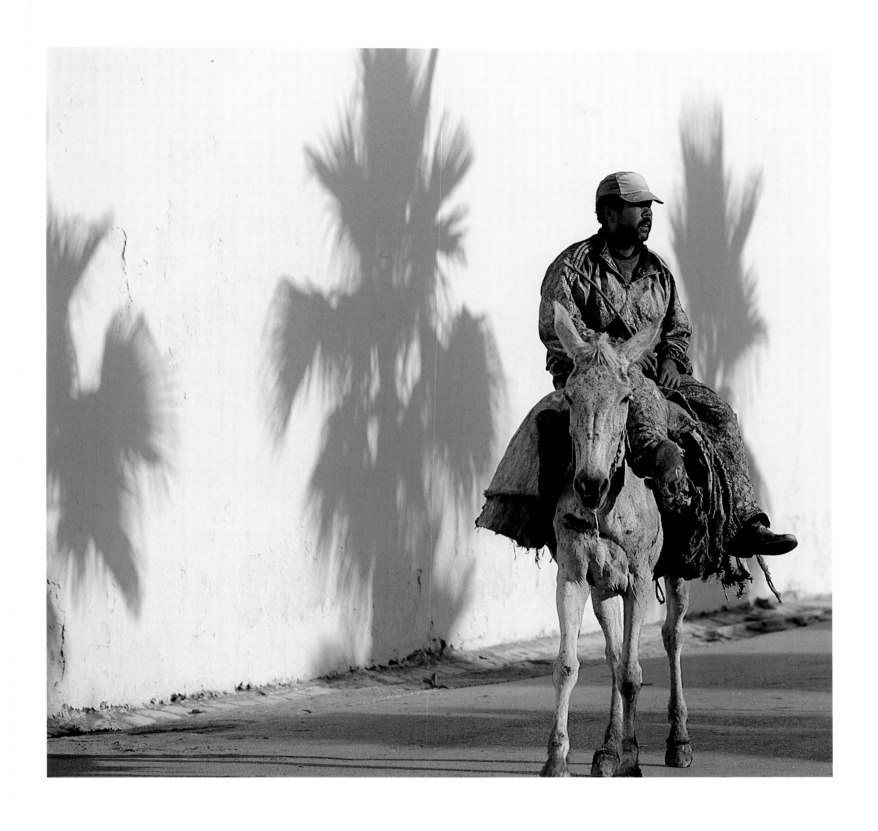

MULES AND DONKEYS remain an integral part of the transport system of 'modern' Fez. **(TOP LEFT)** Loaded down with dried cowhides, a trader and his long-suffering mule set off from the leather market for the medina. **(BOTTOM LEFT)** Alan, our friend and fixer, helping to 'tidy up' the fallen mattresses at a street corner, which were causing a major traffic jam in the narrow lanes of the old city. **(ABOVE)** Near the north gate of the medina, a worker heads for the tannery.

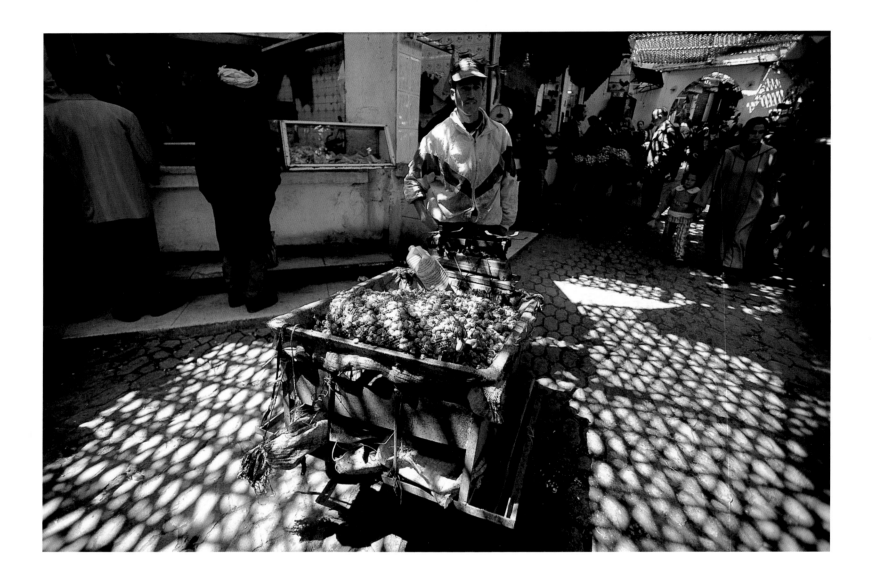

LIFE IN THE MEDINA. This hawker of cockles in the food market **(ABOVE)** shows his flair for the dramatic by choosing to display his wares in the centre of the dappled light shining through the woven roof. **(TOP RIGHT)** Brass pans being polished by fire and galvanised with zinc to protect them from the 'rust that never sleeps'. While on the other side of town **(BOTTOM RIGHT)**, coats of lime are applied to cleanse the animal skins before dyeing.

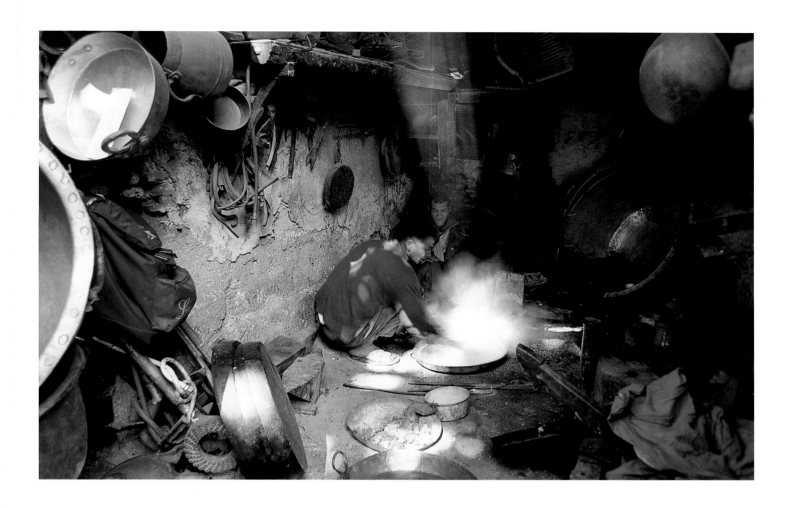

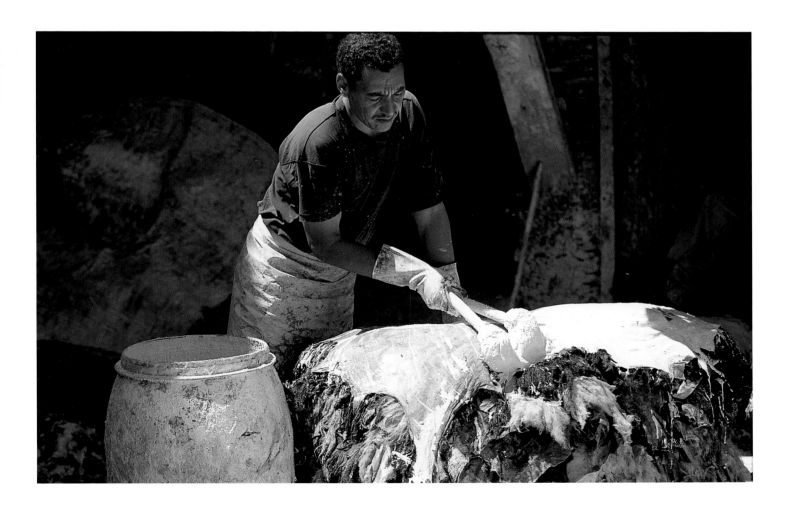

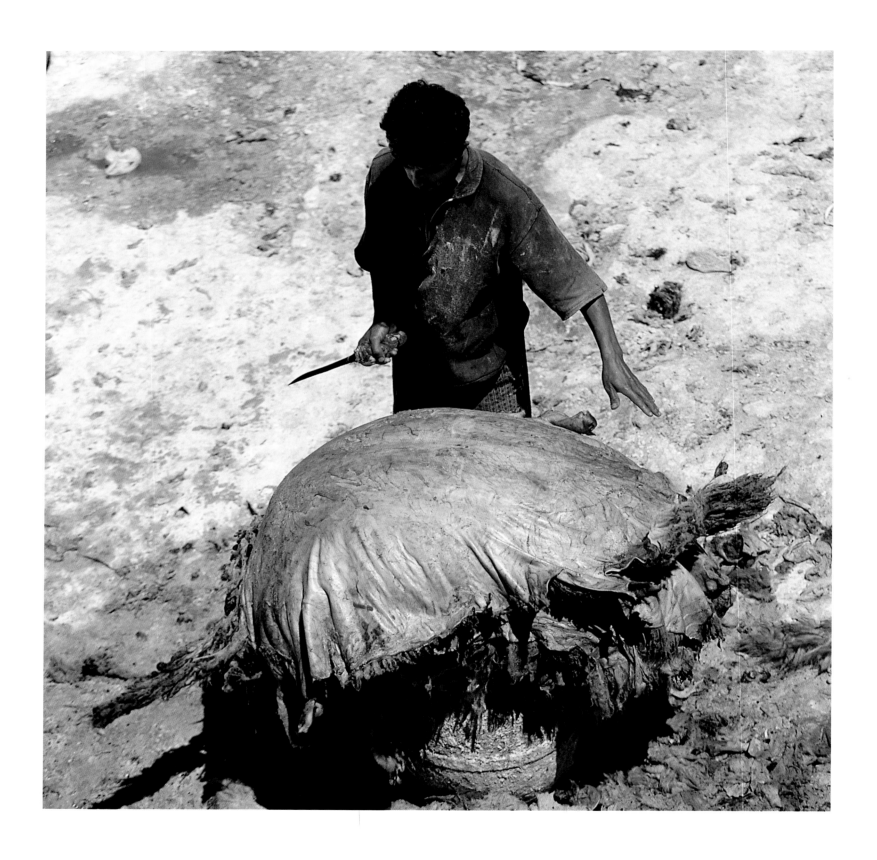

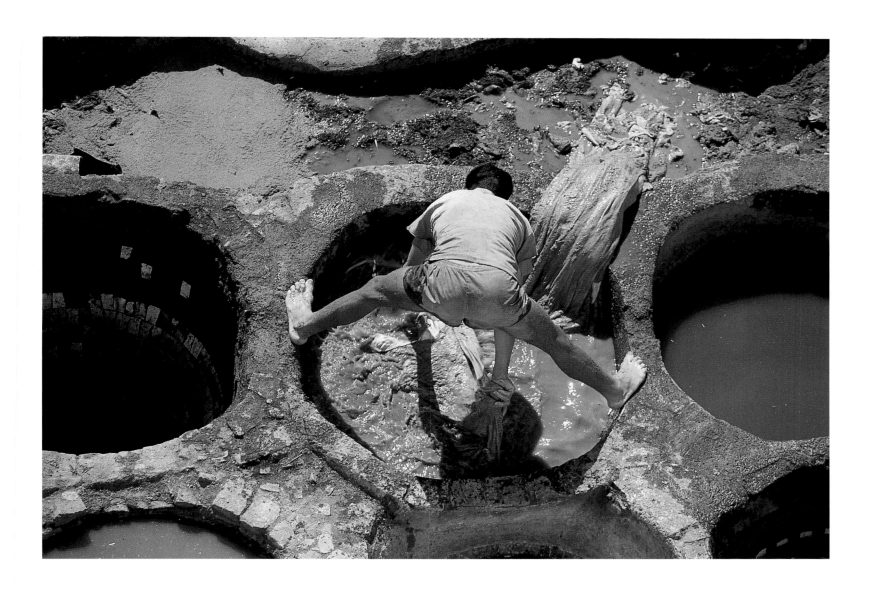

OUTSIDE THE TANNERY (LEFT), this worker has the unenviable task of trimming all the offending bits off the raw hides in preparation for the lime treatment. **(ABOVE AND OVERLEAF)** The tannery itself is breathtaking in both sight and smell. The stench from the vats punches you in the face long before you actually see the courtyard. It makes one's eyes water just to imagine that there were 200 of these tanneries in the medina back in fifteenth-century Fez. Now there are only two, where young men toil with pungent hides inside a lethal cocktail of dyes, urine, pigeon dropping and a dash of quicklime, for roughly US$7.50 a day.

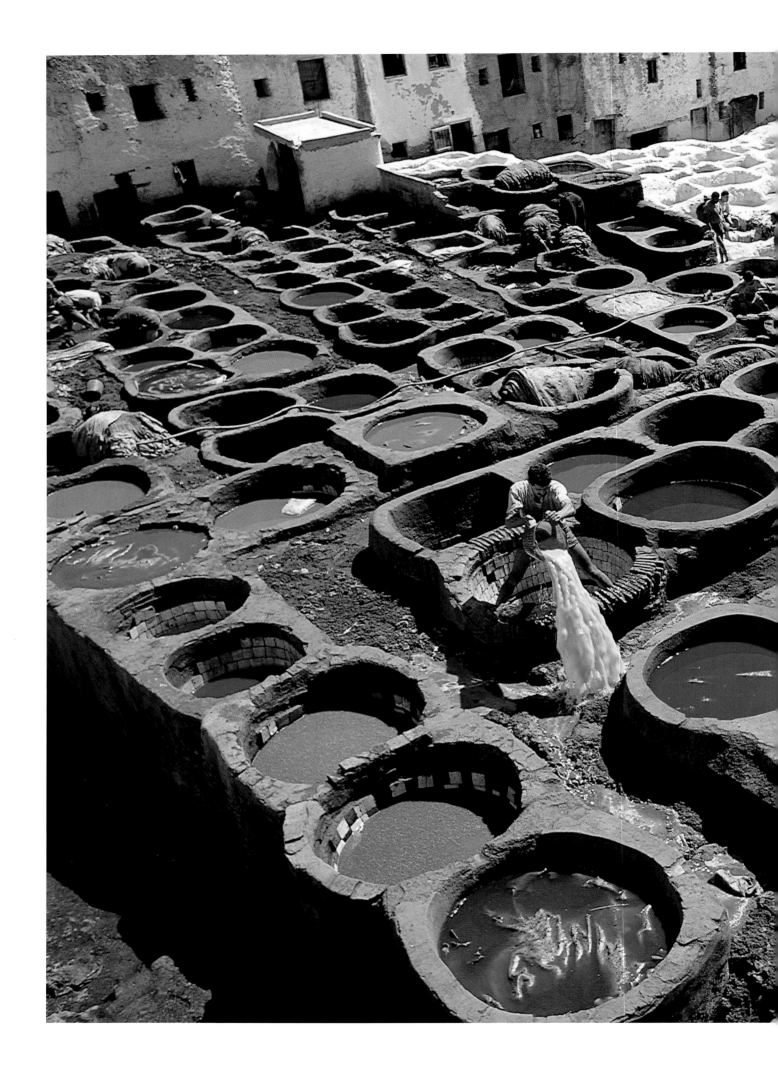

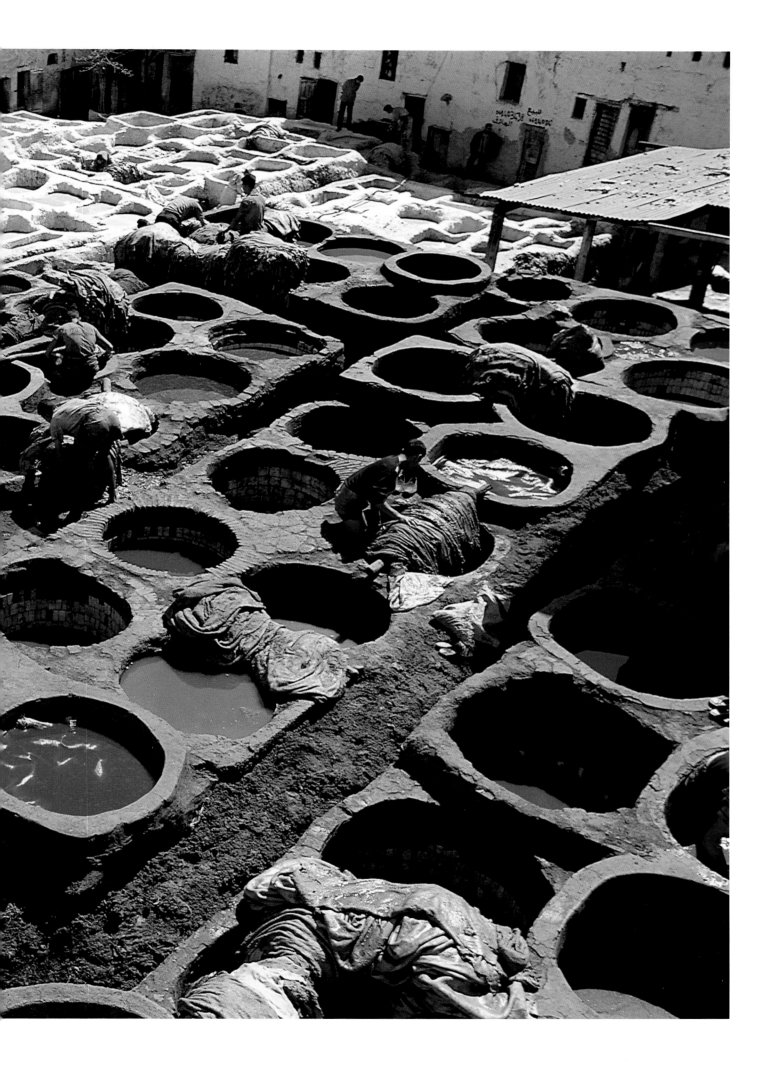

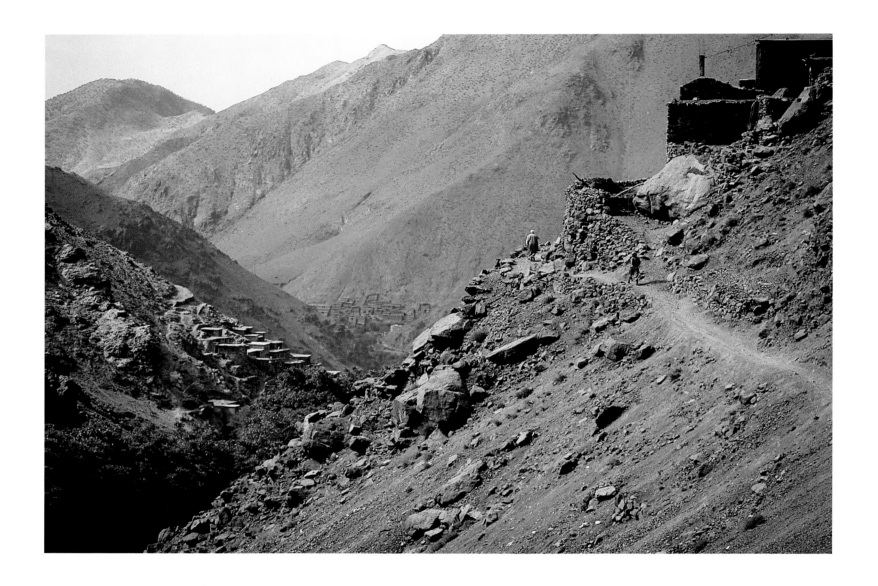

EIGHT THOUSAND FEET up in the High Atlas Mountains **(ABOVE)** is the Berber village of Aremd, where we were treated to an excellent lunch of lamb tagine, and entertained with a mating dance that involved a lot of shaking of the shoulders. Martin Scorcese used this area for Tibet in his film *Kundun*, based on the autobiography of the Dalai Lama.

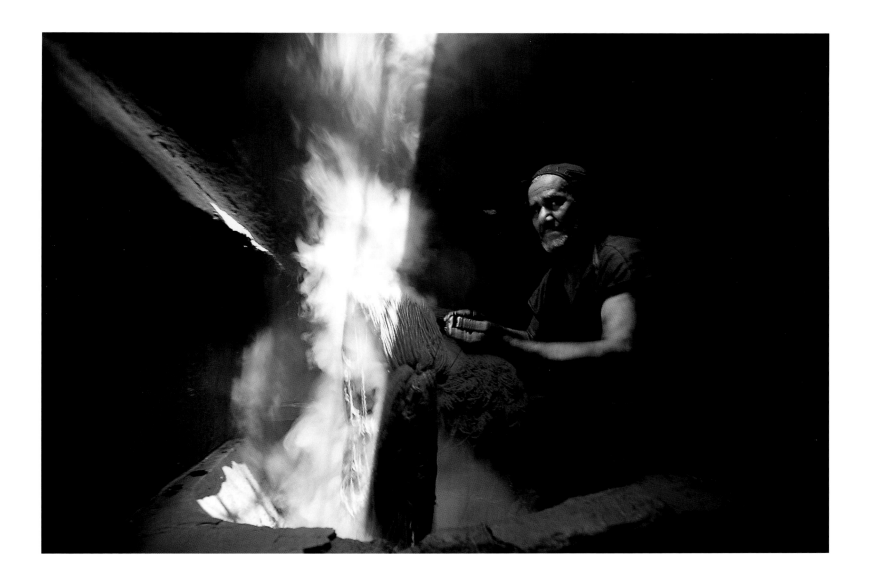

(ABOVE) The historic souk of Marrakesh is situated just off its main square, the Djemaa el-Fna (translated as Assembly of the Dead). Inside the old market, behind a street covered by multi-coloured scarves drying overhead like banners from a Kurosawa shogun epic, I found this man dyeing away in this tiny hovel inside a dark alley.

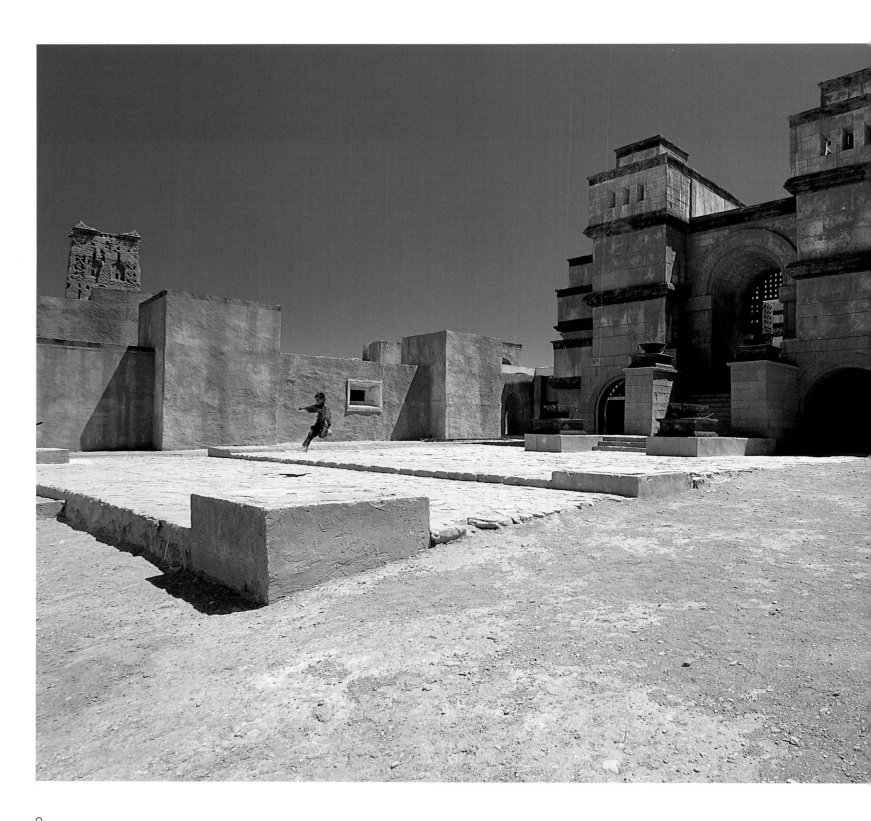

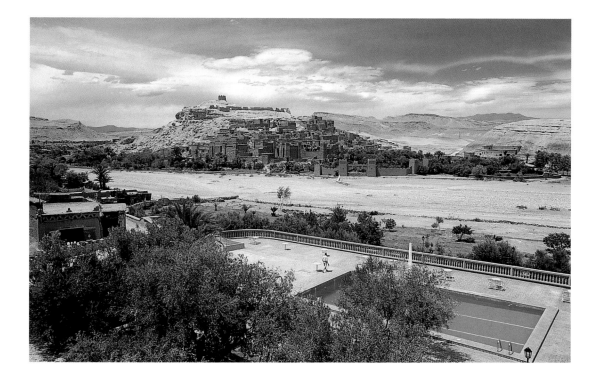

IN THE DESERT, about 10 miles outside of Ouarzazate **(LEFT & BOTTOM RIGHT)**, we came across Jerusalem, a film set built by an Italian team who were producing a series of biblical stories for television. Later in the evening, back at the hotel, we met Jesus and his disciples having supper at the next table. **(TOP RIGHT)** The Aït Benhaddou area has a long history as a film location, parts of features as diverse as *Lawrence of Arabia*, *Romancing the Stone* and, most recently, *Gladiator* were shot around here.

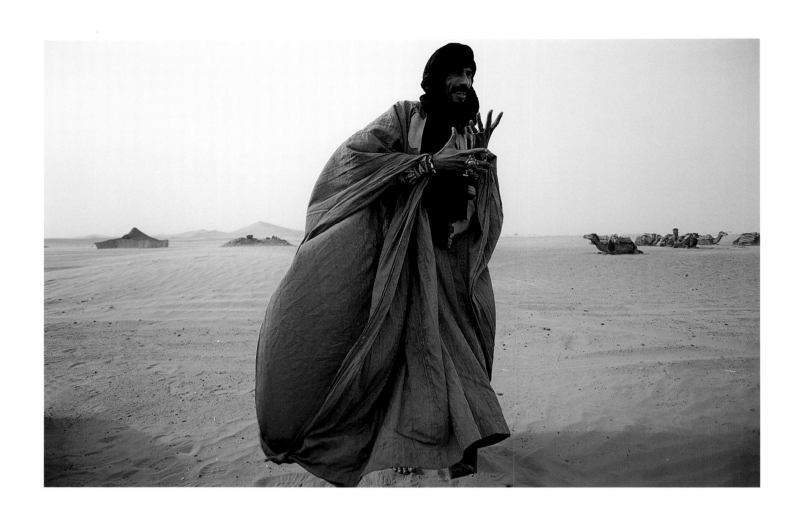

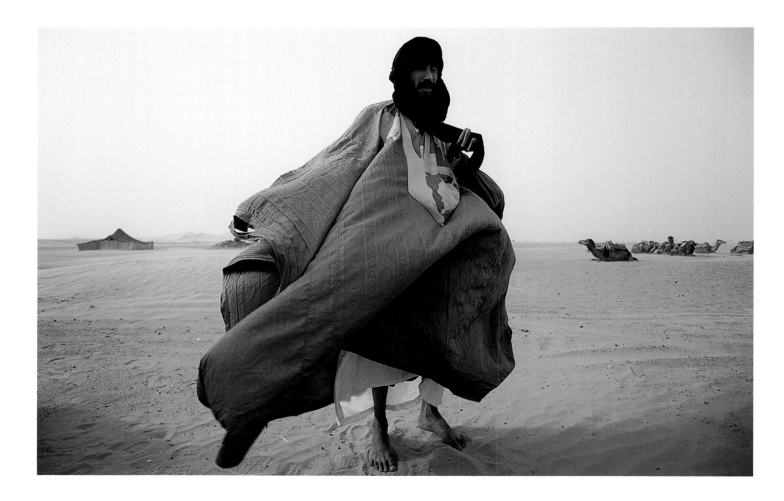

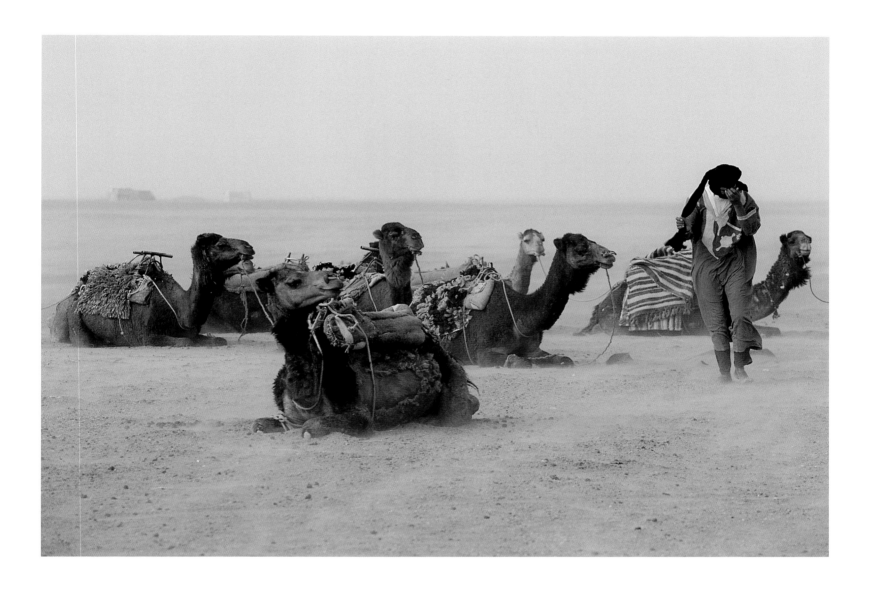

TO PHOTOGRAPH a full-blown sandstorm is a physical impossibility, because sand fills the sky and blocks out the sun. Shifting sand simply will not register on film, unless it is perfectly backlit. A high wind was blowing through the desert in Mhamid, where the Moroccan highway abruptly vanishes. We took refuge from the storm in the tent of a Touareg gentleman who ran a 'Desert Experience' camel train for tourists. The solution to my problem came **(LEFT)** when he stepped outside to speak to a friend and the billowing form of his *boubou* articulated the wind for my camera. When one of his assistants **(ABOVE)**, who was dispatched to calm the camels, got sand in his eyes, the task of illustrating high wind in the desert was finally accomplished.

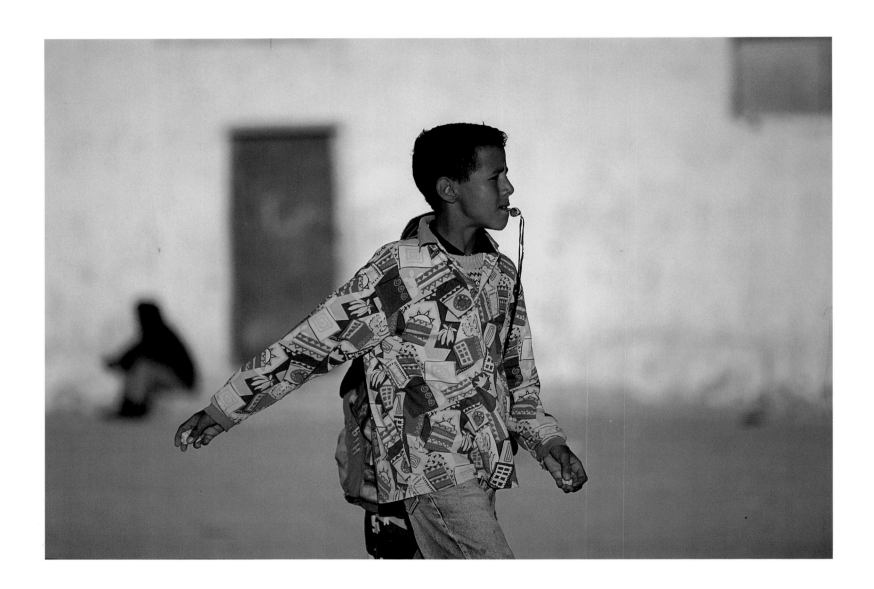

AT THE HIGH SCHOOL in the Polisario camp of Smara **(TOP RIGHT)**, teachers use the low stone wall as their command post to orchestrate the students in a rehearsal for a parade to commemorate the establishment of the Polisario. **(BOTTOM RIGHT)** Sixteen miles outside of Smara, an old tanker is filled at the artesian well. The water is then delivered to a series of cisterns dotted around different areas of the camp, where the Saharawi families go to collect their daily needs. **(ABOVE)** At daybreak, this prefect at the local primary school throws small rocks at the feet of the children to hurry them on to class. Education is a major priority for the Polisario and they have a 90 per cent literacy rate.

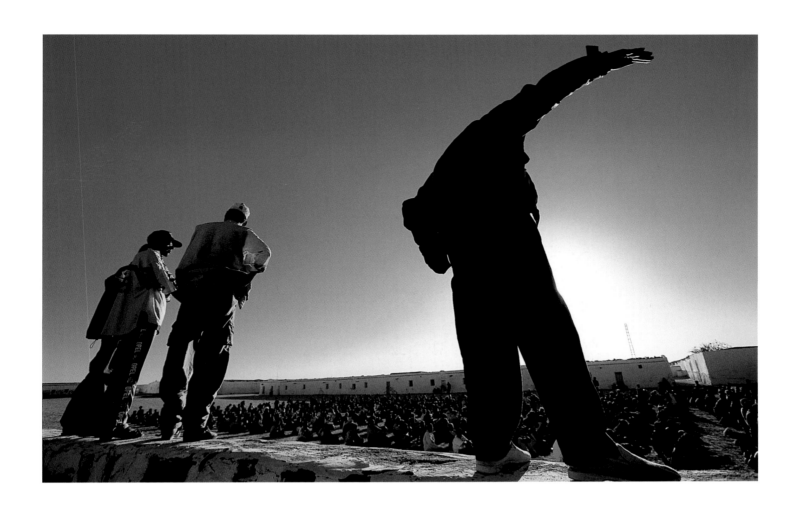

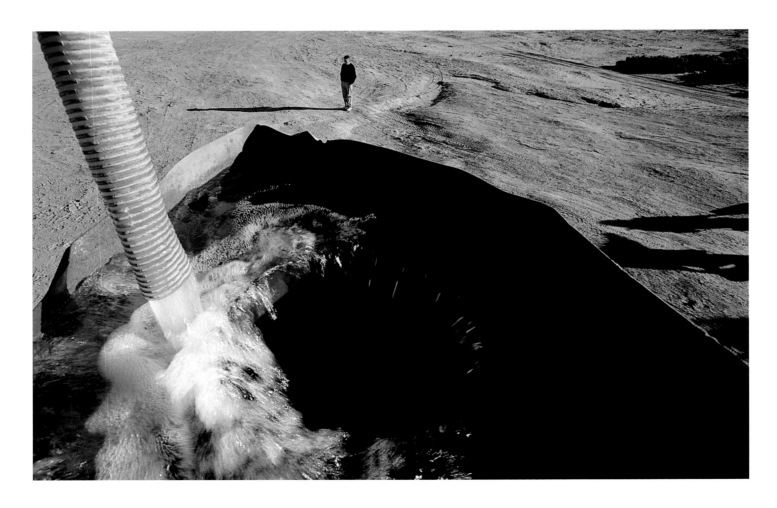

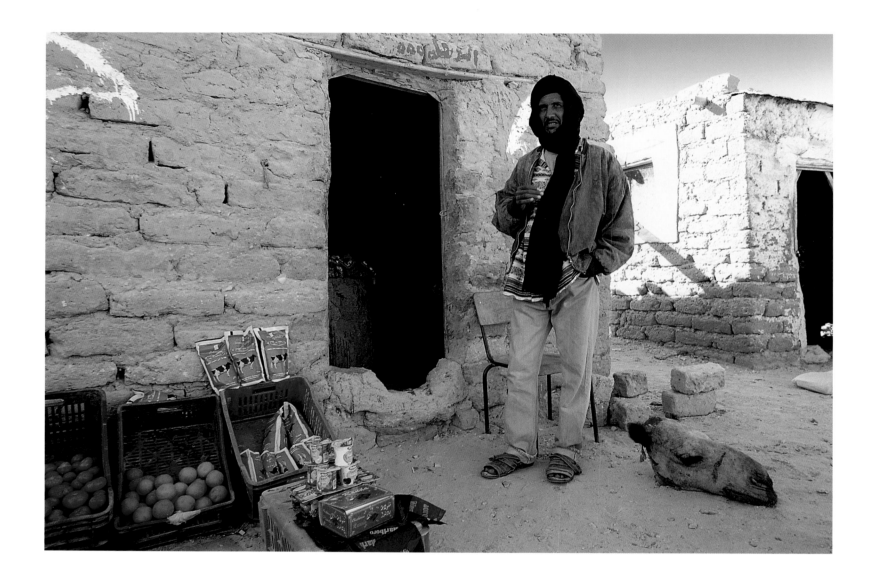

THE PRIVATE MARKET at the camp **(ABOVE)** did not have a lot on offer, but it was the first market I'd ever been to where I could have picked up a whole camel head. The extended family plays an important role in the smooth running of the camps. **(RIGHT)** Our host Bachir's mother-in-law is a frequent visitor to the house to help with the children and chores.

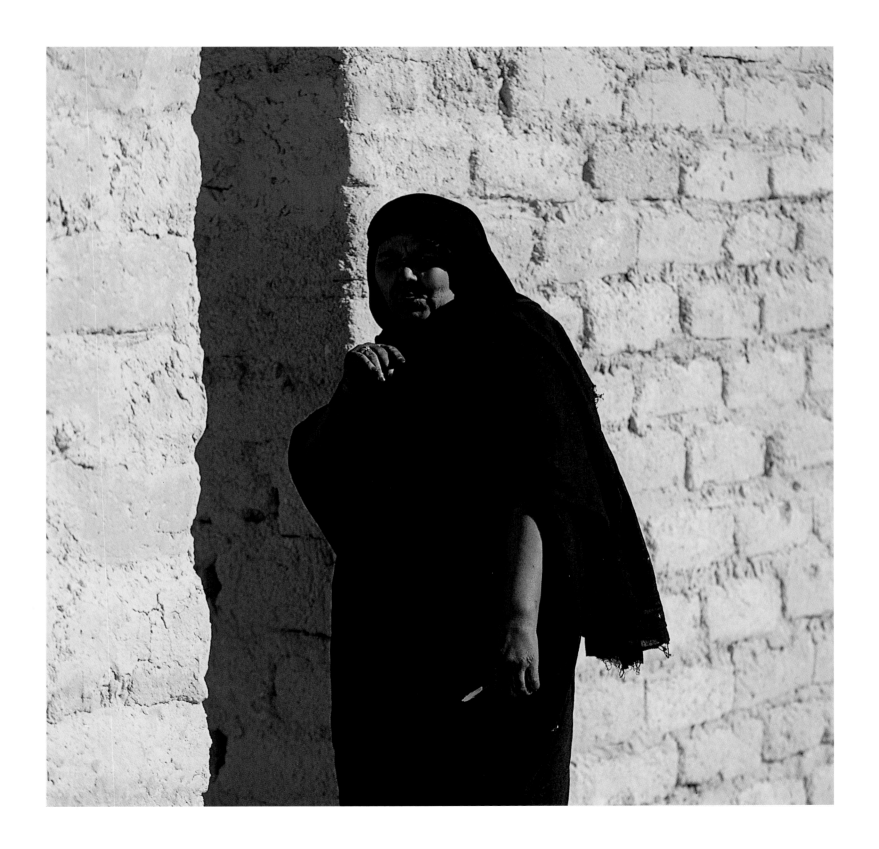

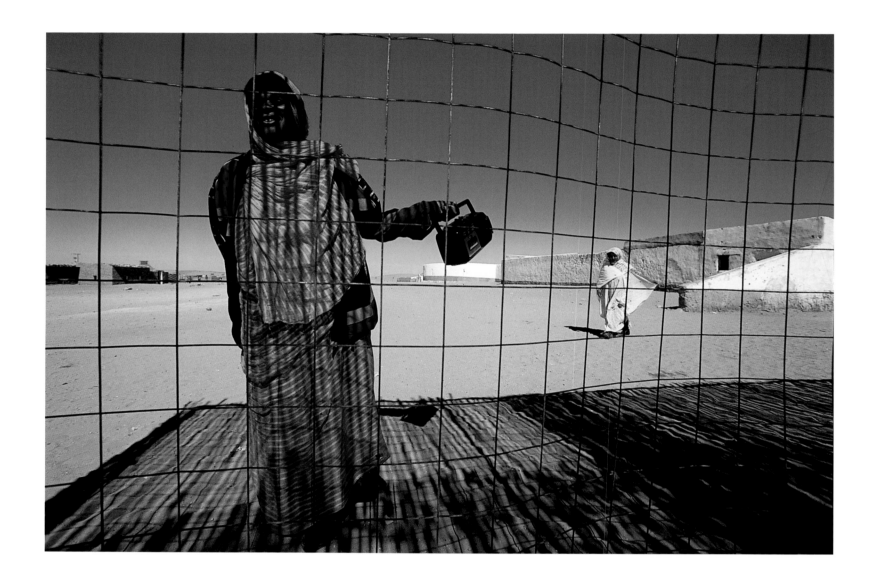

THESE YOUNG SAHARAWIS were born in the camps set up by the United Nations twenty-five years ago. For them, this piece of no-man's-land on the Algerian border is home, while their country, Western Sahara, exists only in name and their collective imagination. **(ABOVE)** A young lady sings along with her prized possession outside the audio/video rental shop in the 27th February Village. **(RIGHT)** This girl was observing us from a distance. My eye was glued to the

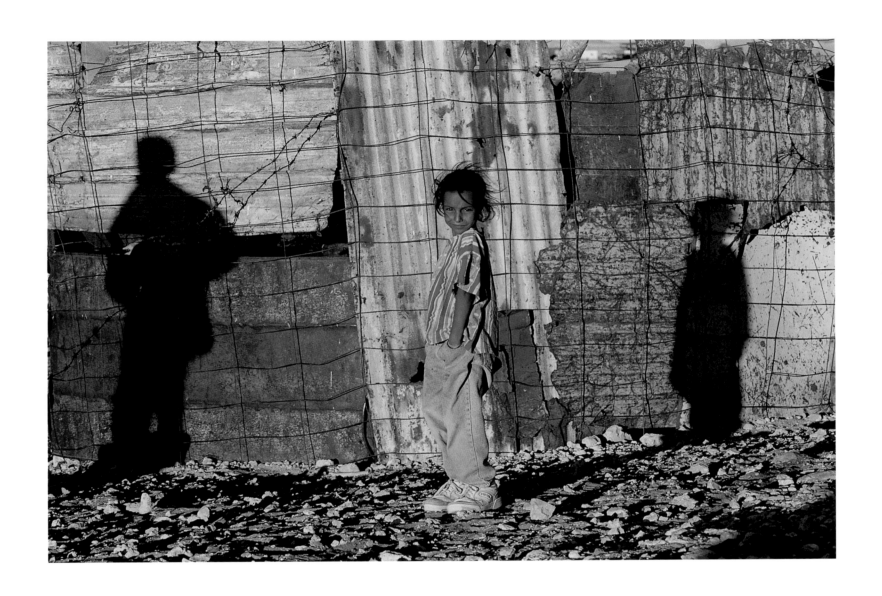

viewfinder, following Michael and a family moving around the animal enclosures. I caught a glimpse of her out of the corner of my eye. In an instant, I turned, framed and let the shutter go. Then a goat ran across the frame. We were both laughing by the time I lowered my camera; she was completely surprised and quite delighted.

(OVERLEAF) On top of a small hill, at sunset, a camel enclosure is under renovation.

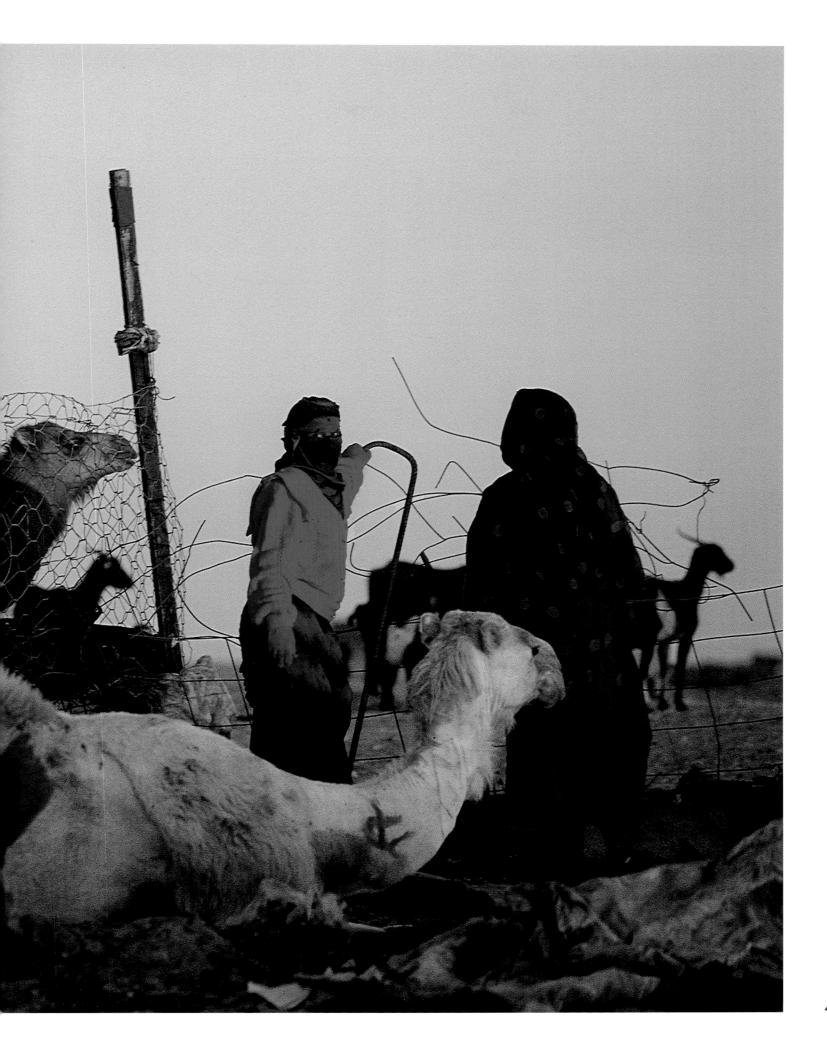

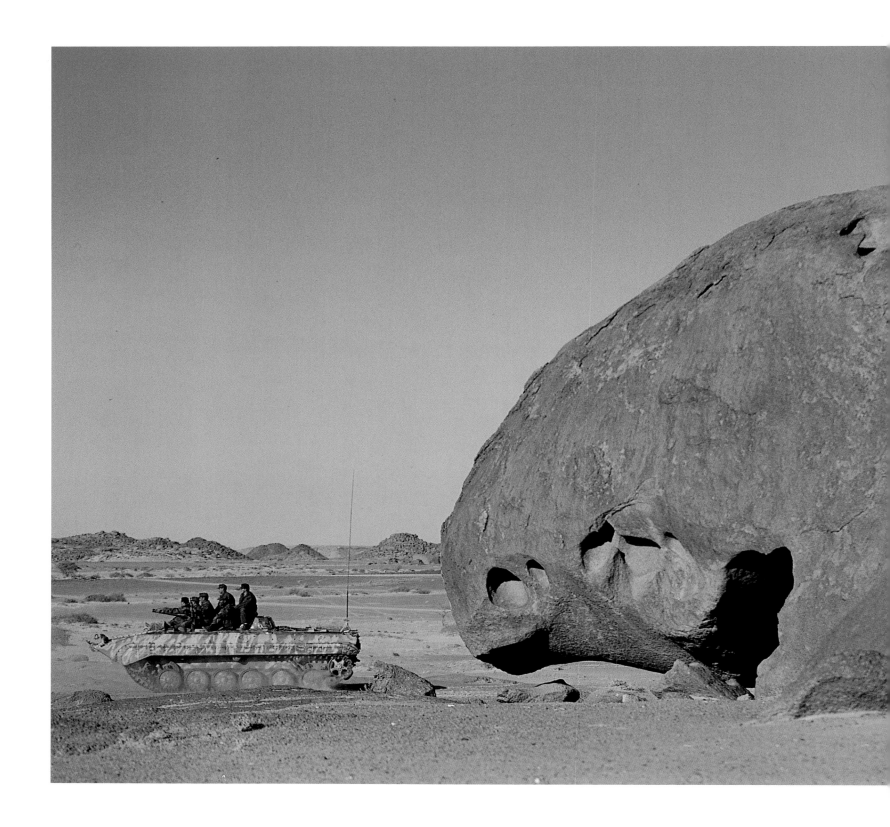

THE POLISARIO ARMY. (LEFT) Around the headquarters of the Second Army District, near the Moroccan border, camouflaged inside an area of extraordinary rock formations like a Henry Moore sculpture garden, old Russian tanks are wheeled out for an exercise, much to Roger's delight. Later, he said he felt like Napoleon. **(TOP RIGHT)** Outside the barracks in Mejik, where

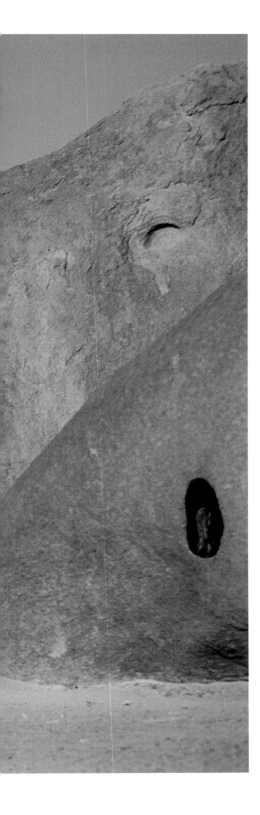

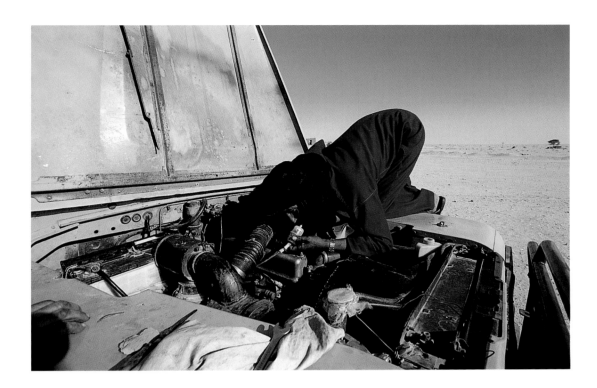

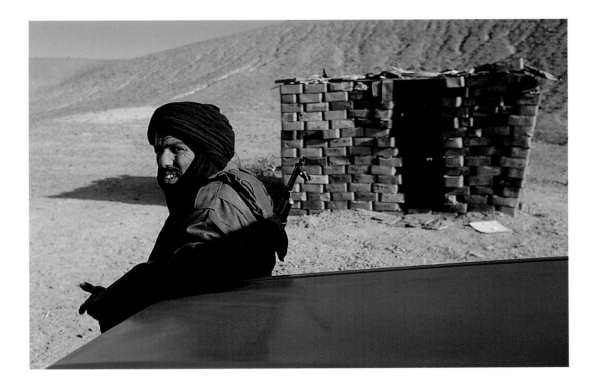

we spent our last night with the Polisario before crossing into Mauritania, a Toyota is given the kiss of life as the driver attempts to fix it with his mouth. **(BOTTOM RIGHT)** At the edge of occupied Western Sahara, where the Moroccans have constructed their own 1000-mile-long 'Great Wall', a Saharawi soldier stands guard outside his post built out of empty ammo containers.

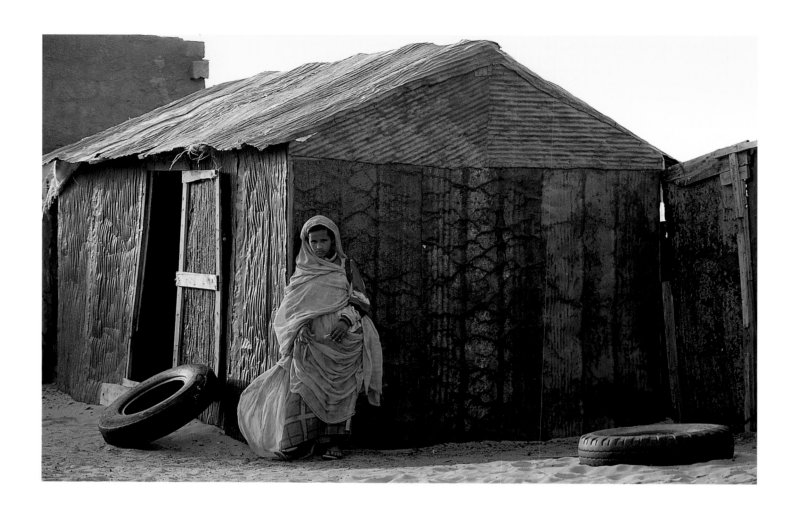

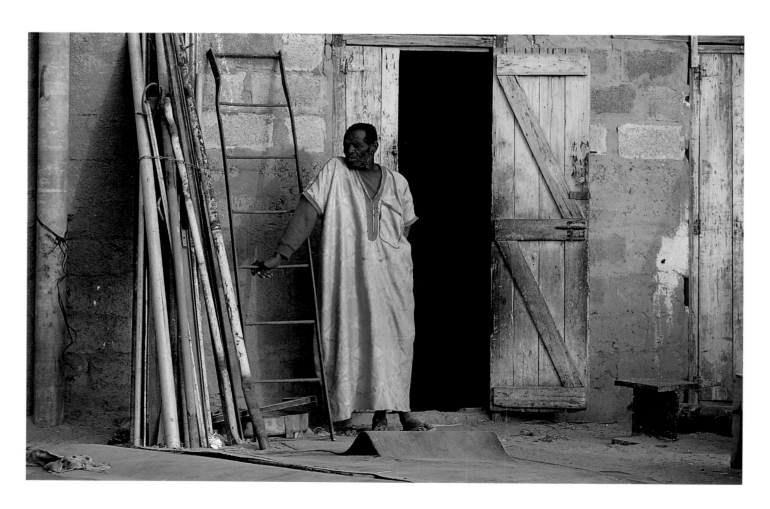

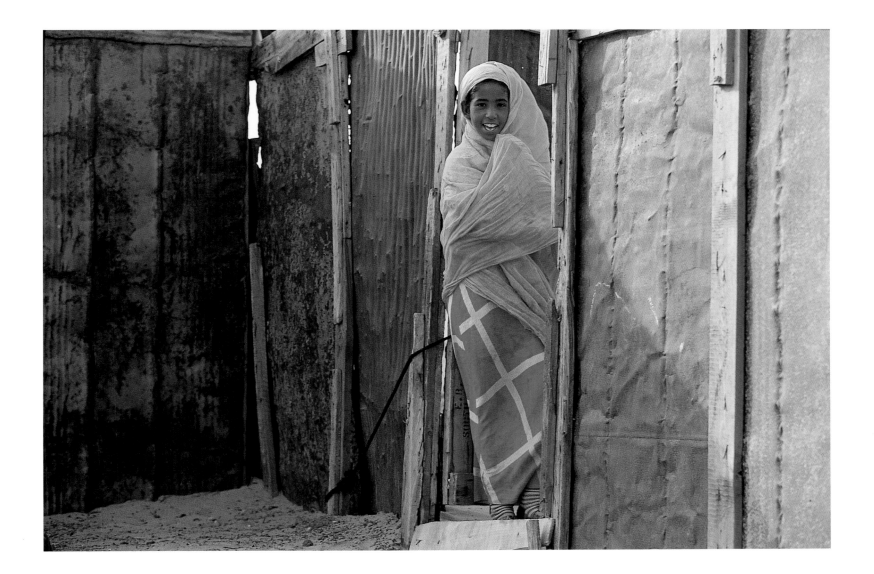

THE BIDONVILLE (tin city) of Zouérat, where thousands of nomad migrants have been driven to settle by years of drought in the interior, is almost entirely built with 6-foot-long sheets of metal beaten out of BP oil drums. **(TOP LEFT)** A young student pauses outside her house on returning from school. **(BOTTOM LEFT)** One of the *quincailliers* (ironmongers) of Zouérat, who can turn an oil drum into a flat sheet in less than five minutes. **(ABOVE)** This little girl from the neighbourhood does not let her primitive living conditions affect her glorious smile.

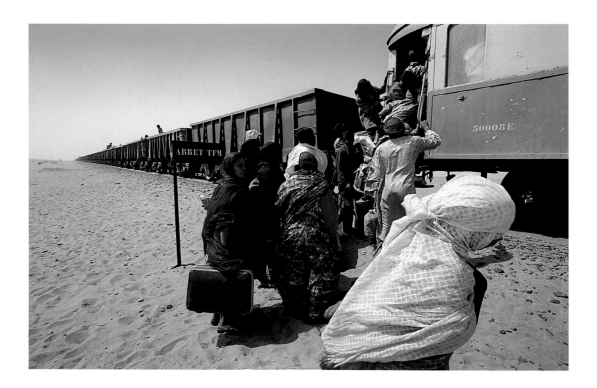

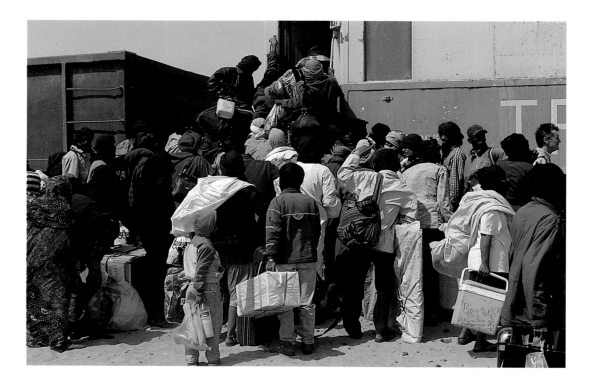

THE TRAIN that carries iron ore from the Guelb mines to the port of Nouâdhibou on the Atlantic coast each day is of great importance to the Mauritanian economy and is zealously guarded. The long line of wagons begins its journey 9 miles southeast of Zouérat; **(TOP LEFT)** we got on the train's passenger carriage after battling our way through thick crowds at Arrêt TFM, which

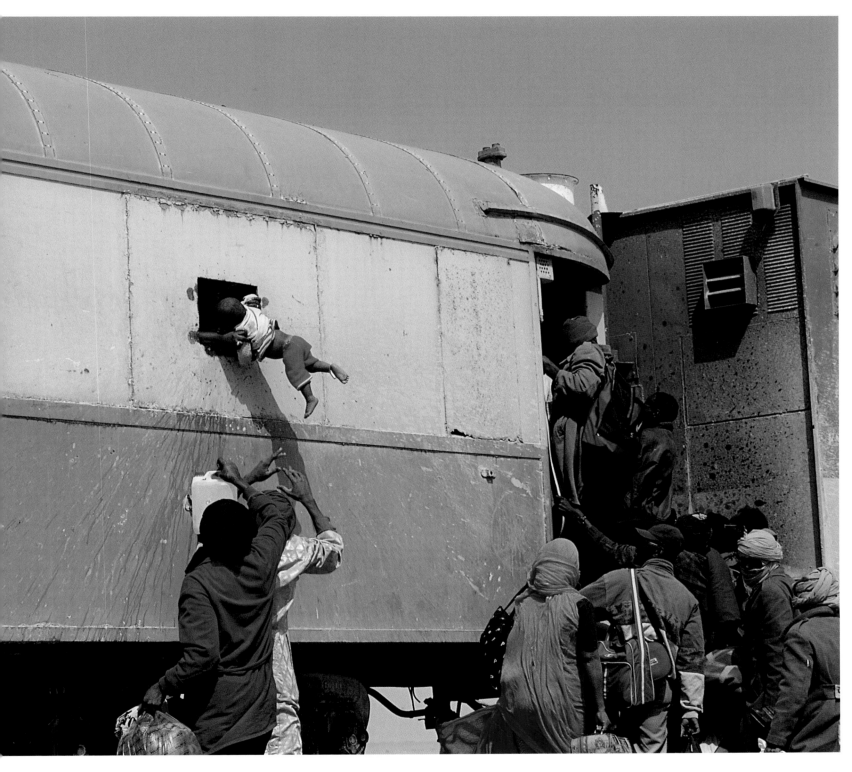

is nothing more than a signpost next to the track in the middle of nowhere. Living proof that pictures do lie (BOTTOM LEFT): Michael was not, when caught in that whirlwind of chaos, as calm as this photo might suggest. (ABOVE) Passengers inserting themselves into the carriage through every possible opening.

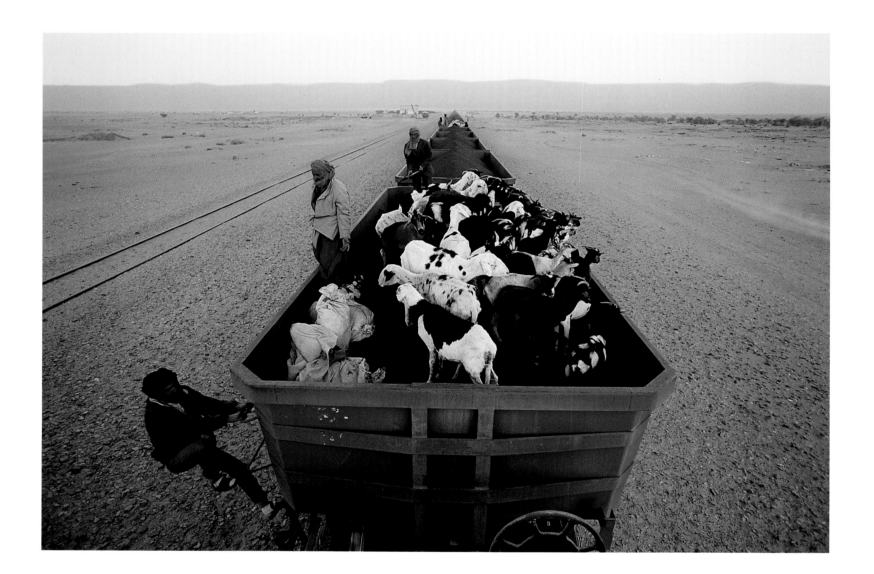

WE GOT OFF the train at Choûm, but before we drove off towards Chinguetti, we managed to catch this sequence **(ABOVE)** of a herd of goats being loaded onto a wagon. What impressed me most was how quickly the animals adapted to their new environment; they just roamed around over the mound of iron ore as if it was the most natural thing to do on a Monday evening. **(RIGHT)** One of the first people I met in Chinguetti – a lady who ran a souvenir stand out of a tent and was keen to do some business with the 'Japanese tourist'.

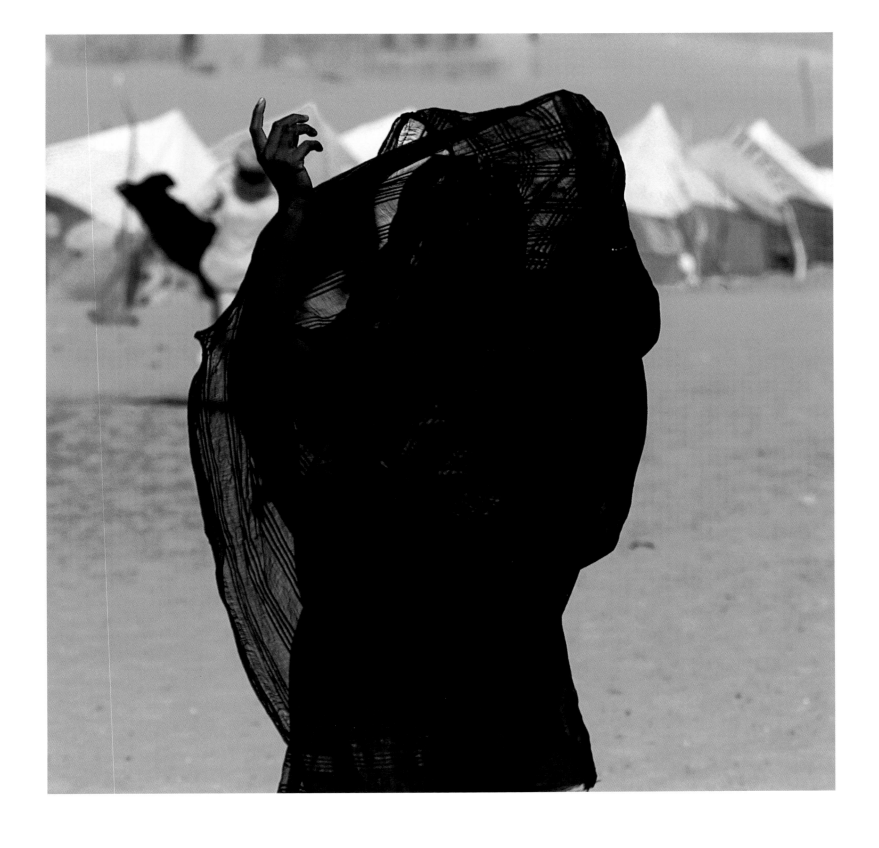

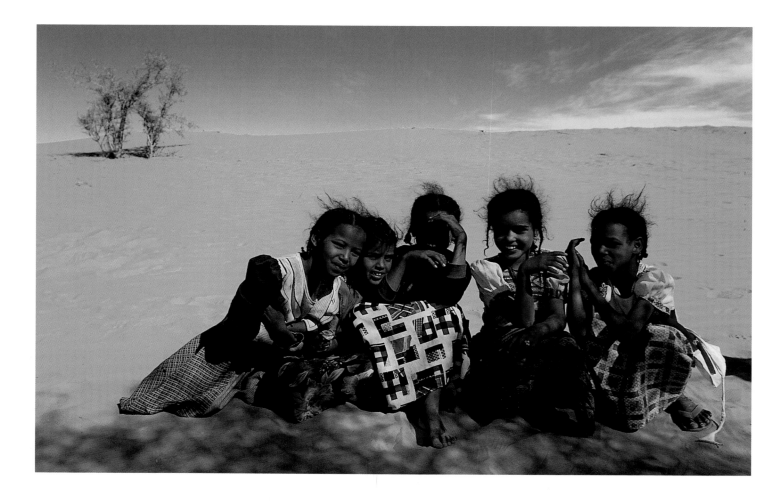

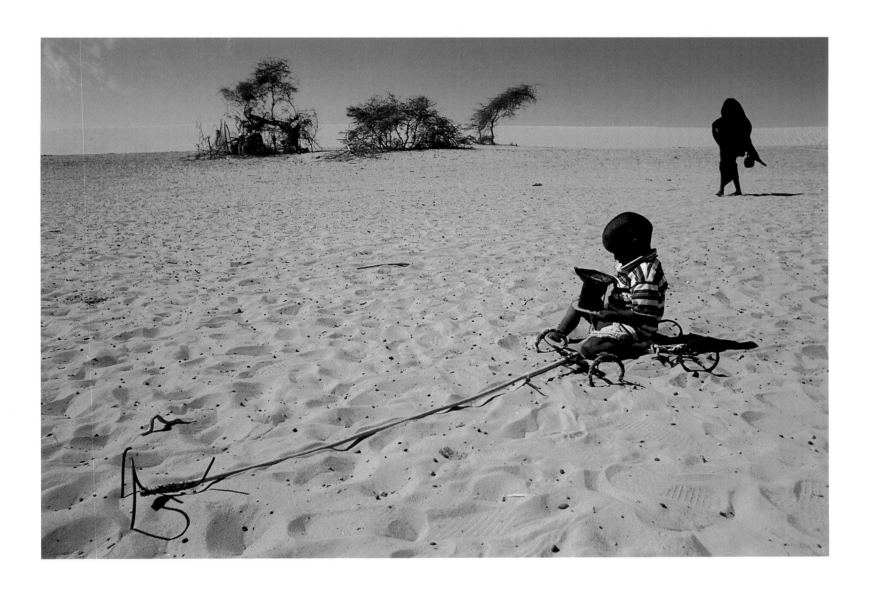

WHILE WE WERE OUT exploring the dunes around Chinguetti, we met up with this nomad family, who showed us the typical desert hospitality. **(TOP LEFT)** Tea was brewed while lunch was being prepared. Like most family situations we got involved in, I found myself drawn to photographing the children. **(BOTTOM LEFT)** These little girls made a game out of it, running away from me time and again only to return to pose for this picture. **(ABOVE)** This boy has his two favourite toys, the family brazier, which he was not supposed to be playing with, and the ubiquitous African boy's toy, the home-made 'Wire Car', with the same ingenious design from here to Zimbabwe.

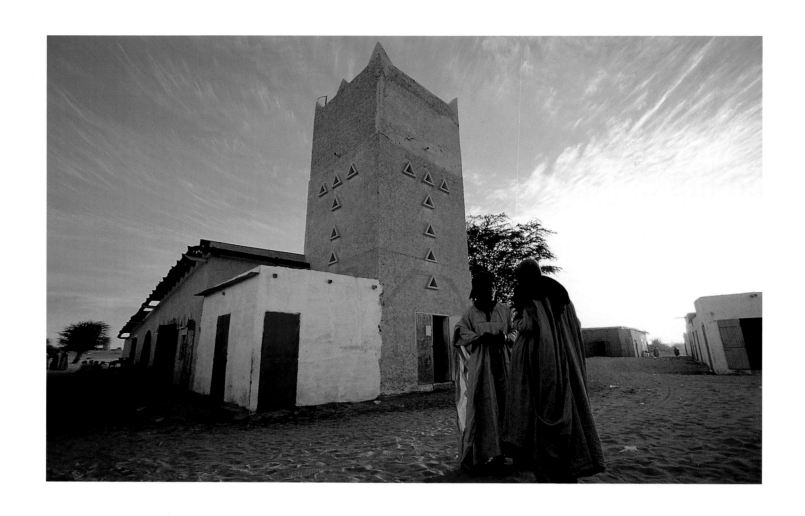

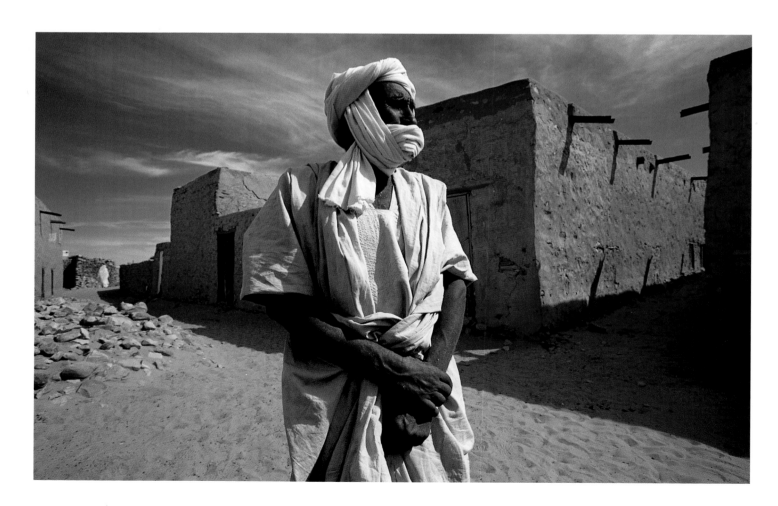

AT FIRST SIGHT, old Chinguetti has the appearance of an abandoned ruin. But behind the crumbling walls, it is a living city, teeming with a way of life that the outside world has largely forgotten. These are some of the inhabitants we encountered, leading their lives at a medieval pace. **(TOP LEFT)** Village elders chatting in front of the mosque. **(BOTTOM LEFT & ABOVE)** Men in *howlis* (headdresses) on the sun-drenched streets of the old town.

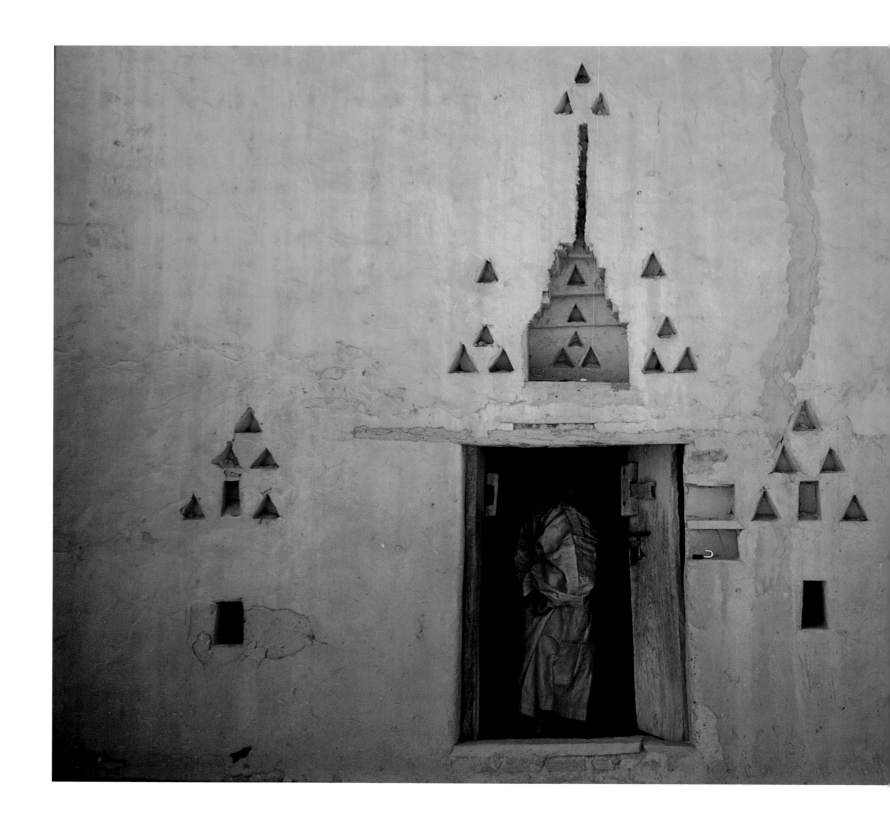

BEING THE SEVENTH holiest city of Islam, the old city of Chinguetti is home to numerous *bibliothèques*, containing thousands of priceless books and documents dating back to 1000 AD, perfectly preserved because of the dry desert conditions. **(ABOVE)** Abdallahi inside the entrance to the Bibliothèque Al Halott, the main library of the city. **(TOP RIGHT)** Inside one of the small red stone buildings, we discovered this gentleman in a tiny room measuring no more than 15 feet

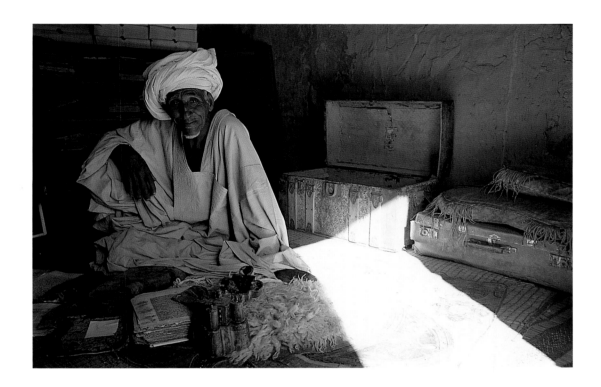

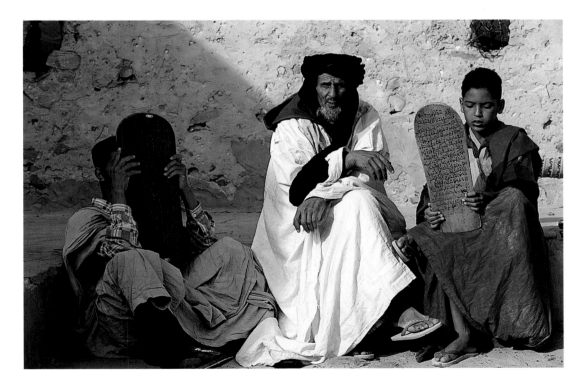

square. He is the proud owner of a private library, which contains an exquisite collection of manuscripts dating back to the fourteenth century, passed down through generations by his forefathers. **(BOTTOM RIGHT)** Inside the courtyard of his house, the imam of the old mosque does his best to maintain the reputation of the old city as a centre of learning. Here, he listens closely to his two star pupils reciting the Koran.

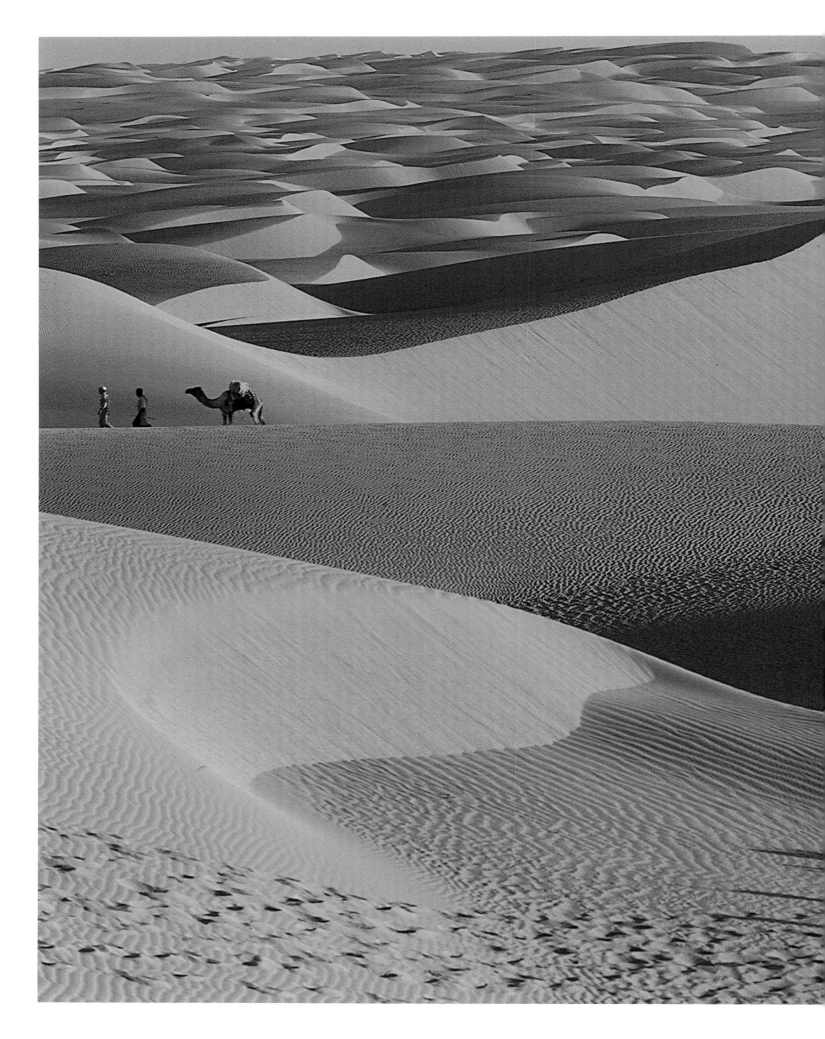

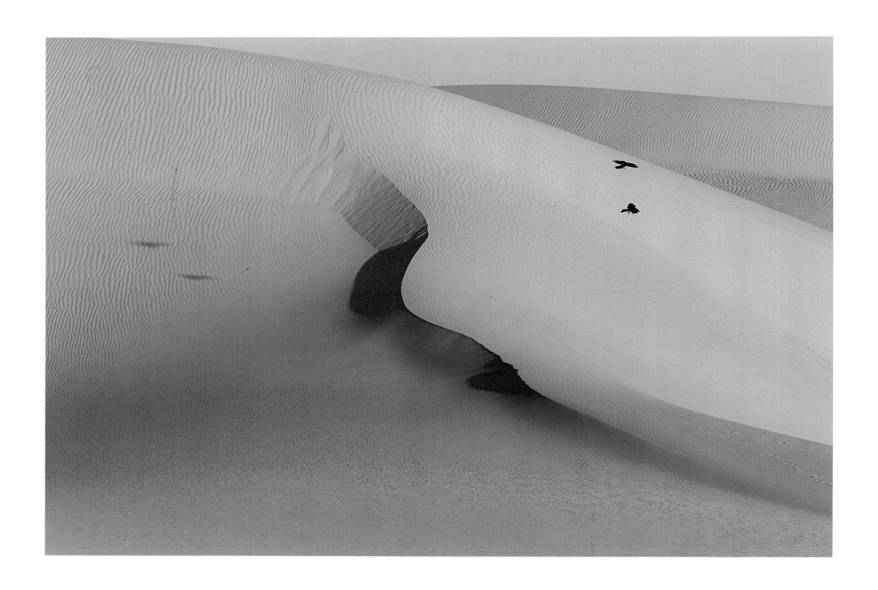

(PRECEDING PAGES) Filming Michael crossing the Great Erg over the sand sea of Chinguetti.
UGLY AND UNPLEASANT birds though they are **(ABOVE)**, the two crows rollicking on the dunes reminds me of two lines from an old Chinese poem, or perhaps they were lyrics from a corny Cantonese opera, in which two lovers declare their undying love: 'In the heavens, a wish to be birds with wings wedded / and on earth, to be trees with branches entwined.'

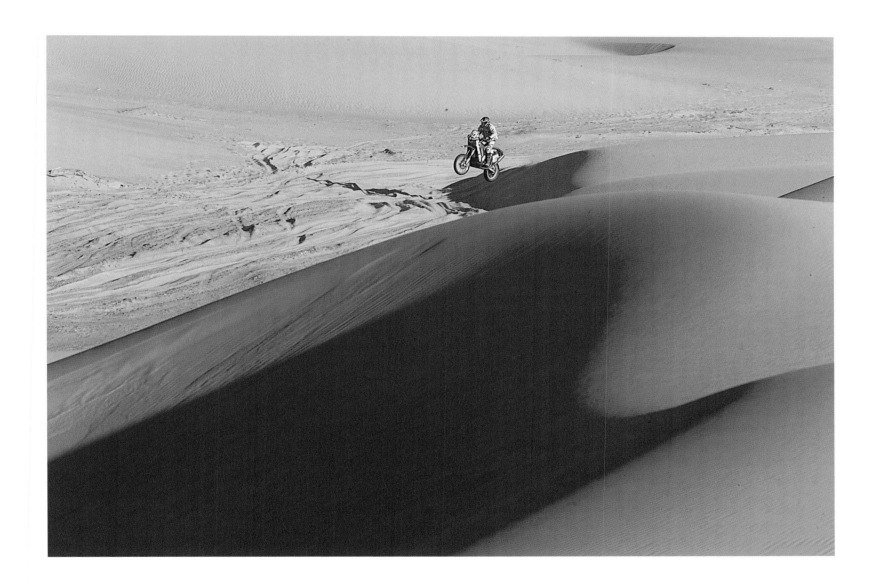

(ABOVE) Outside Atâr, where high dunes press up against the Rift Valley-like escarpment, there was nothing remotely poetic about the hundreds of bikes and souped-up sedans and garbage truck-like vehicles we saw ripping up the desert. But in the minds of the drivers competing in the famous Paris-Dakar Rally, this notoriously dangerous endurance contest is undoubtedly the most romantic thing in the world.

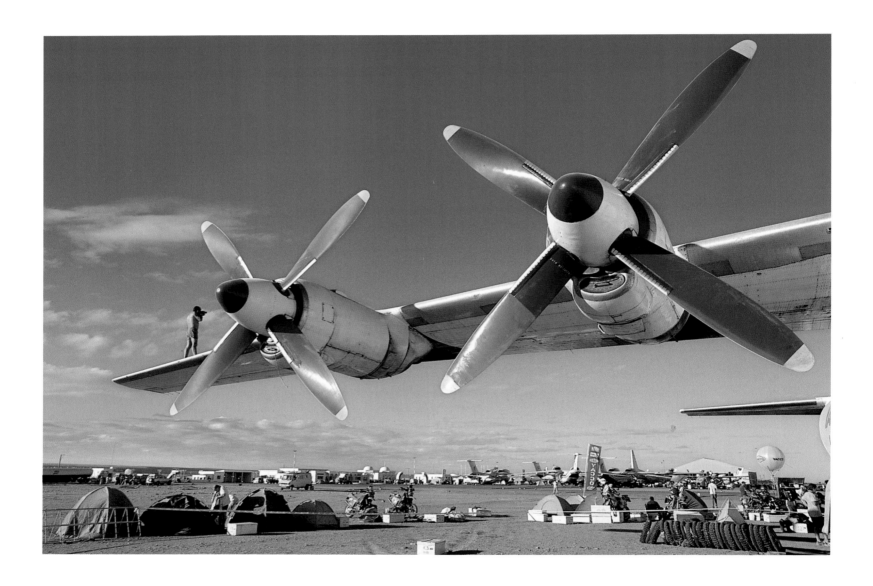

THE PARIS-DAKAR RALLY. For thirty-six hours, the sleepy airport of Atâr was transformed into a tented city of twenty-first-century technology. **(ABOVE)** Cargo planes, Russian jets and helicopters circled the tarmac and the latest in communications equipment was housed in a Hercules, from where they broadcasted the race all over the world. **(TOP RIGHT)** From the wing of an Antonov turbo prop a home movie is being made. **(BOTTOM RIGHT)** Girls from the local village came out to the starting point to watch the road warriors' battle against the desert and the clock.

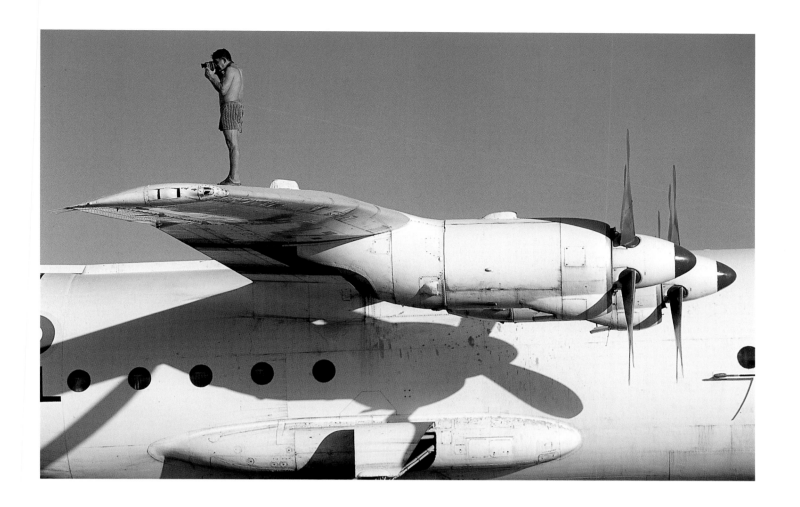

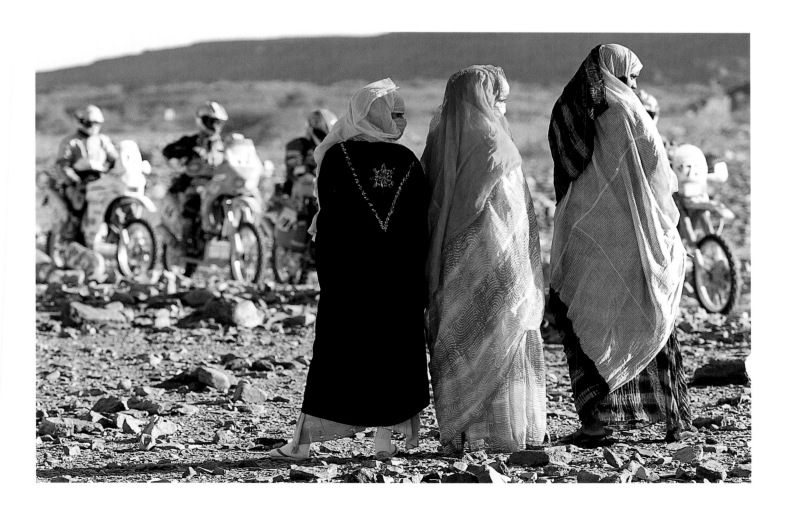

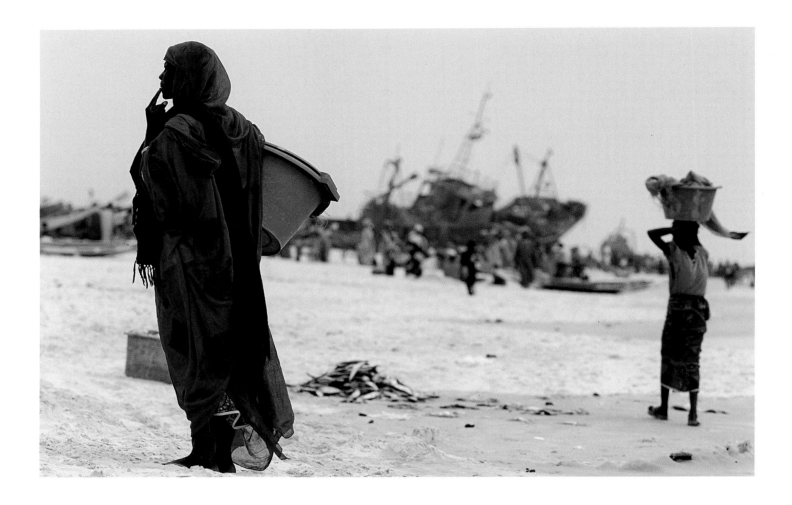

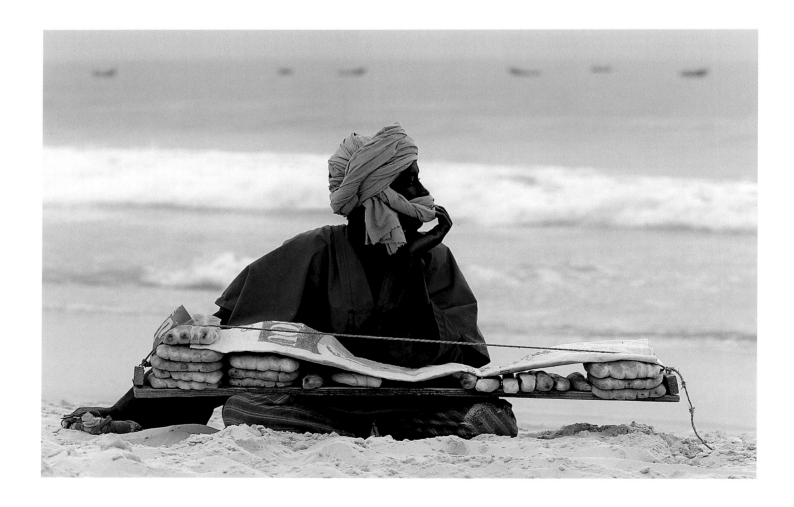

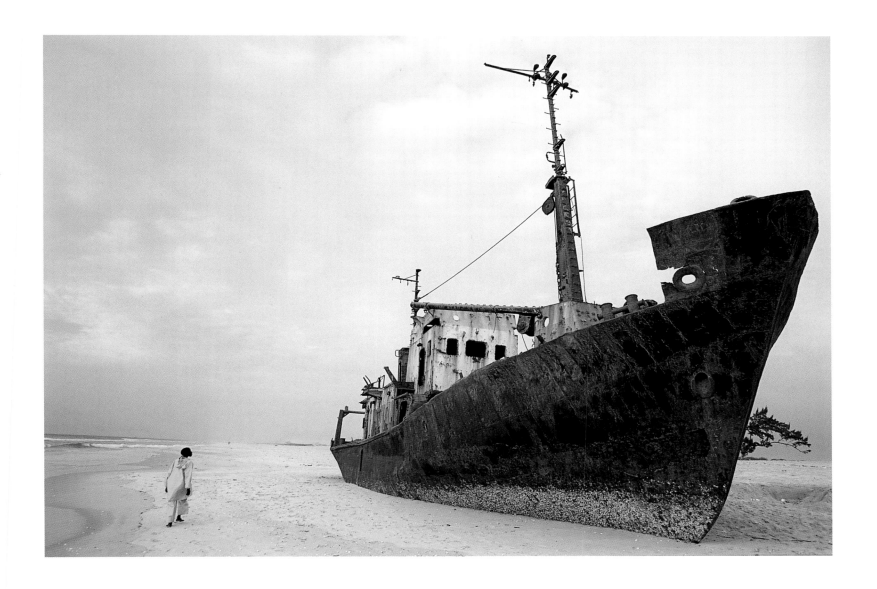

THE CAPITAL of Mauritania is Nouakchott, which can either mean 'Place of the wind' or 'Place of floating seashells'. Taken together, they explain why the quality of light here is so utterly dreadful – an overcast of powdered seashells floating in the Atlantic mist. The lively scenes on the Plage des Pêcheurs – Fishermen's Beach – should have been a great photo opportunity, if only there had been a tiny bit of light. **(ABOVE)** Beached freighters seem to be a standard feature on these shores. This one was found a five-hour drive south in St-Louis, Senegal, but pitiful light seemed to know no national boundaries.

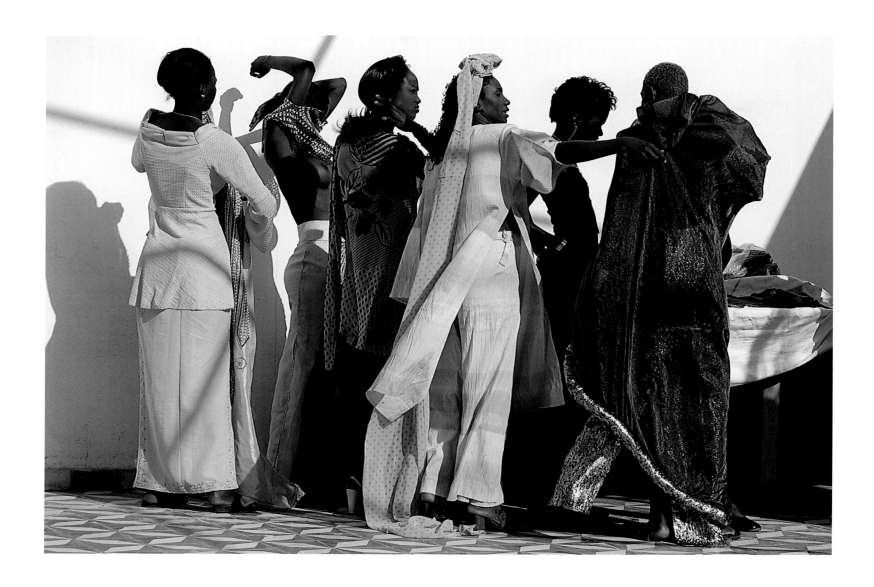

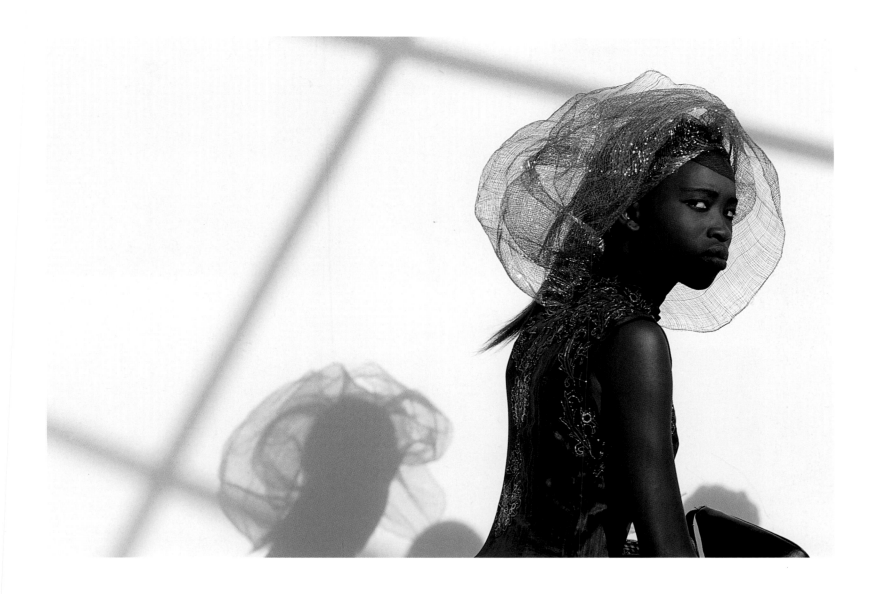

SENEGALESE MODELS busy changing **(LEFT)** in the makeshift dressing room on the roof of the café where the fashion show by Dakar-based designer Oumou Sy (third from right) was taking place. The scene reminded me of a frieze of Greek goddesses preparing to bathe, or perhaps a section of a Chinese scroll where princesses parade across the silk in front of an unseen emperor. **(ABOVE)** This young model, unaware of her own shadow, was a little confused about why I seemed to be focusing on the wall.

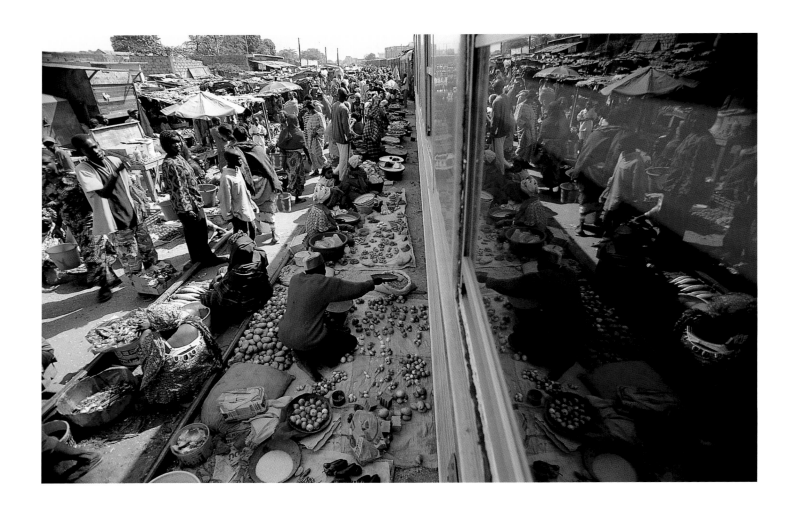

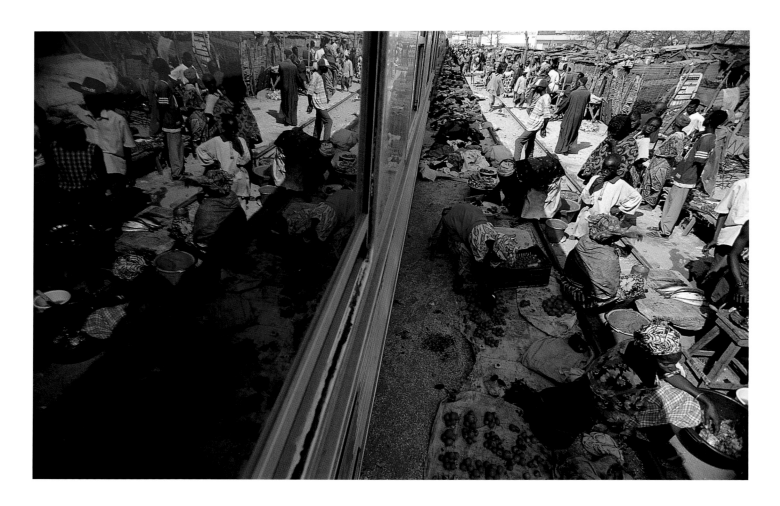

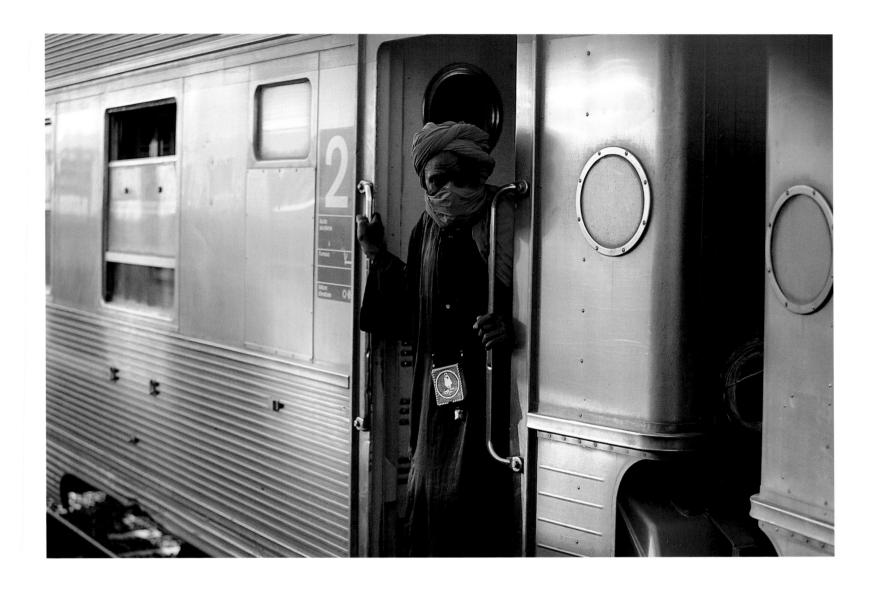

THE TRAIN TO BAMAKO made its first stop in a suburb of Dakar, where the large market had spilled onto the side of the track. These were the views from a window looking ahead towards the front **(TOP LEFT)** and around to the back **(BOTTOM LEFT)** of the train. **(ABOVE)** Nineteen hours later, just before dawn, we finally reached the town of Kidira on the border of Senegal and Mali. The Senegalese-operated train, coming from Bamako, with much newer and more comfortable-looking carriages than the Malian train we were on, had stopped directly opposite us, waiting to clear customs before going on to Dakar.

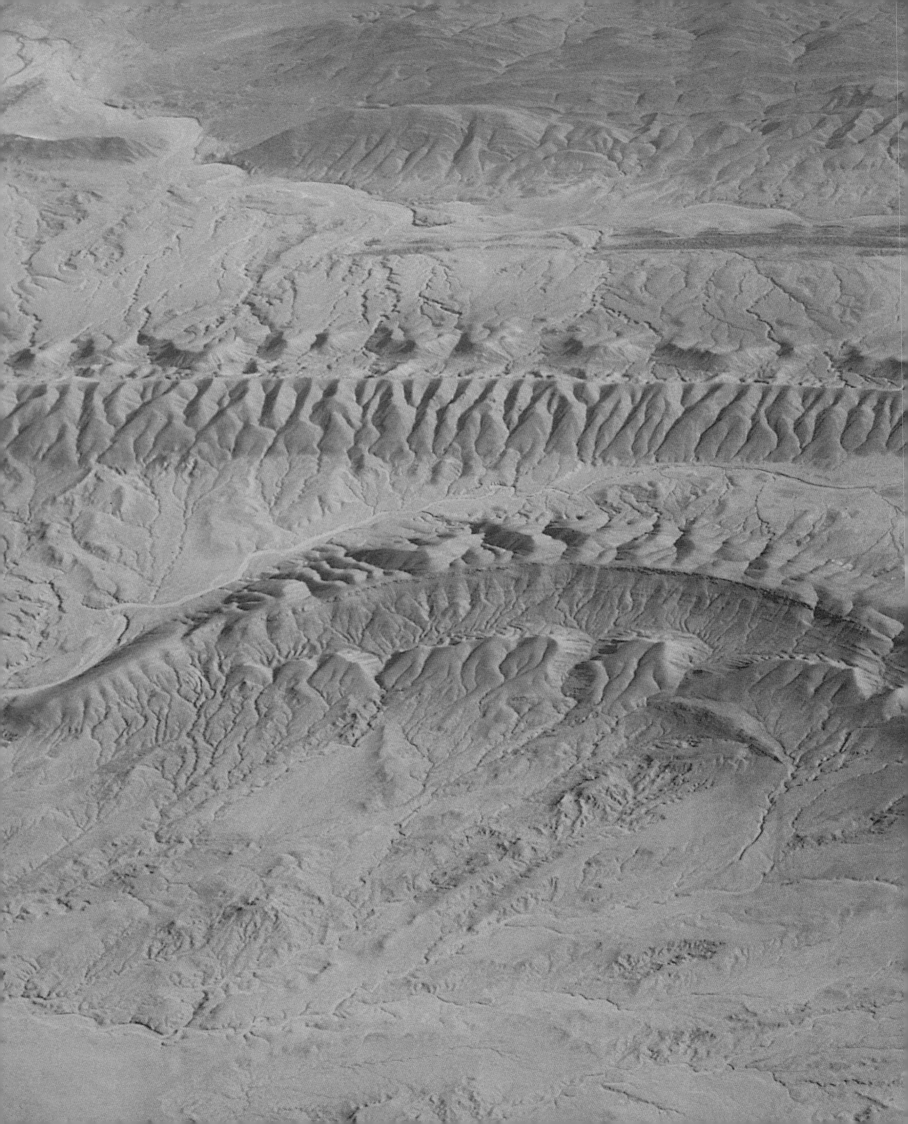

THE**CENTRE**

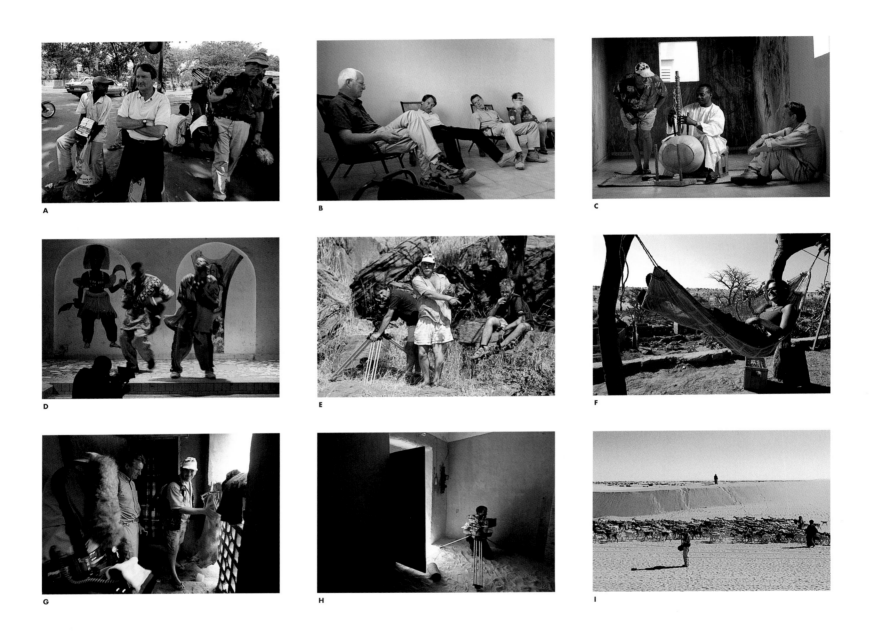

MALI (A) The crew waits for transport and lunch on a busy street corner in Bamako. (B) Waiting for the Great Toumani. (C) Toumani finally arrives and gives a beautiful performance and a terrific interview for the camera. (D) Nigel filming the Malian rappers in Dakar. (E) JP directing traffic in 130°F heat in Dogon Country while the Meakins display their usual enthusiasm for passing shots.

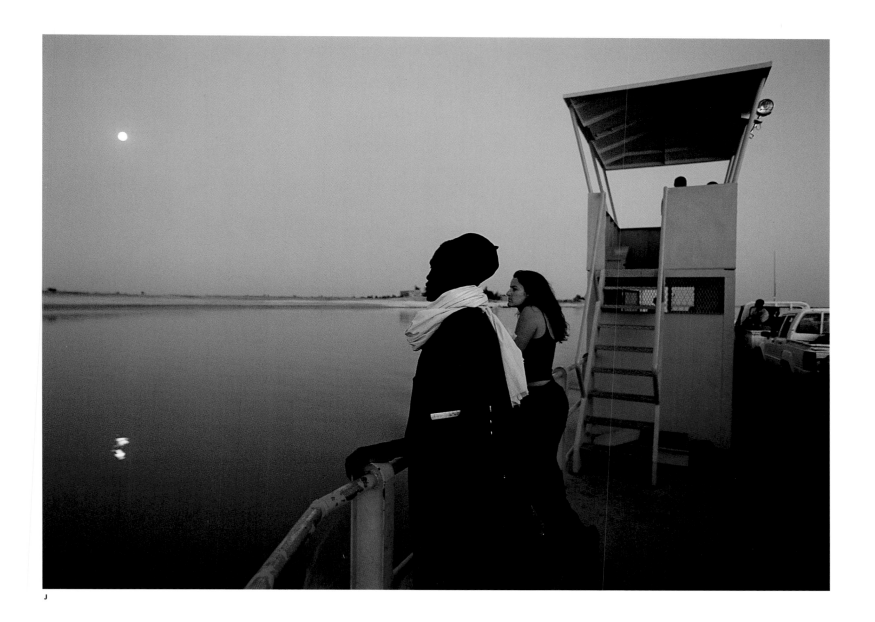

J

(F) Dudu gets her turn on the hammock at Tirelli. (G) JP shows his appreciation of the sacrificial goat as Mike gets his mike adjusted at Pigmy's house in Djenné. (H) Camera in position for the interview with the imam of Timbuktu. (I) Yes John, don't look so surprised, you were in my shot the whole time. (J) Dudu crossing the River Niger on the ferry, with a full moon on the rise.

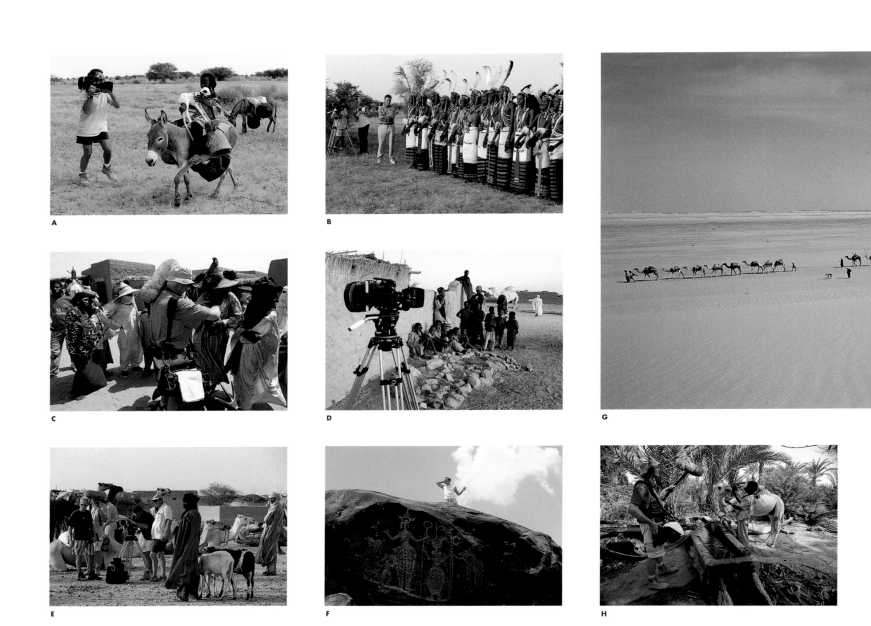

NIGER (A) Nigel with a Wodaabe donkey boy outside Ingal in Niger. (B) The Fulani men roll their eyes in amazement as the Meakins discuss the price of the 300-mm at the *Gerewol*. (C) At the Ingal market, John does to Doulla what he has done to so many celebrities before; he slips his hand inside the front of the gown in order to sort out the wiring of the radio-mike. (D) The camera takes centre stage in the village of Tabelot, when Nigel goes for a walkabout in the Ténéré desert. (E) On his return, Nigel sets out to immortalise the camel's lips and nostril hair on celluloid with his 300-mm. (F) Pete stands atop 'ancient rock art' that just happened to be at the side of the road, a stone's throw away from the oasis. (G) The caravan crossing the Ténéré

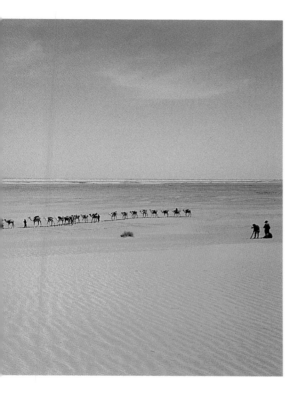

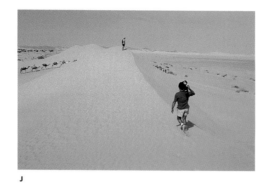

J

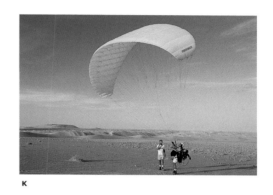

K

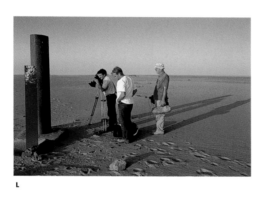

L

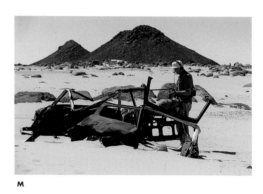

M

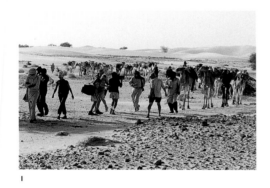

I

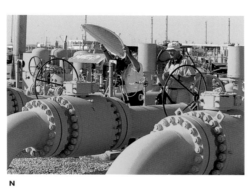

N

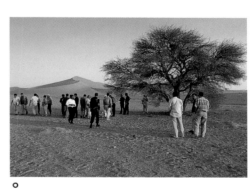

O

Desert for the camera. **(H)** At the oasis, John does a 'wild-track' of the camel munching, a sound which Michael had described as 'a noisy paper shredder'. **(I)** The camel train sets off, following the film crew into the Ténéré Desert. **(J)** JP beckons Nigel to a commanding camera position on top of the dunes. **(K)** French paragliders François and Renaud get ready to take off. **ALGERIA (L)** Yet another exciting morning in the glamorous film industry, this time out on the Algerian-Niger border at I-n-Guezzam. **(M)** At the 'Cemetery', John is disappointed that the car radio has ceased to function. **(N)** 'So where did you say the assistant was this morning again?' **(O)** The full Algerian contingent reveals itself for tea around the acacia tree on the Libyan border.

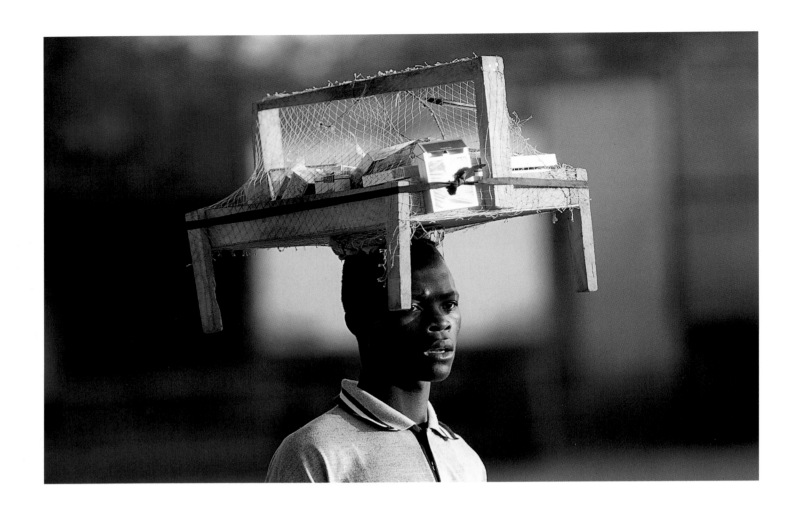

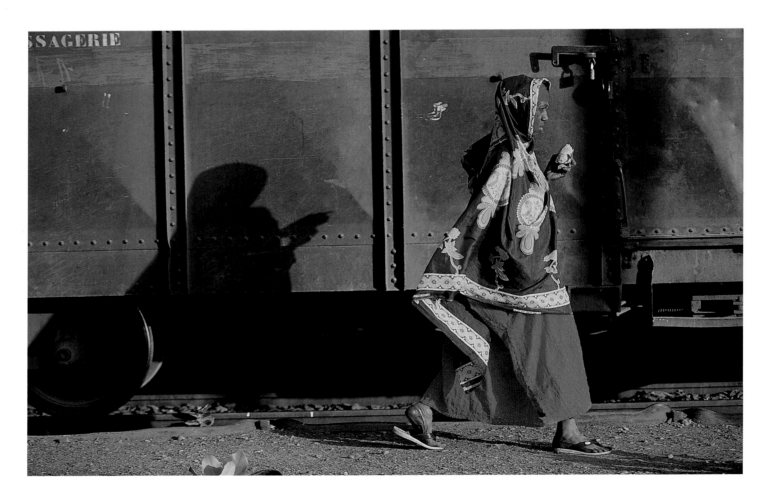

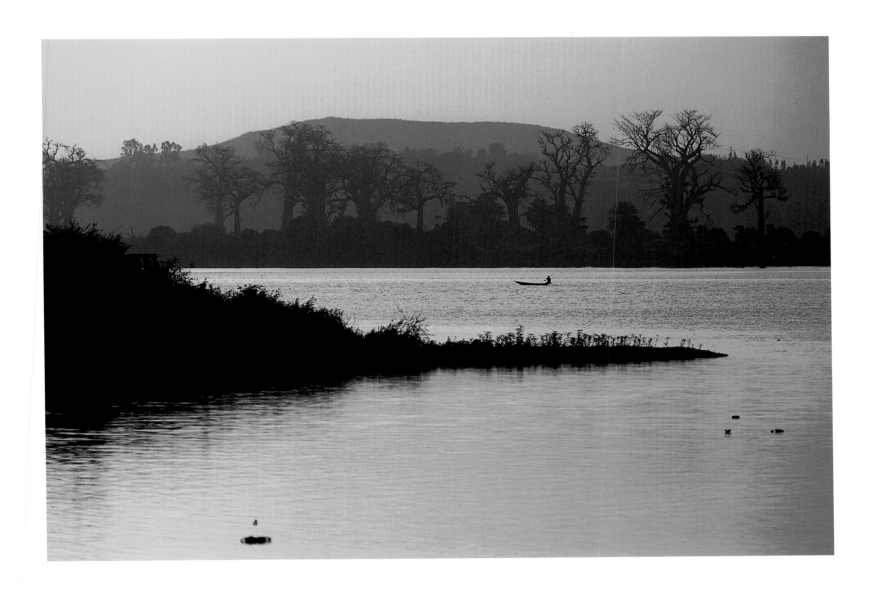

OUR FIRST SIGHT of the River Niger **(ABOVE)** from our hotel in Bamako. The scene of peace and tranquility was met with a grateful, collective sigh of relief. We had arrived at the station in pitch-blackness at five in the morning, to be met by utter chaos and mayhem, but no fixer and no transport – an episode which Michael describes as 'the heart of darkness'. The hawkers of Dakar use their heads as display stands. Colourful towels, fitness machines, plastic buckets, even bottles of wine can be had from the top of people's heads. **(TOP LEFT)** A cigarette salesman shows off his merchandise in the best possible light. **(BOTTOM LEFT)** In Kidira, a passenger, with her breakfast, walking towards Mali in equally good light.

MALI

81

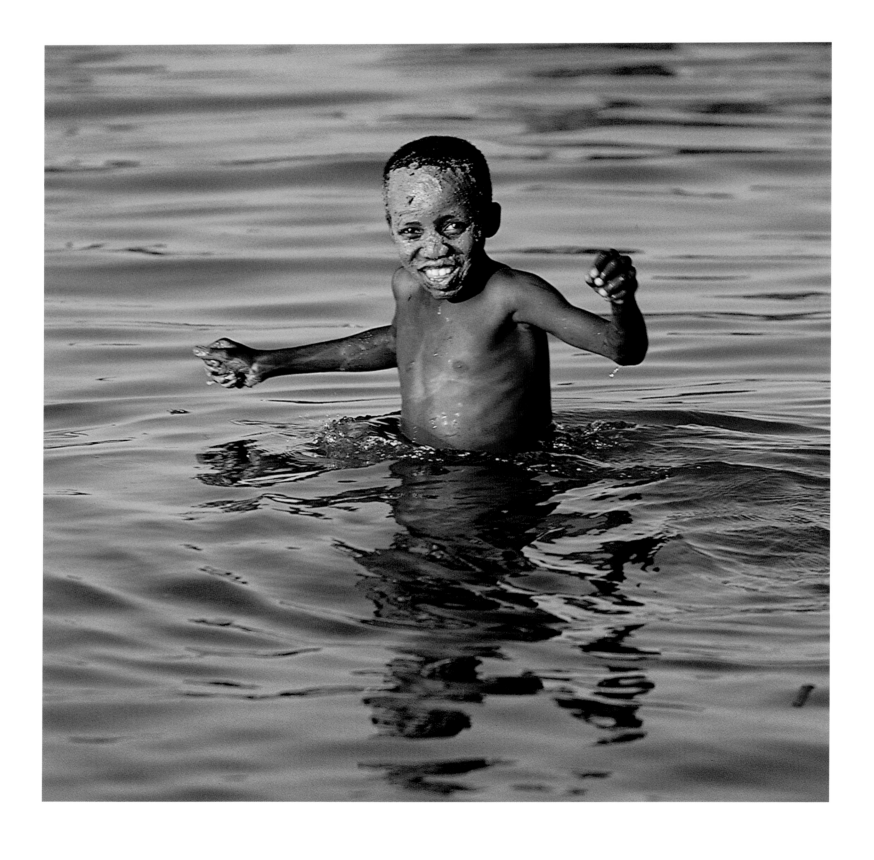

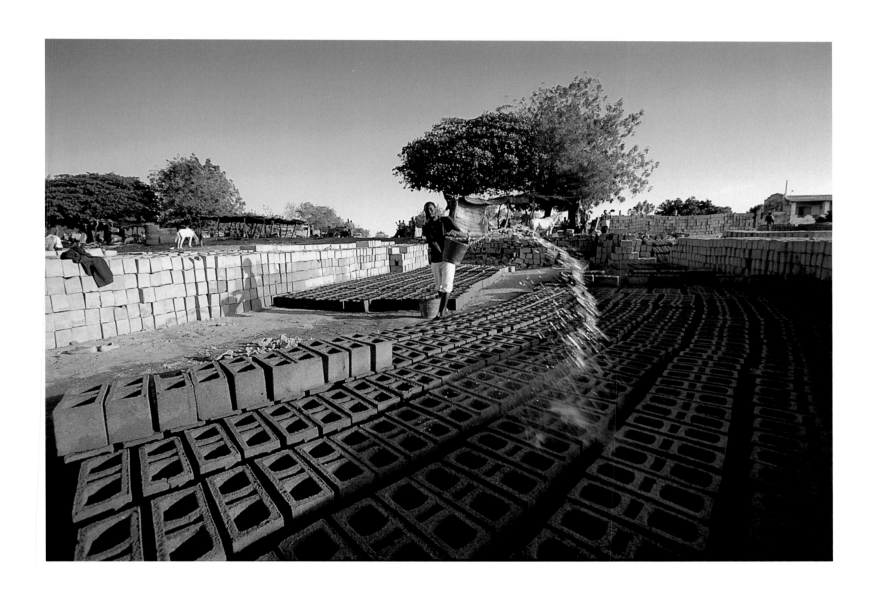

TWO HUNDRED YEARS after Scottish explorer Mungo Park became the first European to set eyes on the River Niger, we arrived on the same beach in Ségou, where we found this boy **(LEFT)** and his friends 'having a facial' with the protein-enriched river mud, and witnessed the cooling of building bricks made from the same.

(OVERLEAF) The drive to Dogon Country was suffocating, difficult and seemingly interminable, and lasted well into the night. It was all shadows and rough dunes by the time we finally arrived in Tirelli and set up camp. So the first sight of the Bandiagara escarpment, the next morning at first light, was a truly 'awesome' experience.

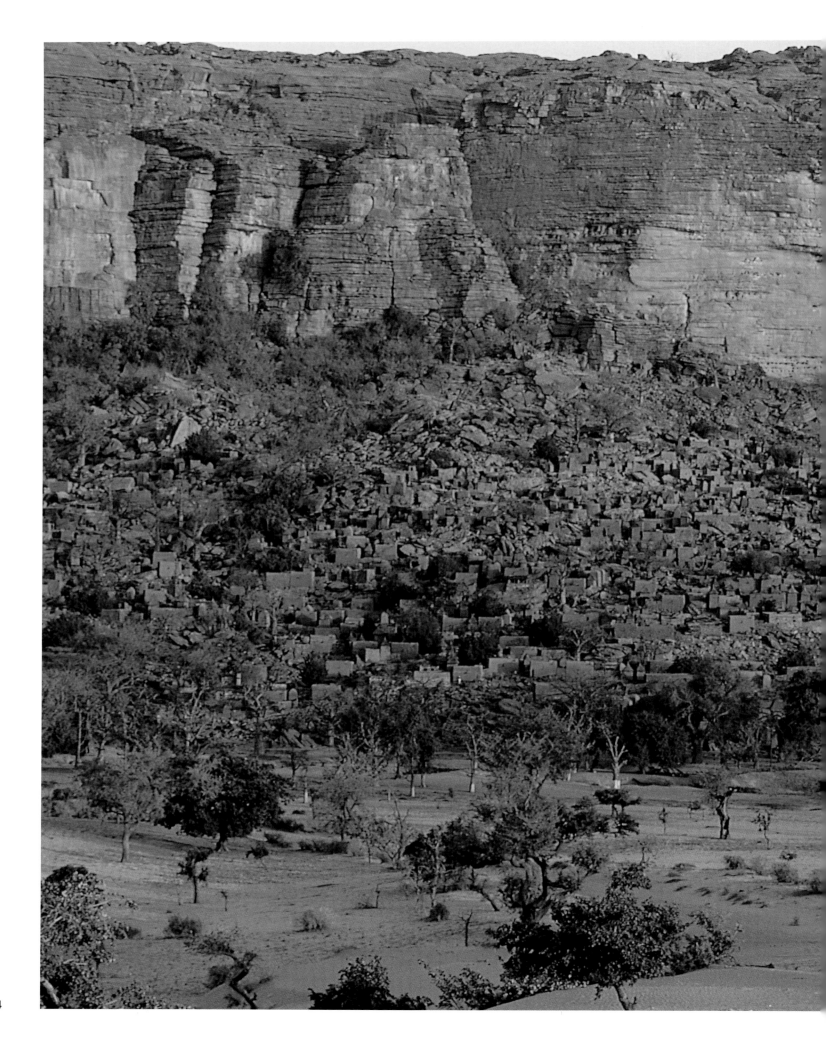

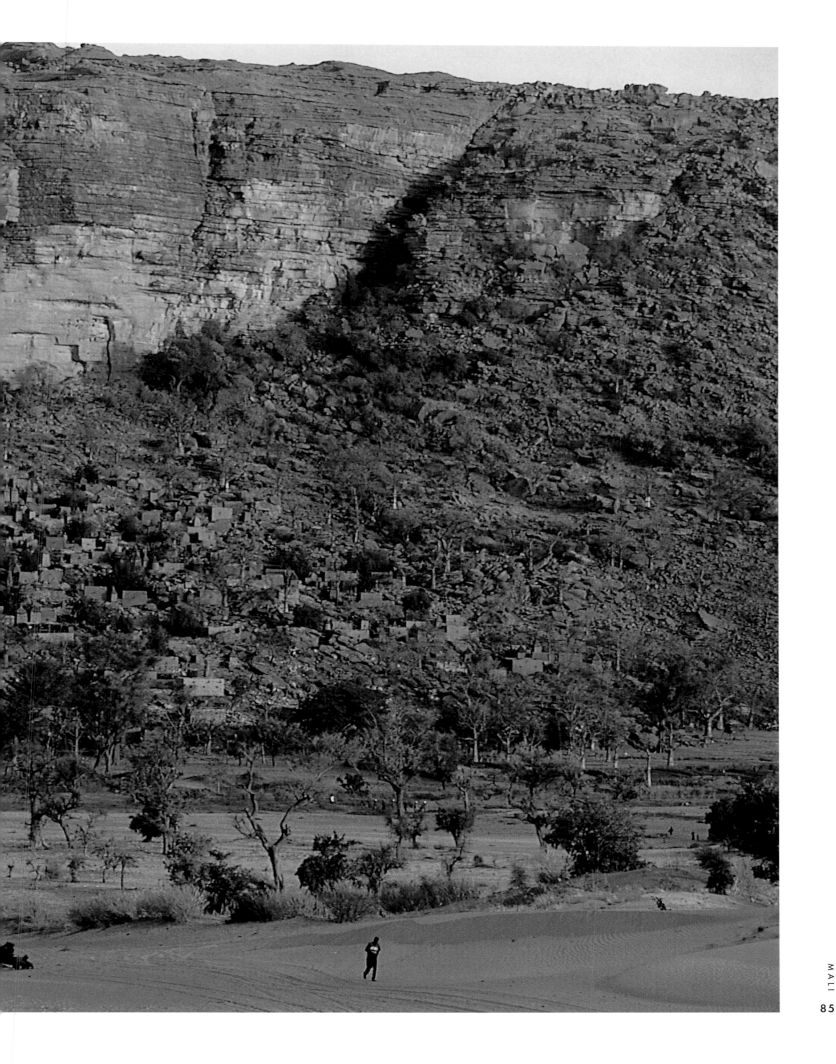

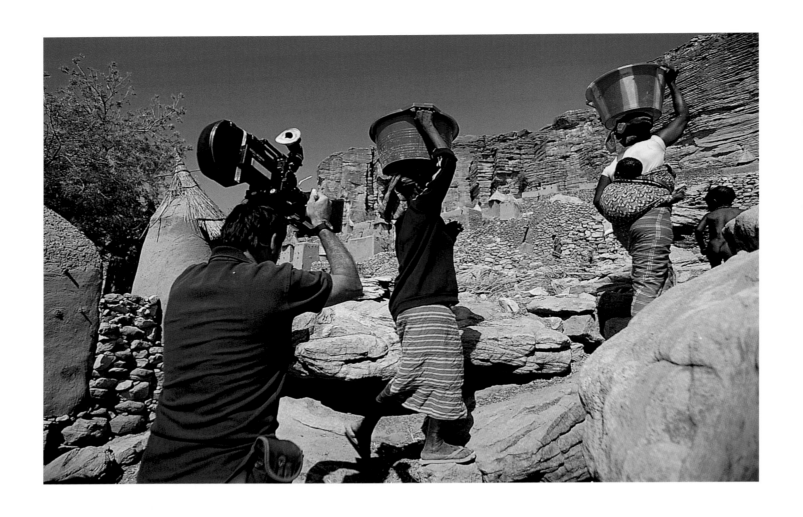

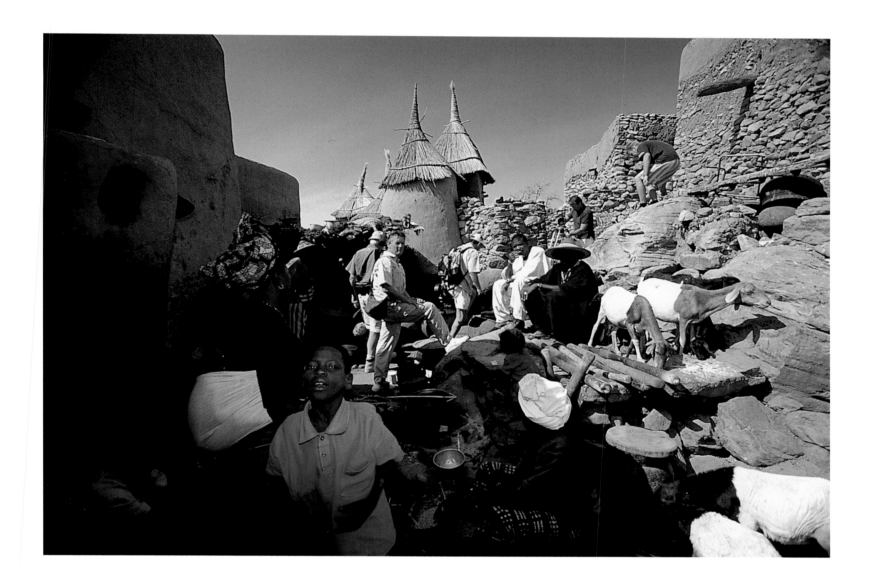

FOLLOWING THE EXAMPLE set by the women of Tirelli, who have to carry their water up the steep escarpment several times a day from a well at the bottom **(TOP LEFT)**, Nigel soon learns to use his head for heavy loads. **(BOTTOM LEFT)** At the headman's compound, one of the children climbs back out from the granary, after scooping out bowls of millet to be pounded and made into a grey-green porridge for lunch – umm, yum! **(ABOVE)** Filming Michael's lunch with Degobou, the headman, was an excruciating experience for everyone involved. By noon, the temperature had reached 135˚F in the open courtyard. The crew had to climb up and down the scalding boulders with the goats, and Mike had to dip his hand into the burning food. I spent most of my time hiding in the cool entranceway.

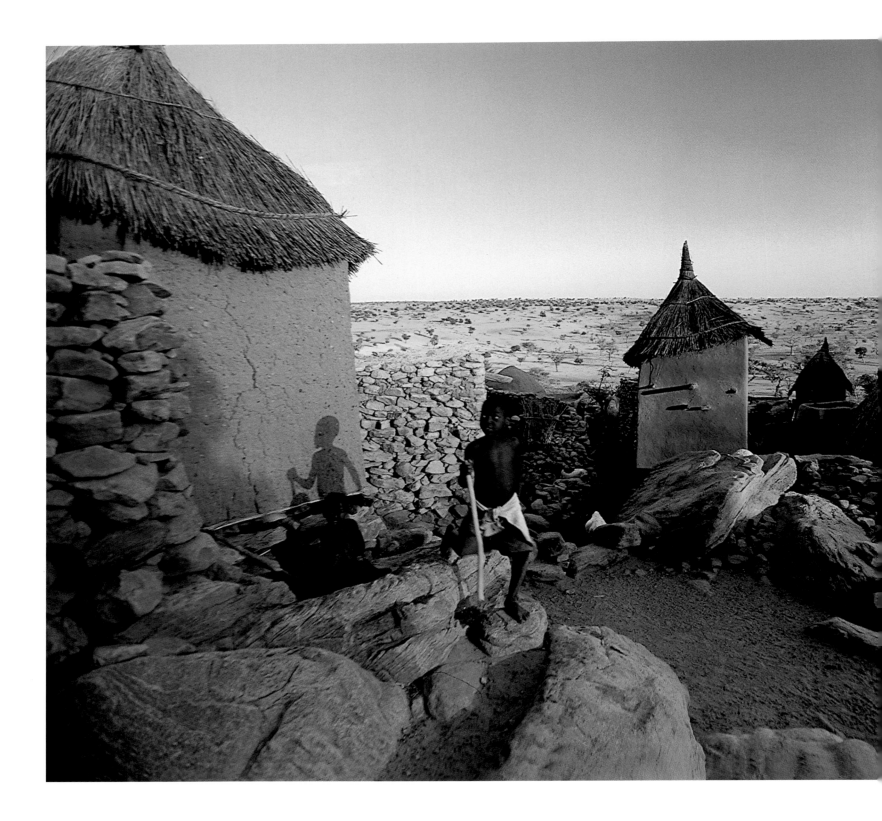

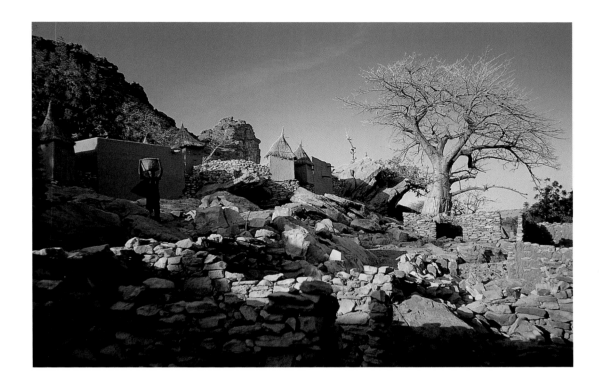

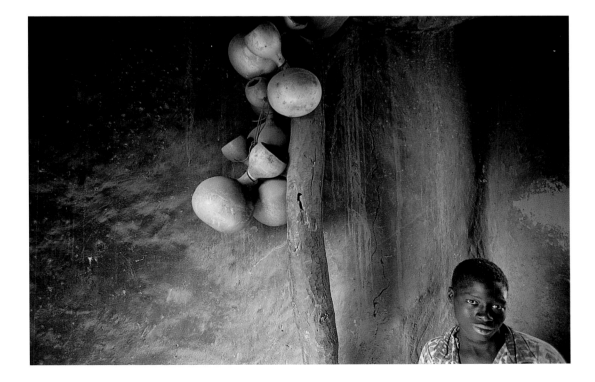

AS EVENING DESCENDS on the escarpment, the oven-like heat from the rock wall slowly subsides. All around, the people's steps seem lighter. **(LEFT)** Children emerge from their huts to play, while **(TOP RIGHT)** this man, who has just collected some grain to take home, hurries down the hill. **(BOTTOM RIGHT)** Earlier in the day, in the aforementioned cool dark entranceway to the headman's compound, where I was hiding from the heat and any serious work, I took this picture handheld, a 1.6 seconds exposure, with my breath held tight and my body rigid.

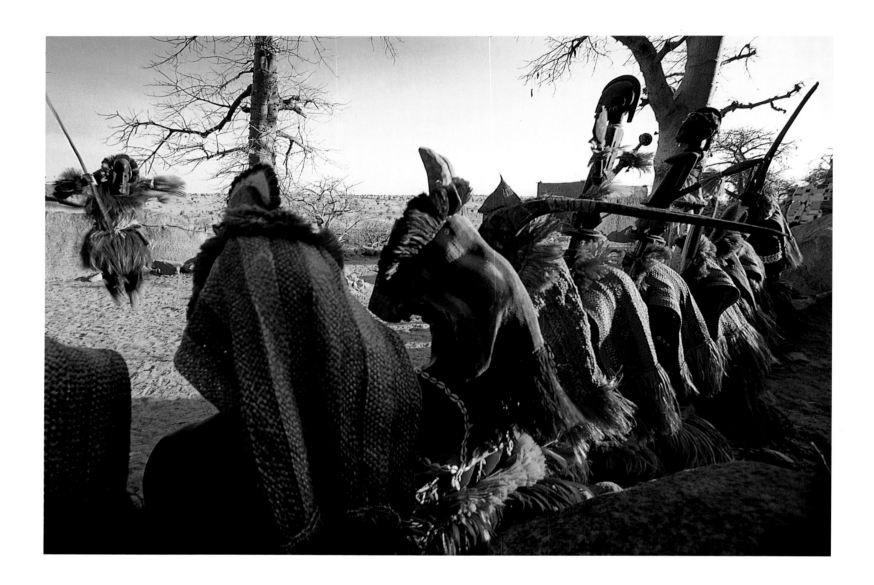

THIS CEREMONIAL DANCE marked the beginning of a week of funeral celebrations at Tirelli. The dance, and the huge wooden masks of birds, antelopes, serpents and other abstract forms worn by the dancers, are all manifestations of the animist belief that all things under heaven have a living soul. I knew nothing more about the dance beyond this, but I did wonder about whether this belief extended to include *krim-krim*, as our campsite was under attack from a

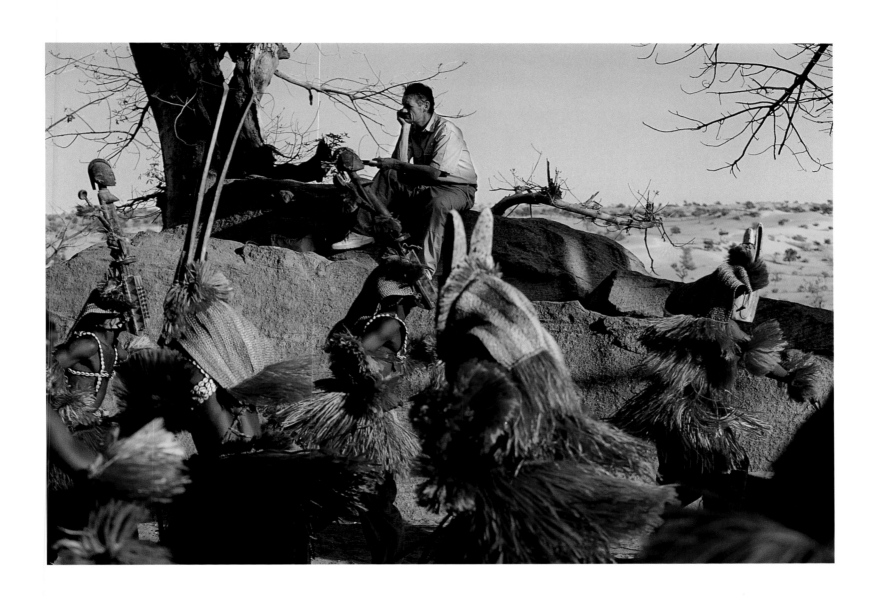

plague of these tiny seed pods, covered with sharp spikes like miniature sea urchins. They hide in the sand in the thousands and attack anything that crosses their path, day or night. Once inside your skin they are most reluctant to come back out. They hurt like hell and often draw blood. So far they had managed to get into everything except the dance. Or maybe there was a *krim-krim* mask and I just missed it.

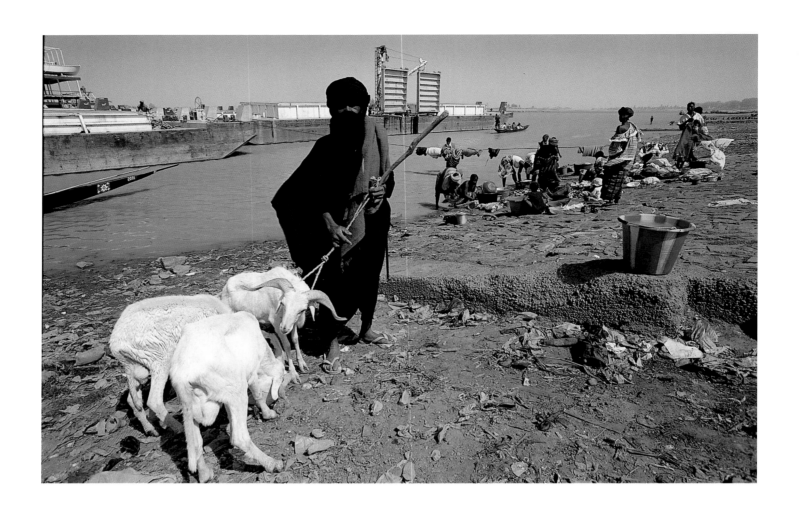

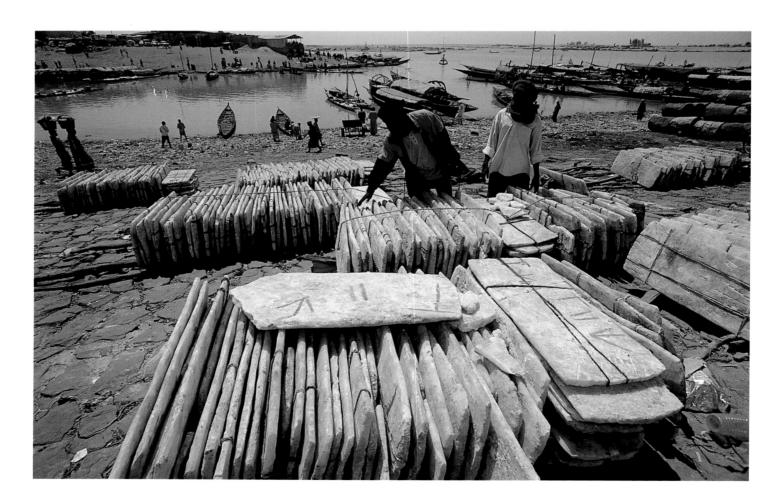

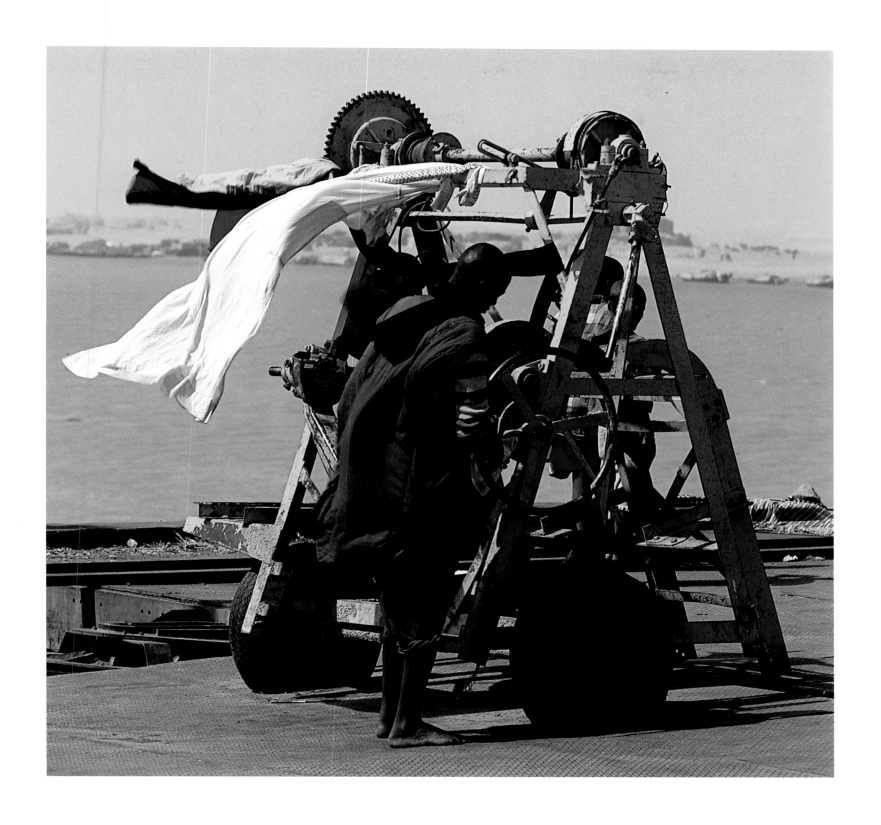

ALL CREATURES GREAT AND SMALL were preparing for the festival of *Tabaski* along the Mopti waterfront. **(TOP LEFT)** Goats feast on garbage on the riverbanks, unwittingly fattening themselves for the sacrifice, while the local people get themselves ready by doing their laundry. Sometimes hanging it to dry **(ABOVE)** in the most unlikely places. **(BOTTOM LEFT)** Further along the beach, we have our first encounter with the giant tablets of salt from the interior, which have played such an important role in the history of the Sahara.

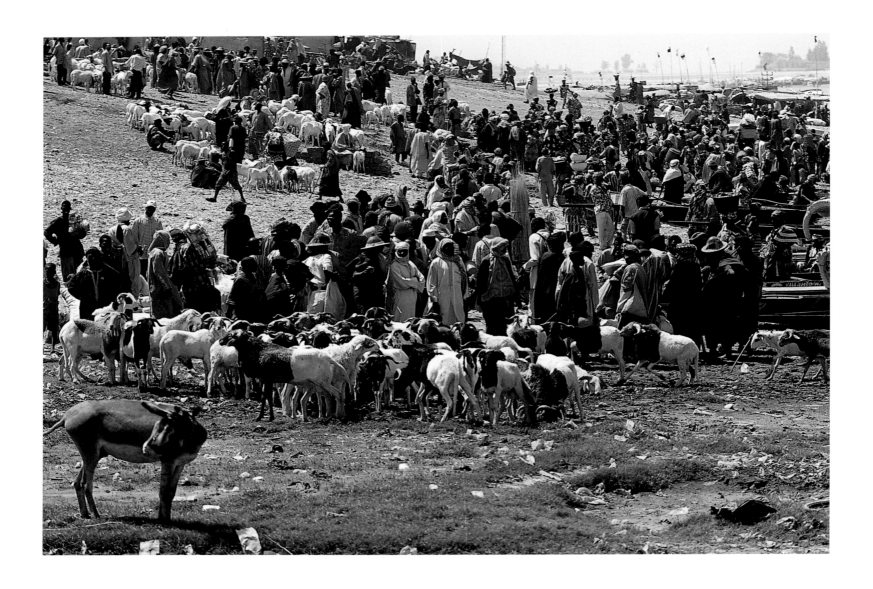

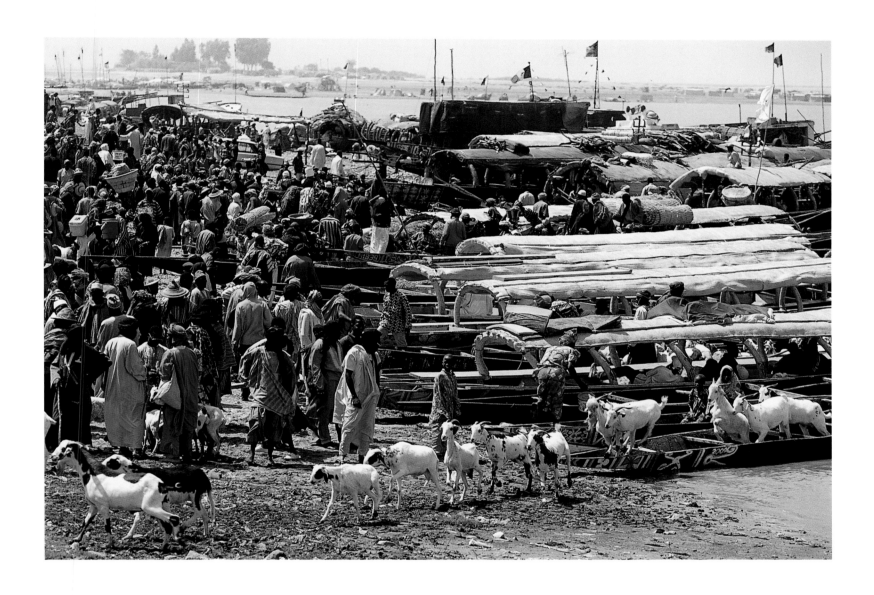

SITUATED AT A CONFLUENCE of the Bani and Niger rivers, Mopti has developed into a major trading port at the expense of cities like Djenné further downstream. We arrived to find the giant triple-decker ferries that normally ply their trade on the River Niger tied up like beached whales on the muddy banks. Being the end of the dry season, the river was too low for them to get through. Smaller crafts such as pirogues, however, continue to operate, and on this day, just before *Tabaski* **(LEFT AND ABOVE)**, the Mopti waterfront was positively jumping with action as they jockeyed for position along the shore.

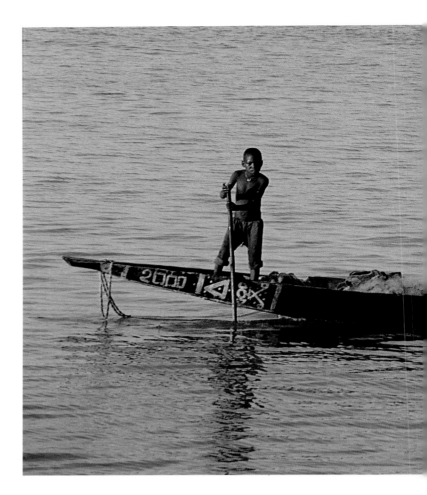

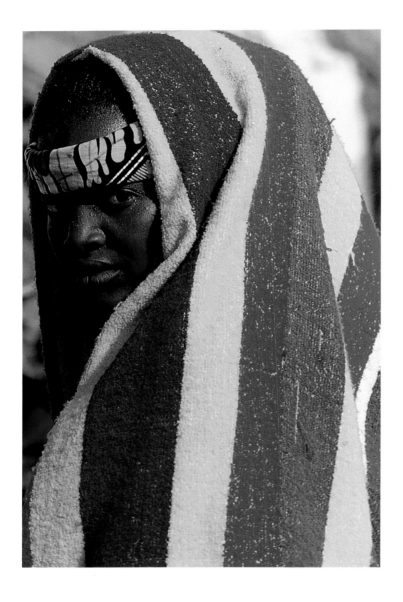

WE ENCOUNTERED these colourful ladies on the banks of the River Bani, just outside Djenné, universally acclaimed as the most beautiful town of the Sahel. In the thirteenth century, it was the most important trading port in the region, with fleets of large boats travelling up and down these waters, transporting ivory and gold from black Africa in the south, and salt from the interior through Timbuktu in the north.

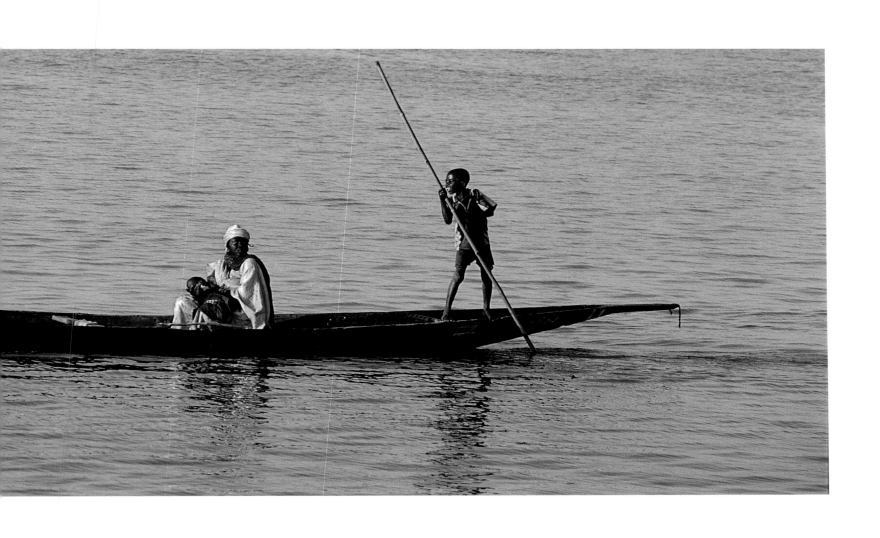

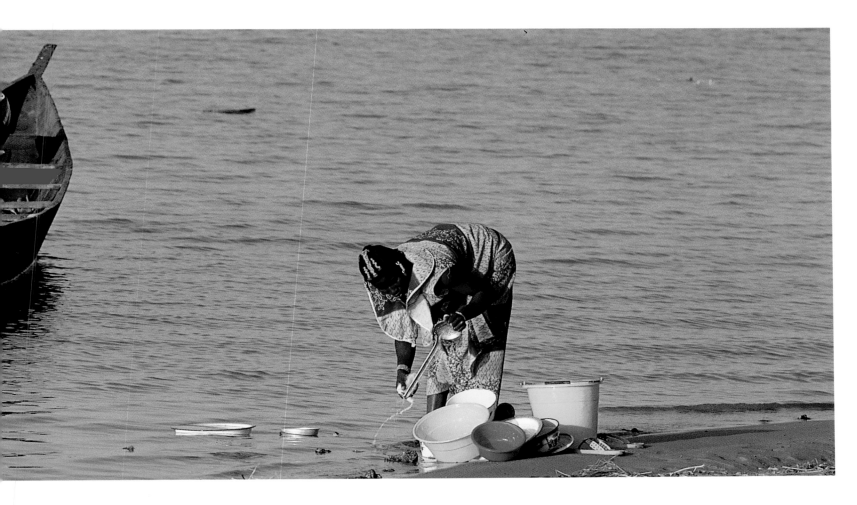

THIS TREE (ABOVE), located near the ferry crossing which put us on the road into Djenné, gives an indication of how low the River Bani is before the rainy season. **(LEFT)** Down by the river, a scene of quiet contentment in the warm glow of the evening light, as villagers from all around, who came in to trade, mingle with the local people at the end of a festive market day in Djenné.

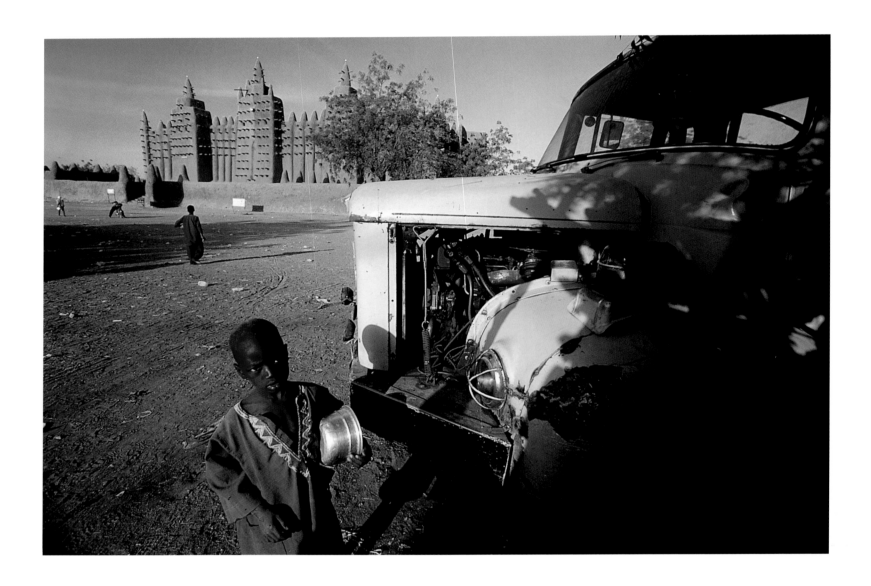

DJENNE is now primarily a market town, renowned for its Sudanic style of architecture. This boy (**ABOVE**), however, was far more interested in why the 'Chinaman' was photographing the engine of a broken-down truck than the fact that the *Grande Mosquée* behind him was built in 1327 by an Andalusian architect and is the largest mud structure in the world. These boys (**RIGHT**) gave me the best surprise of all. They were the only people on the street when I left my

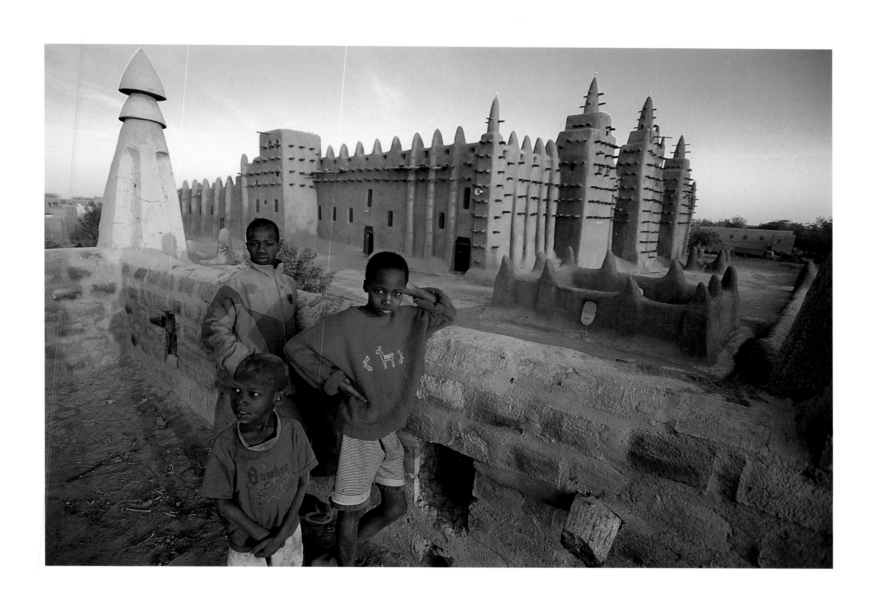

room at 5 am to do some shooting before the day's filming began. They followed me around with the normal plea of *'gado, gado'* (presents). I gave them a pen and some small notes with the intention of getting rid of them, but they took me by the hand and brought me up to this roof, where I watched and photographed the sunrise slowly giving form to one of the most beautiful buildings in the world.

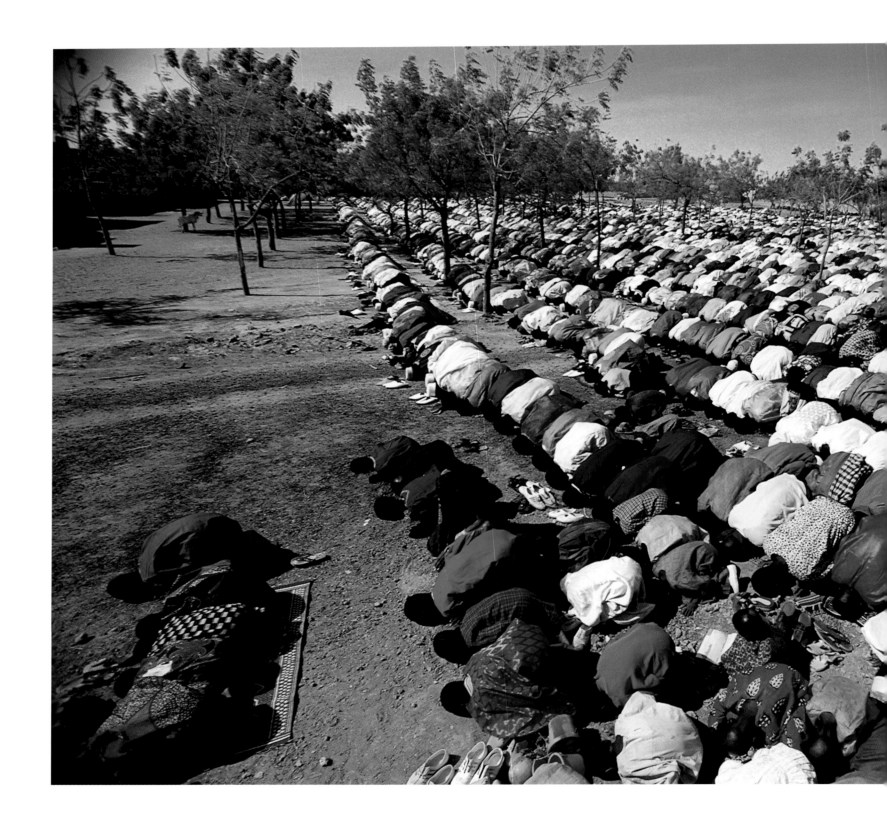

A HANDSOME GOAT watches impassively from the shade as thousands of Malians, dressed in their finest, join in special prayers with the imam of Djenné. **(ABOVE)** The ritual sacrifice signals the start of *Tabaski* – an important Islamic festival where Muslims all around the world slaughter millions of sheep to celebrate the legend of Abraham's willingness to sacrifice his only son in submission to the will of God.

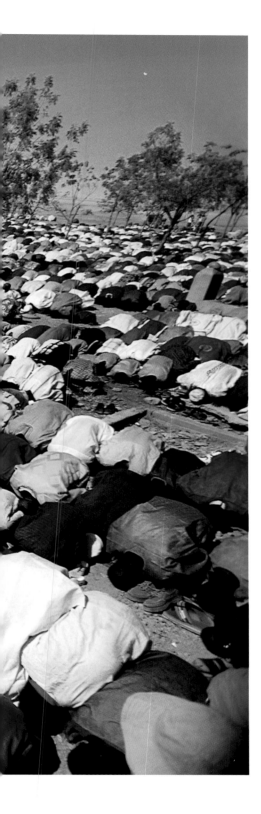

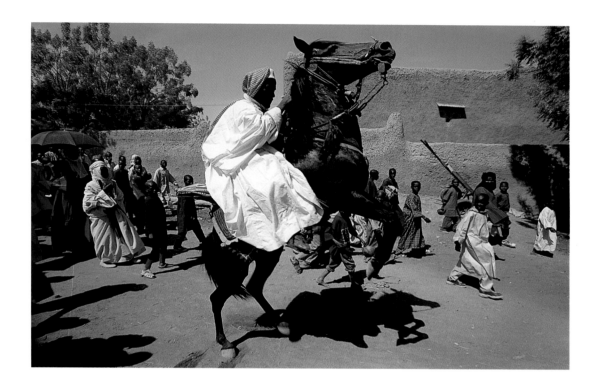

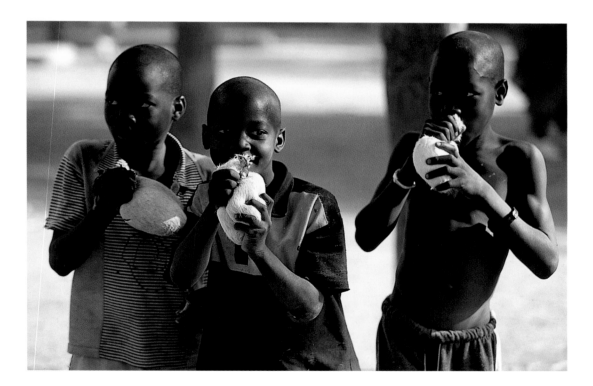

(TOP RIGHT) After the prayers, the imam's retinue parades through town on its way back to his residence. Every part of the sacrificial goat is put to good use; some of the meat is given away to the less fortunate, the head is boiled for soup, and the testicles are given to school boys in the belief that they will make them more clever. (BOTTOM RIGHT) These boys clearly had a very different idea about them, making whoopee cushions out of them.

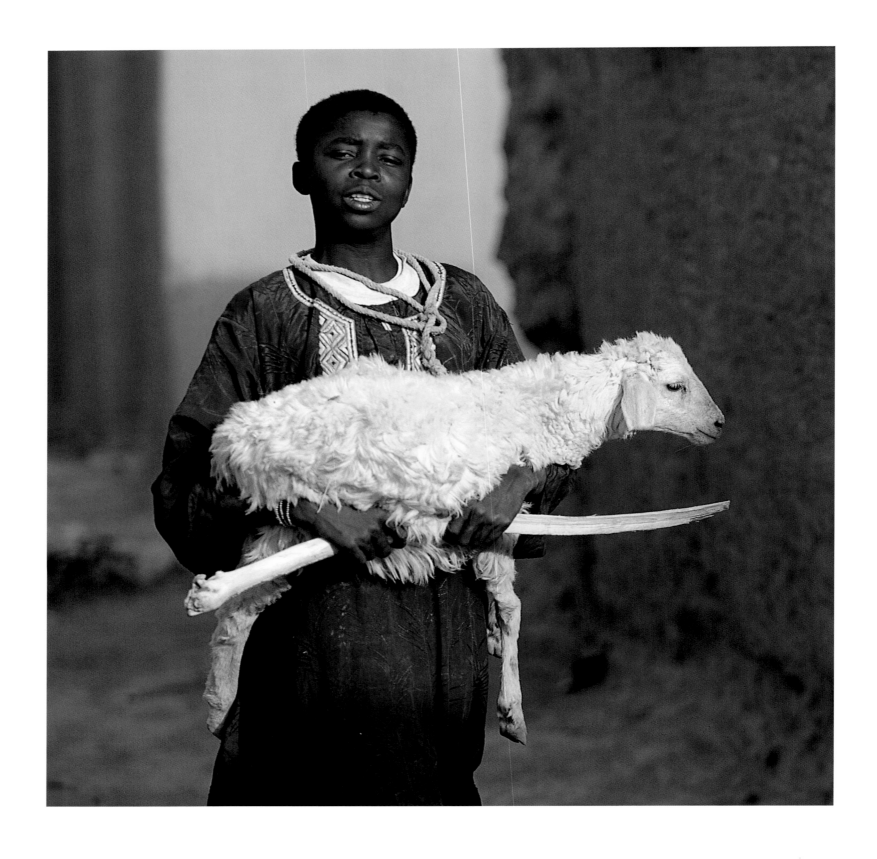

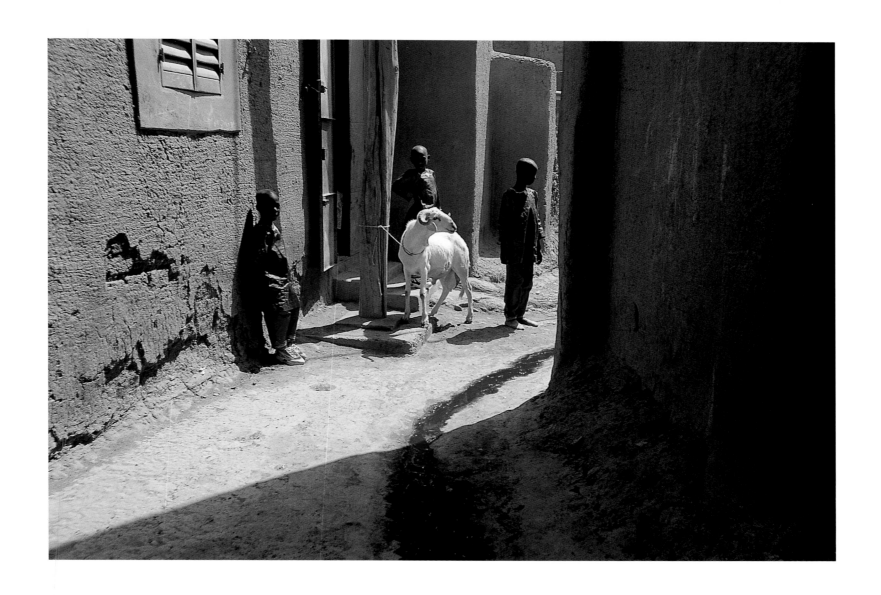

ON A BACK STREET **(LEFT),** this boy carries his lamb protectively while gripping a dangerous-looking wooden blade in his hand. Nearby, in the courtyard of Pigmy's house, I was just recovering from photographing the gory details of the demise of the family goat. When I saw them throwing buckets of water to wash away the blood, I decided to follow the gutter out onto the streets. **(ABOVE)** Just outside his door, I found this shot.

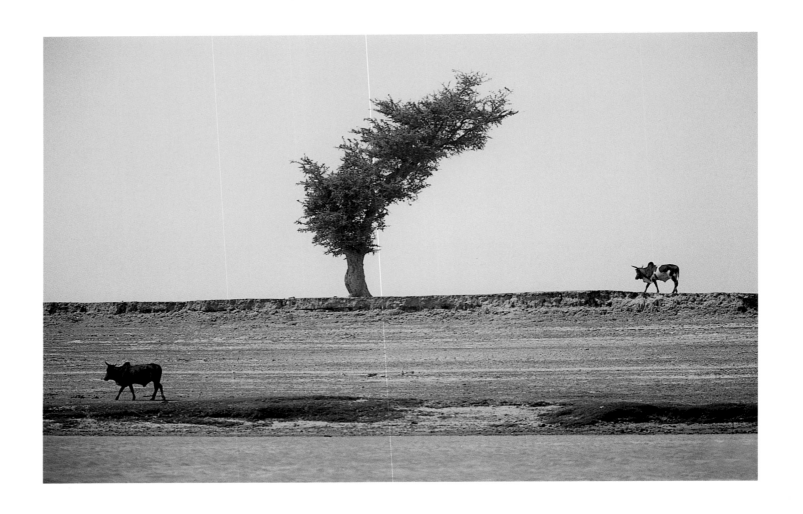

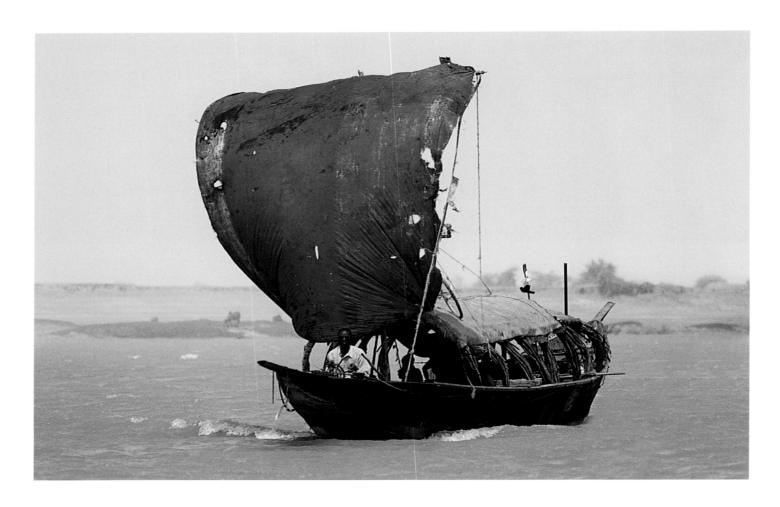

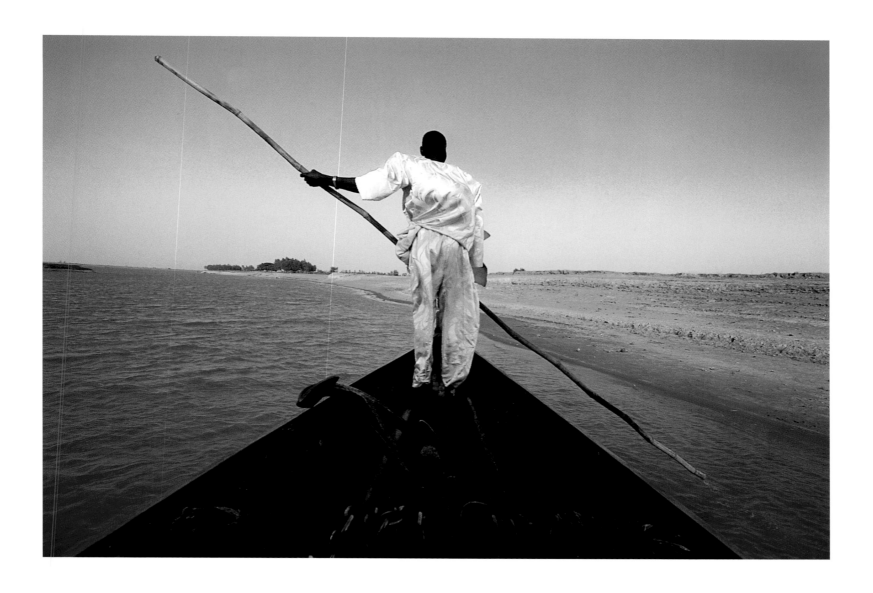

WE FOUND A CARGO BOAT, the *Pagou Manpagu*, better known to the crew as 'the slave ship',
to take us part of the way to Timbuktu. **(ABOVE)** It docked regularly near Bozo villages along the
river, to pick up and drop off passengers and supplies. **(LEFT)** Scenes of the River Niger, taken
from the unspeakably uncomfortable boat.

MALI

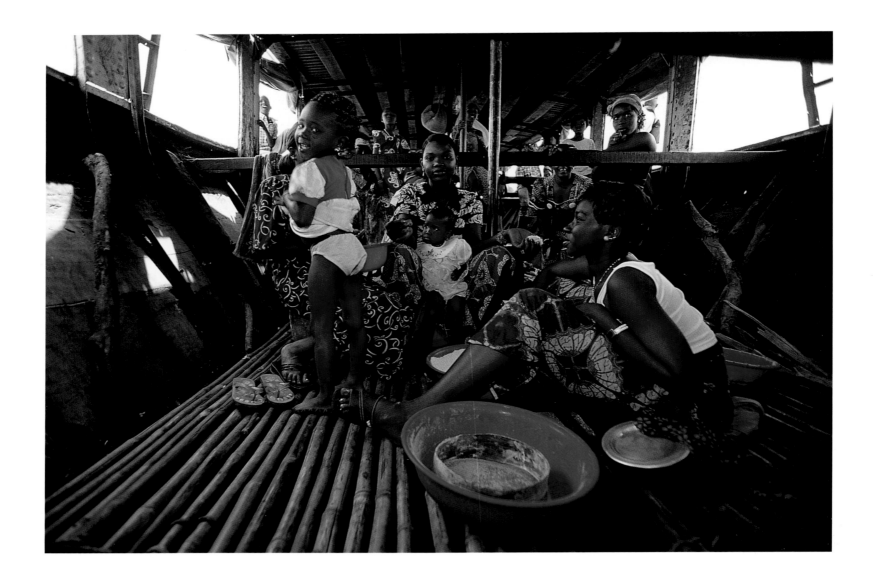

THE BOAT was the most user-unfriendly craft I'd ever been on; it was impossible to move more than just a few inches without bumping your head or running into something sharp. As it was created to carry cargo, and there was none that day, all the proportions of the hull seemed to be entirely wrong for human activities. Except for these families **(ABOVE)**, on the way home to their villages, who were quite happy to turn the empty, leaky bottom into their kitchen and dining room. **(RIGHT)** This stunning little girl reminded me of a diamond resting on a bed of coal.

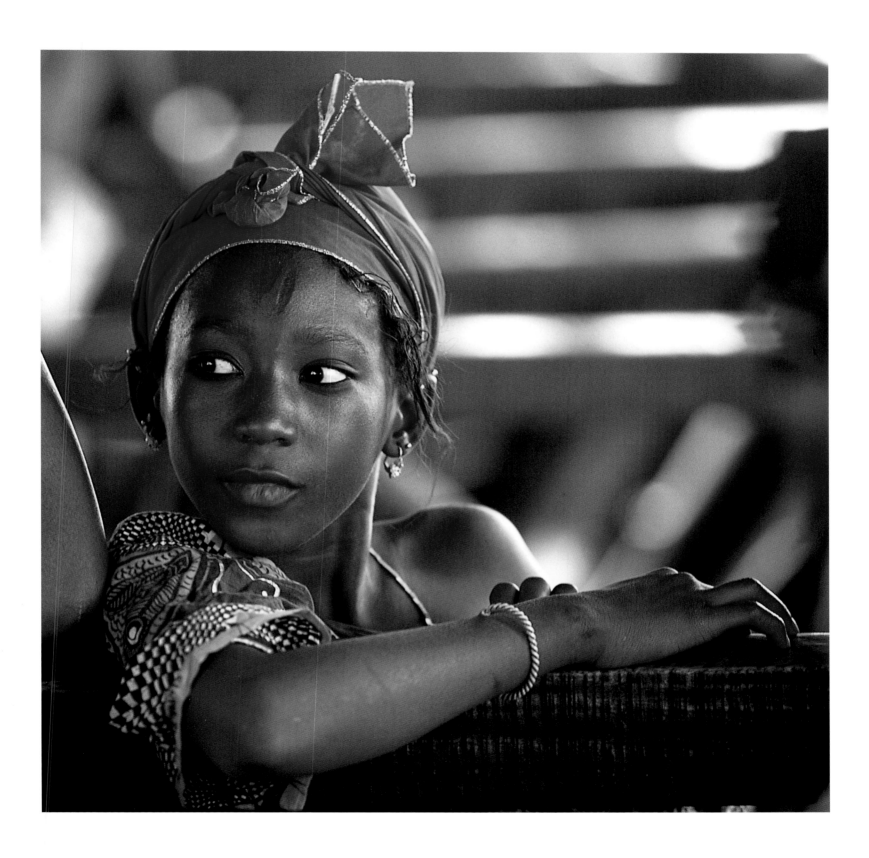

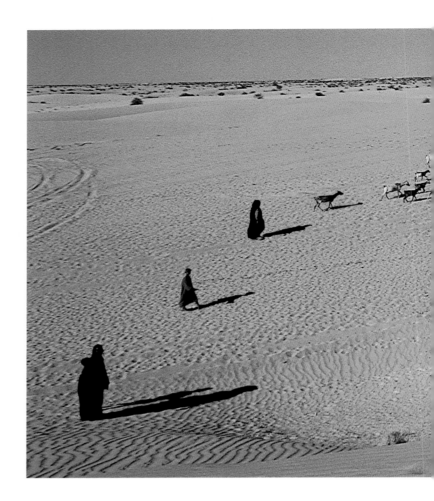

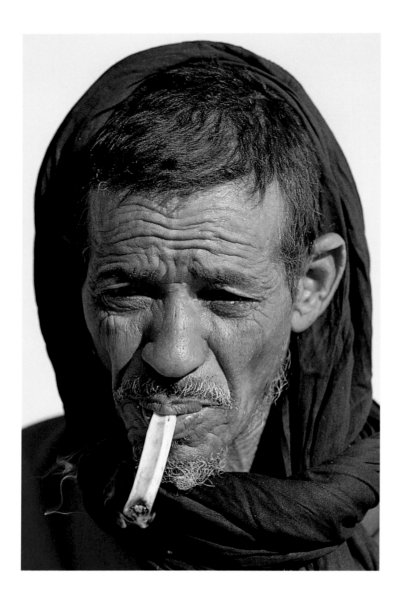

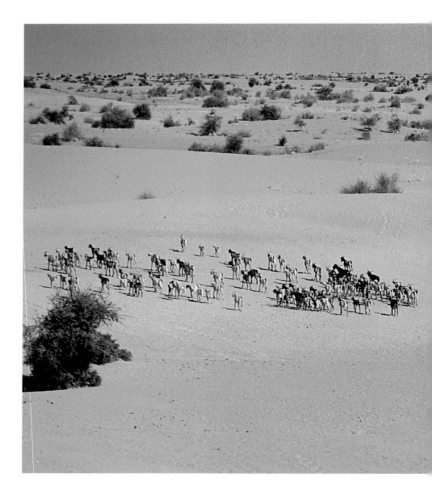

WE FOLLOWED the large herd of goats from the nomad encampment on the outskirts of Timbuktu into the desert. **(RIGHT)** A couple of miles out of town, we had our first sighting of a salt caravan emerging from the interior. The herd and the camel train crossed paths and the owners exchanged greetings before disappearing in opposite directions. Leaving an empty desert full of hoof prints and droppings. The leader of the camel train **(ABOVE)** had the coolest pipe I'd seen thus far in the Sahara.

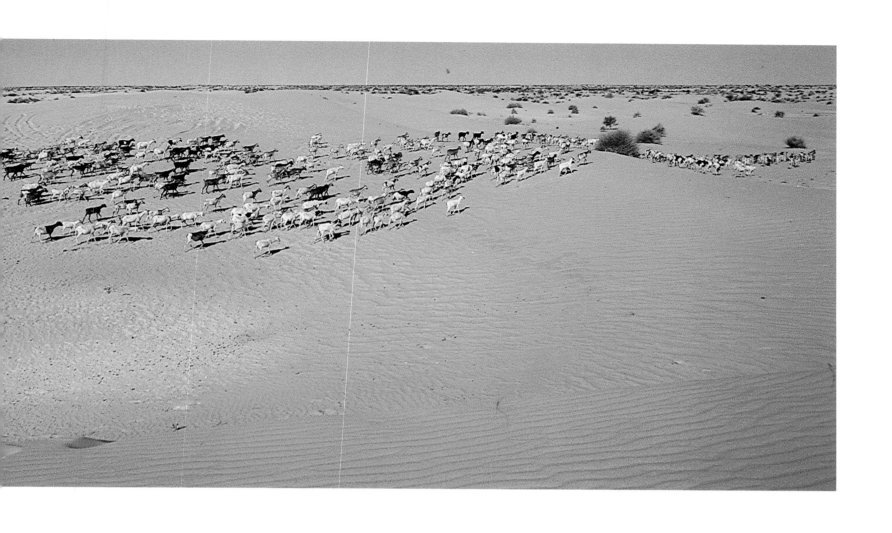

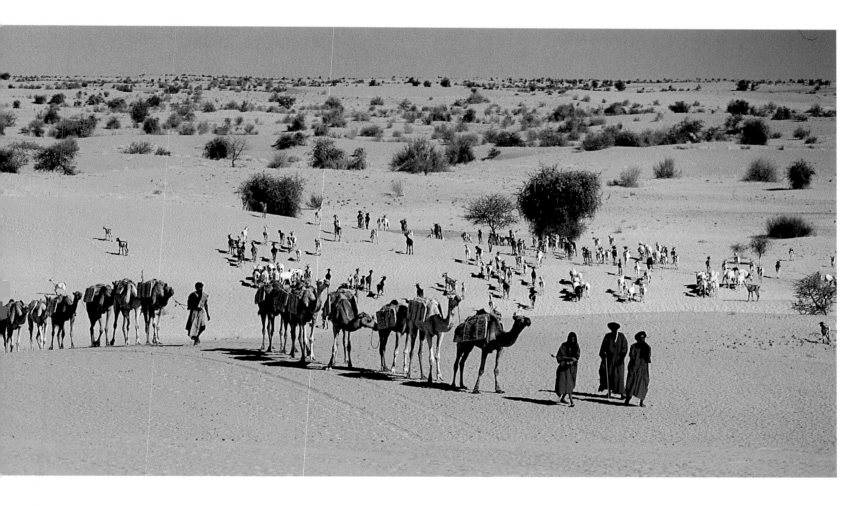

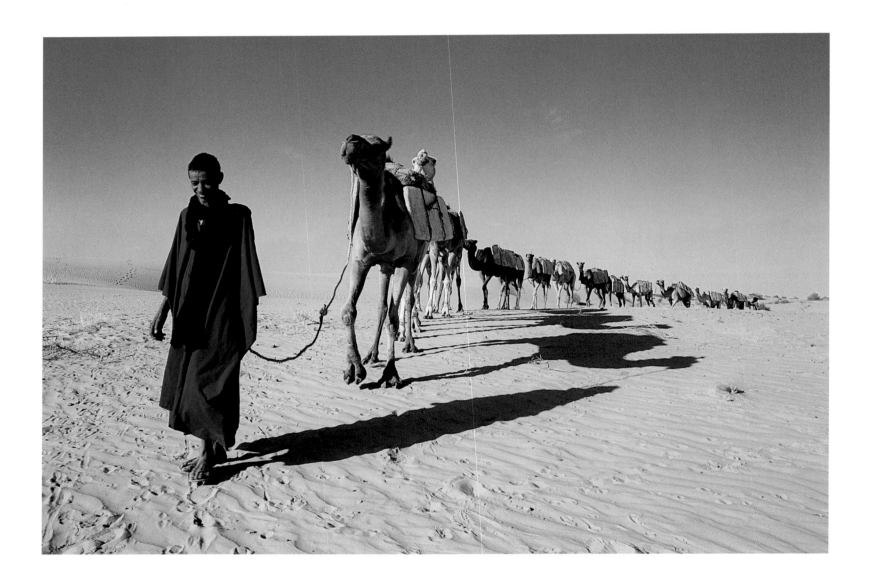

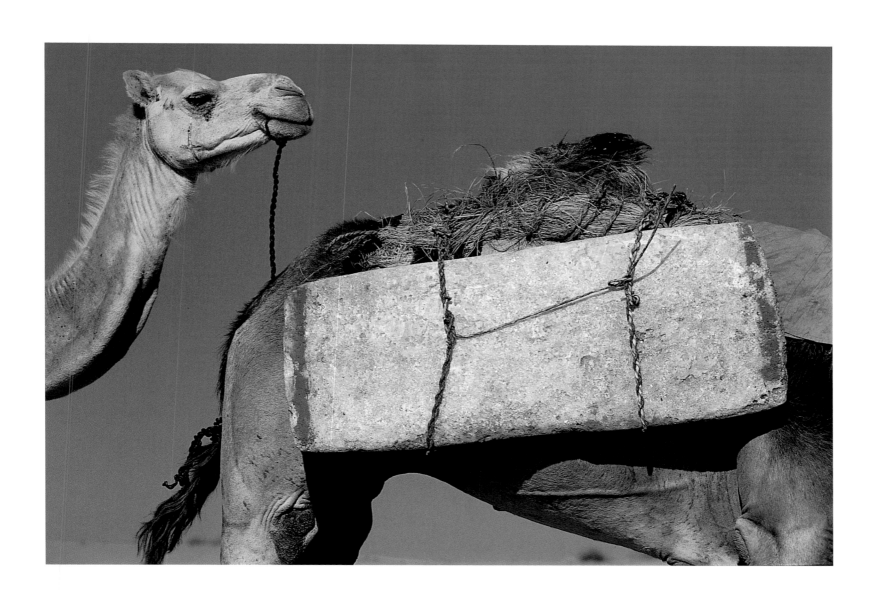

THE TOUAREG cameleer with the cool pipe **(LEFT)** leading his fleet of camels towards Timbuktu, where the tablets of salt, weighing 50 kg each, are unloaded and shipped down the River Niger south into Nigeria and beyond. Legend has it that these slabs of rock salt **(ABOVE)**, were once worth their weight in gold. The trade created unimaginable wealth for the Mali and Songhai empires and endless conflicts between the Touaregs and a succession of rulers of Timbuktu.

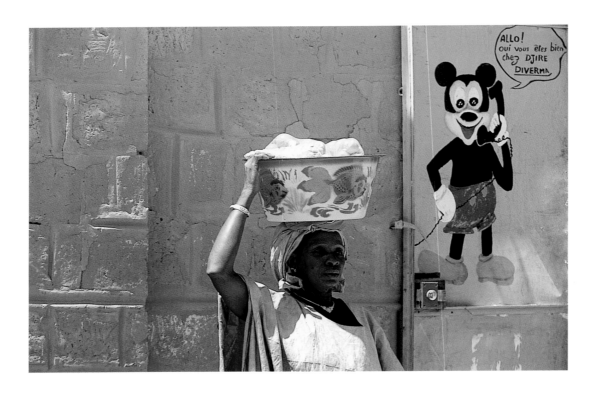

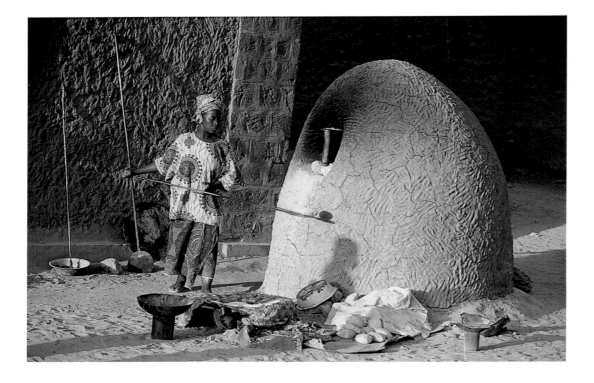

MICHAEL practising his camel riding **(RIGHT)** in preparation for Niger on the main motorway of Timbuktu. **(LEFT)** Mickey Mouse on the telephone and Chinese washbasins blend uncomfortably with bread being baked in mud ovens on street corners in this ancient town, where the way of life for the majority of the nomads living here has remained largely unchanged for centuries.

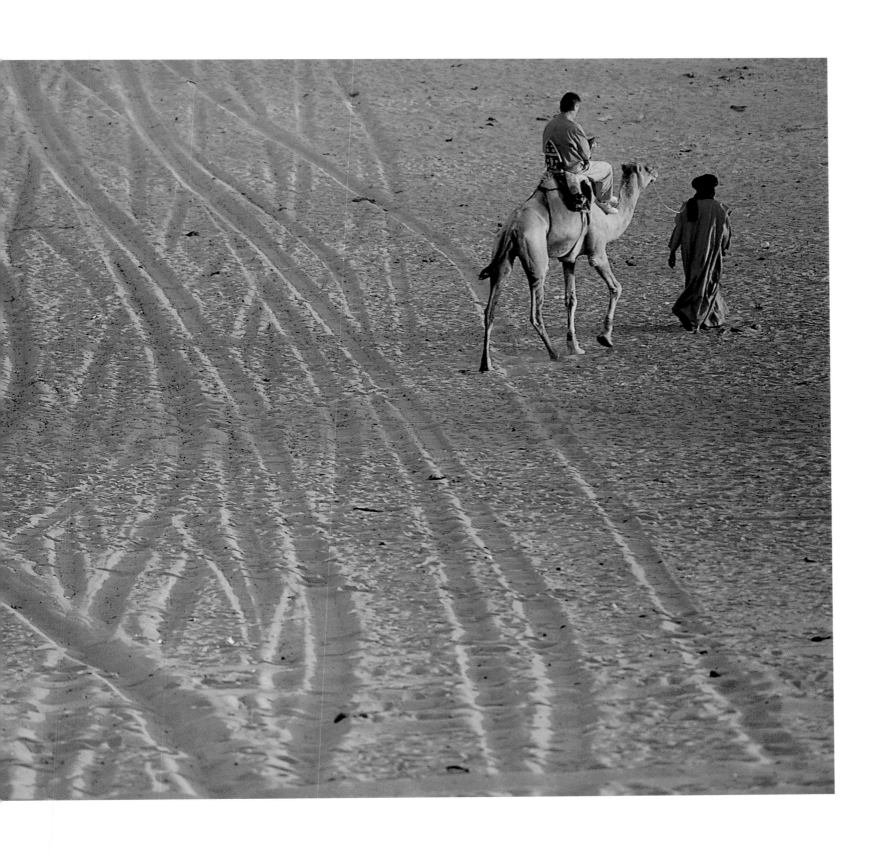

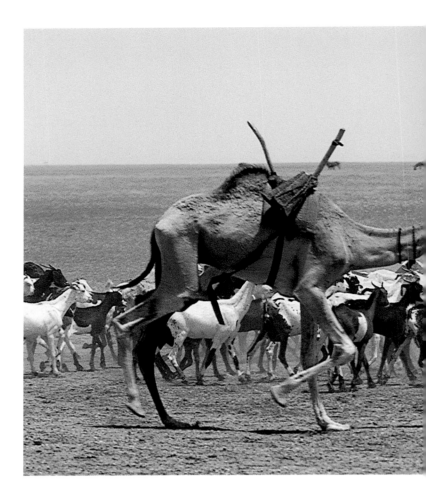

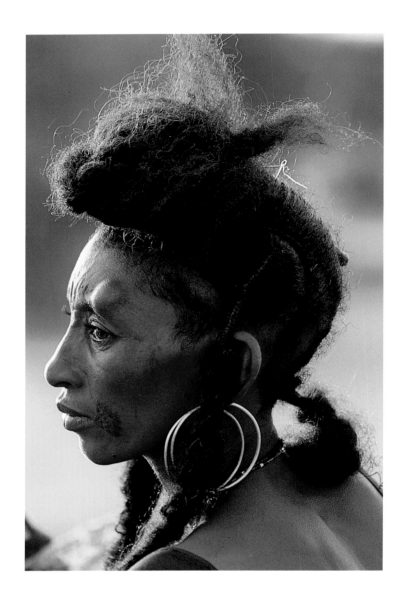

AFTER THE RAIN, thousands of nomads from the region, including Arab, Berber, Touareg, Toubou and Fulani tribes, were all on the move towards Ingal for the *Cure Salée* (Salt Cure), a post-summer migration festival celebrating the fattening of cattle. **(TOP RIGHT)** The rain was good this year, transforming the desert into lush pastures for the livestock. **(BOTTOM RIGHT)** Animals enjoying a cool drink at a busy watering hole. We fell in with a Wodaabe tribe and spent some time with them. **(ABOVE)** This woman is a member of our friend Doulla's extended family.

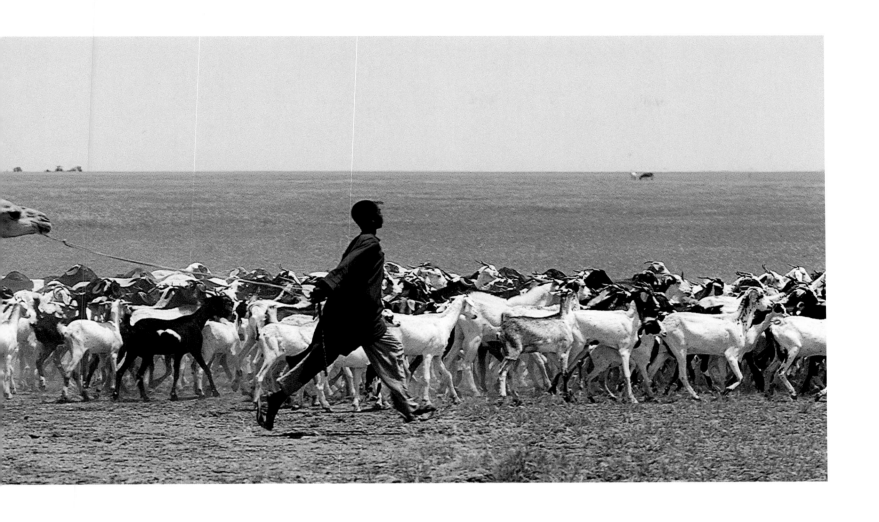

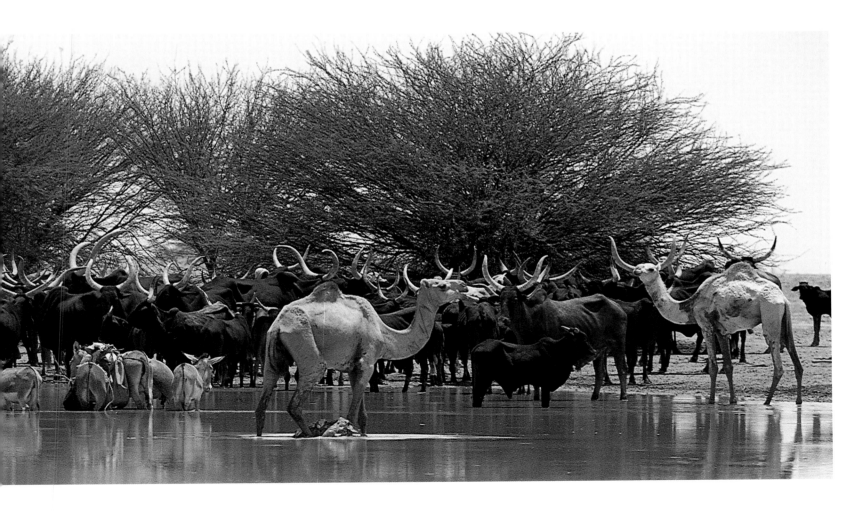

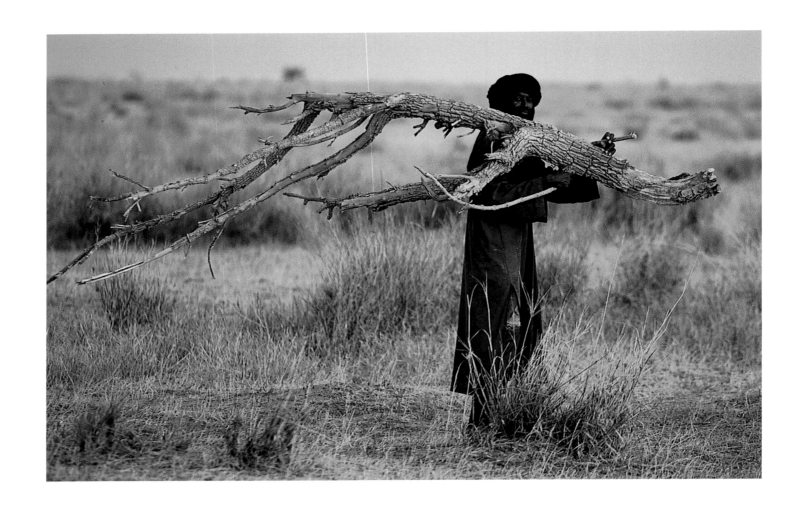

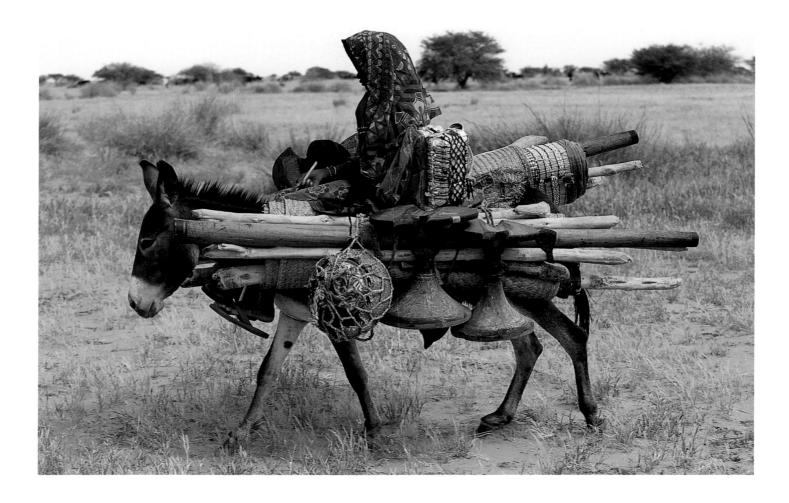

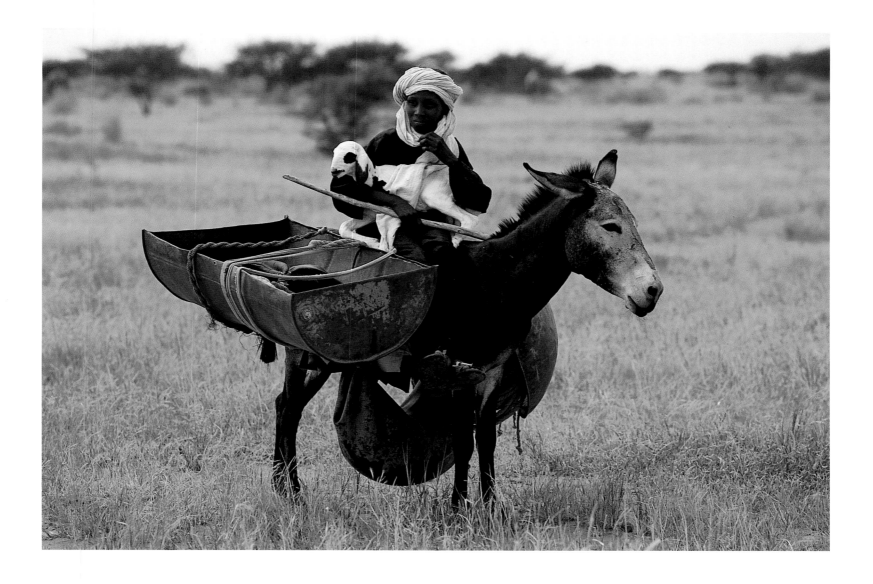

THE WODAABE GROUP we followed had just walked, most of them barefoot, several hundred miles back from the far south, where their cattle had led them for the dry summer season. **(ABOVE & BOTTOM LEFT)** And there are the lucky ones, like these children and the baby lamb, who get to ride on donkeys with all the family possessions. **(TOP LEFT)** As evening falls, camps are set up near a creek, and this man is clearly ready to build a large campfire.

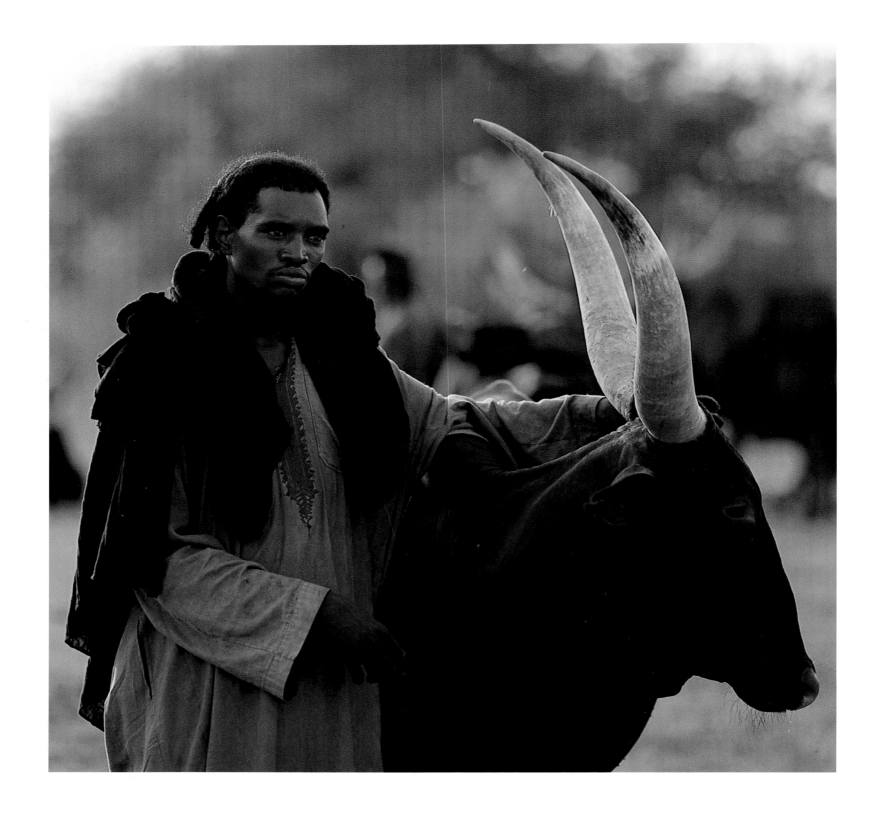

BEING PASTORAL NOMADS, the Wodaabe's lives are firmly tied to the wellbeing of their cattle, and sometimes, deep bonds between men and beasts are formed. **(ABOVE)** Portrait of a Wodaabe man and his 'Big Buddy'. **(RIGHT)** This boy was lost in thought, staring deep into space at some unseen mystery, when I started photographing him. I had taken several shots before this frame came, when the whirl and clatter of the camera finally broke the spell.

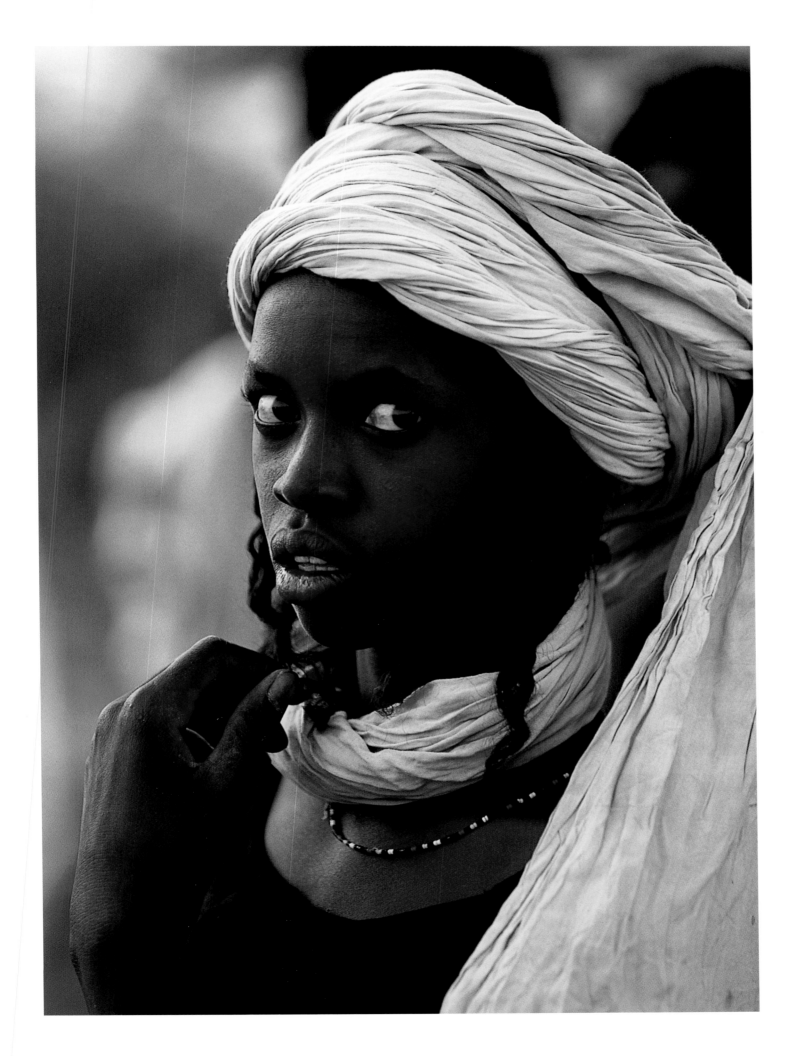

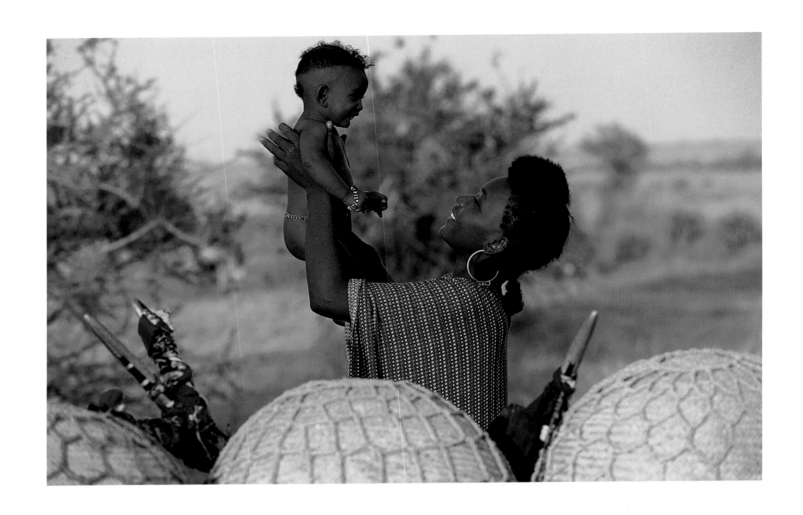

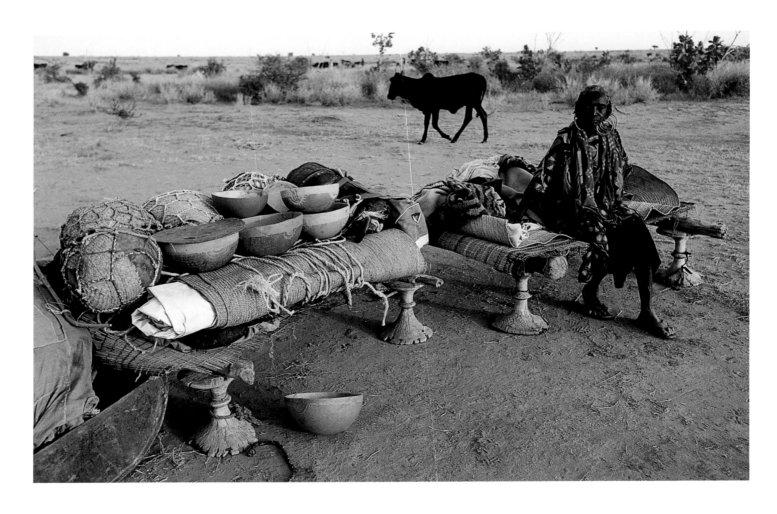

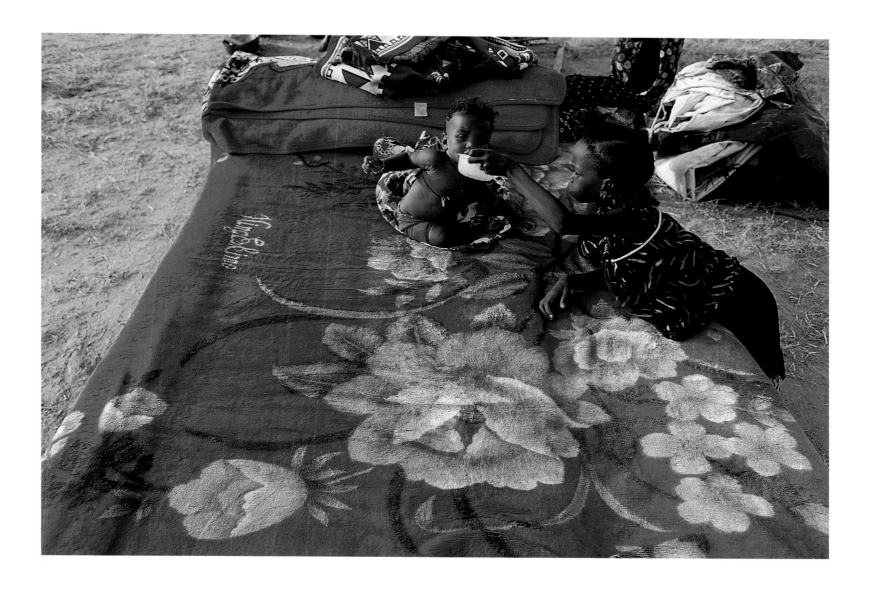

BEDS are the centrepiece of the Wodaabe camp. The double bed with the Chinese blanket **(ABOVE)** looked incredibly comfortable and tempting for someone who'd spent far too many nights inside a tent being 'at one with the desert'. I remember thinking that their 'easy to assemble' design was worthy of the IKEA catalogue, but how to ship the donkeys that carried them was a bit of a problem. If calabashes are indeed the symbol of wealth and status for the nomads, then judging by the number she has on her bed, this old lady **(BOTTOM LEFT)** must be the Bill Gates of the Wodaabe. **(TOP LEFT)** Doulla's cousin, Goude (pronounced Gud-day, as in the Australian greeting), playing with one of his six children by one of his three wives.

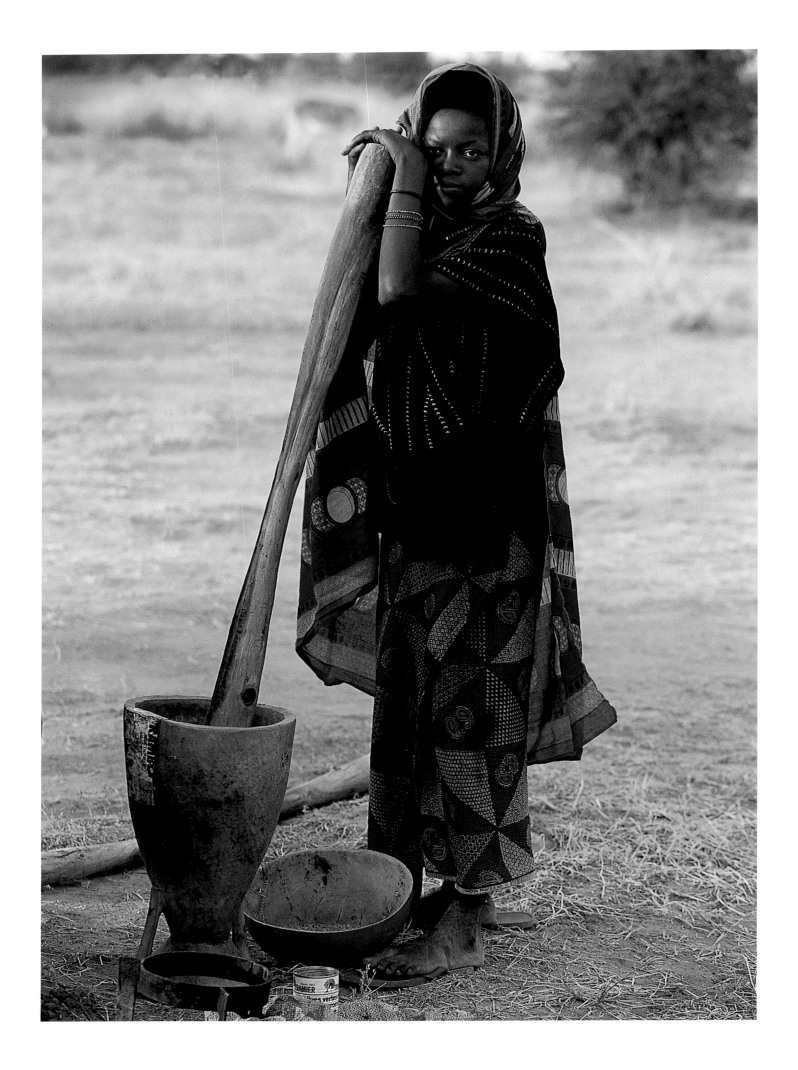

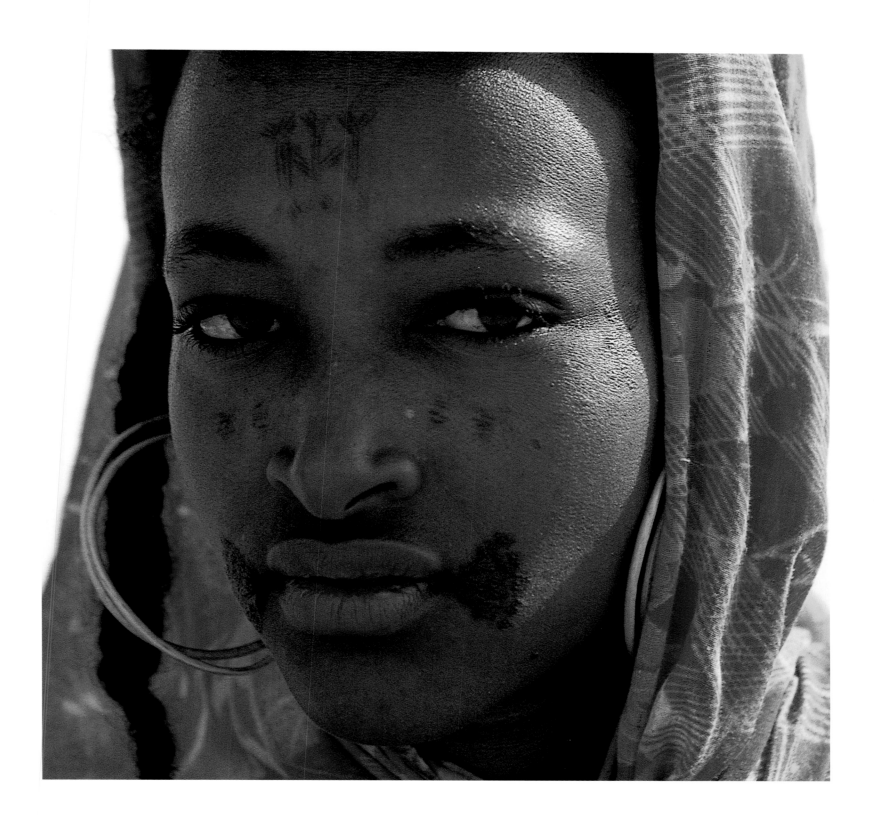

RENOWNED for their physical beauty throughout the Sahara, the Wodaabe people certainly live up to that reputation. Their men and women are amongst the most striking and beautiful I have encountered anywhere in the world. **(LEFT)** A pause from pounding millet for a quick photo-session. When I first saw Didi **(ABOVE)**, I thought she was stunning. Then when I started photographing her, her soft smile and gentle eyes enchanted me, and I thought she had a very unique quality. It was only later that I discovered she was born a deaf mute.

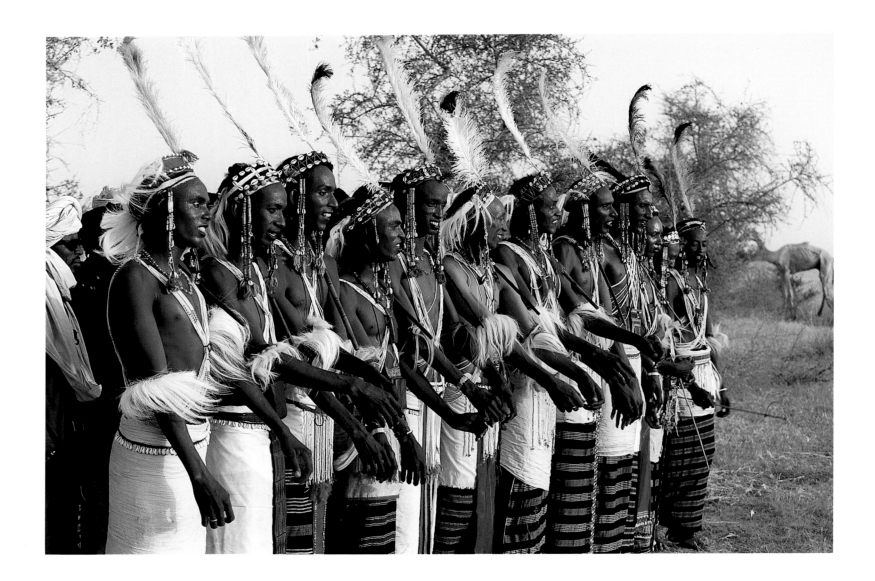

GEREWOL, the Bororo mating ritual, where single males put on heavy make-up and dress up like women to better attract young females, is both weird and wonderful. The 'dance' itself is not much to look at; the men push themselves up and down by their toes in slow motion, their arms rising and falling as they shake their long sticks. But together with the low humming chant in the background, it has the effect of a rolling trance, like waves lapping against the shore. All the serious action is concentrated in their faces, which are contorted into the sort of exaggerated expressions of joy normally only seen in cartoons.

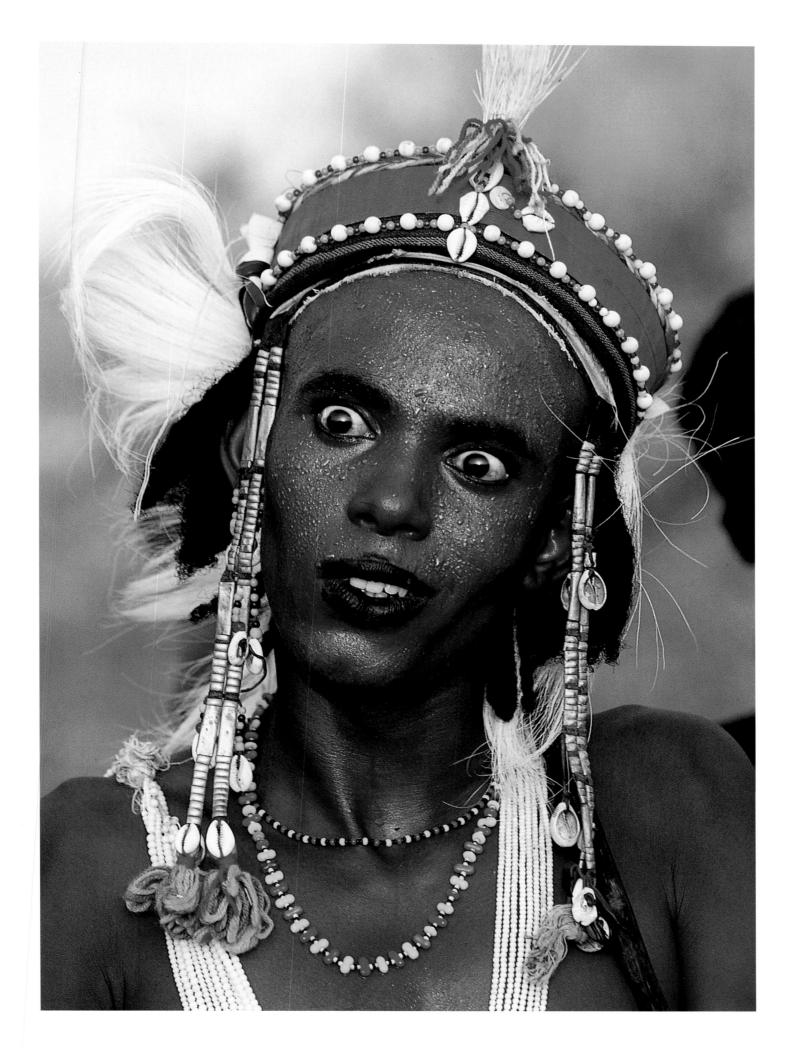

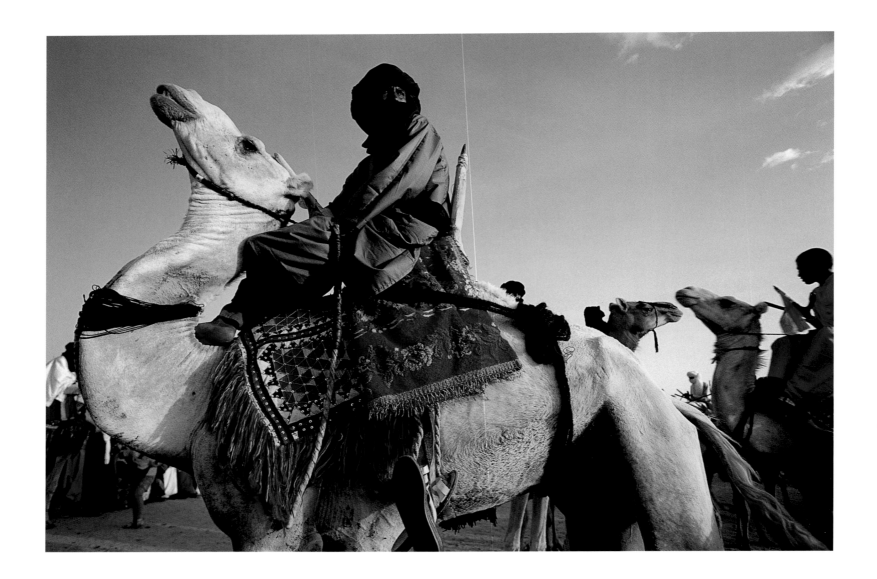

VERY LITTLE TIME was spent at the *Cure Salée,* due to scheduling difficulties, and we missed the big event of the festival, the long-distance camel race. Hundreds of racing camels from all the different tribes took part in the endurance contest, which is not unlike the Paris-Dakar Rally, only more environmentally friendly. **(ABOVE)** We did manage to catch a glimpse of some of the

camels in competition during the opening parade. **(ABOVE)** Mr Abdul Khadir Danger first entered our lives outside his booth at the *Cure Salée*, when he tried to sell Michael a course in sand-skiing. Days later, when we found him deep in the Ténéré Desert, he'd apparently sold sand-boarding lessons to two French sportsmen who were there with their paragliders.

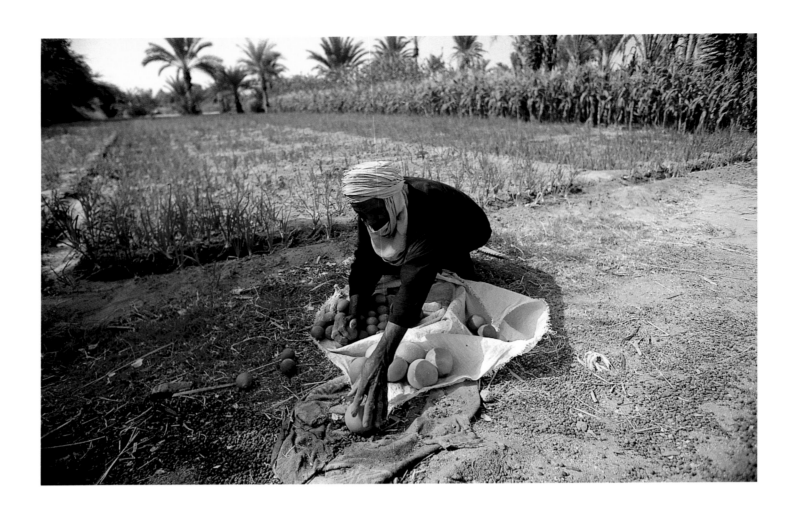

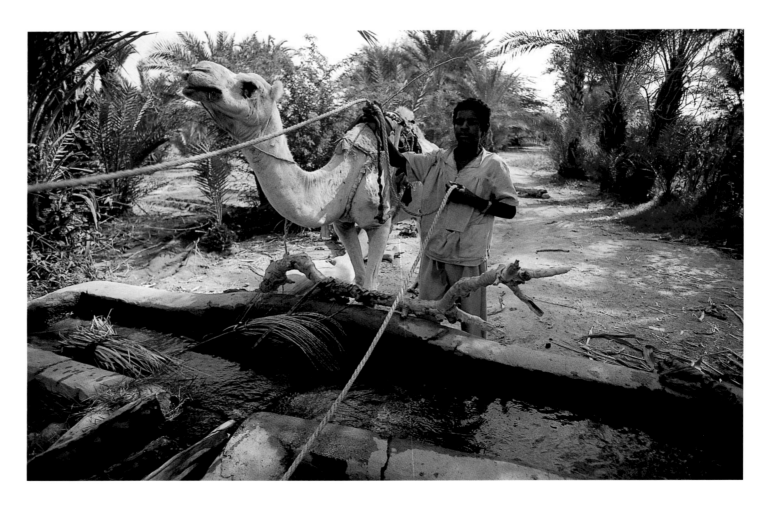

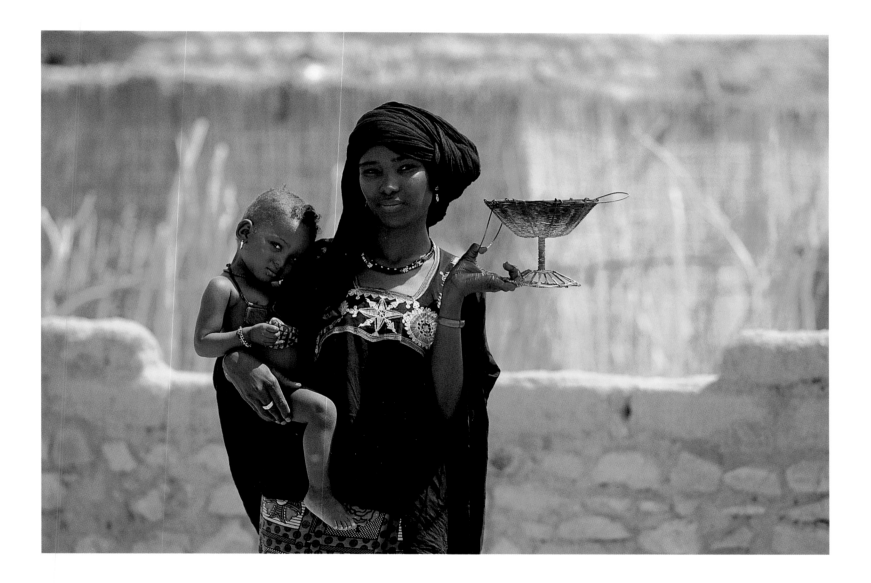

IN THE VILLAGE of Tabelot, in the Ténéré Desert, we were taken to meet Omar, who was leading a camel train on the great salt route to Bilma. **(ABOVE)** This beautiful mother and her gorgeous baby were the first people to greet my eyes as I stepped out of the car. Their natural grace and elegance shone through, even in the harsh noon light. Later, we were taken to the oasis a mile away **(TOP LEFT)**, where an abundance of crops grow, including dates, oranges, maize, onions and carrots. All are irrigated by an ancient well run on camel power **(BOTTOM LEFT)** and a series of ducts very similar to those we saw along the Nile in Sudan during *Pole to Pole*.

131

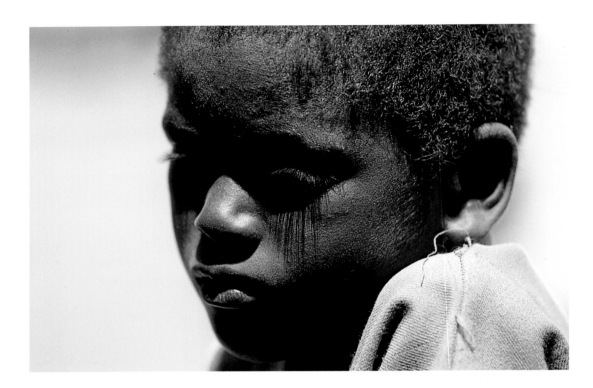

NO OFFENCE WAS INTENDED in comparing the boy's eyelashes **(LEFT)** to those of the camel, but the similarity in the cast shadows made the pairing irresistible. **(RIGHT)** This Touareg gentleman holding his blue 'flip-flops', who bore a striking resemblance to the actor Morgan Freeman, was perfectly at home on the camel named *Ekawik*. Michael also spent some time with *Ekawik* during the journey, and according to his account, a match made in heaven it was not. **(OVERLEAF)** The caravan pauses for evening prayers.

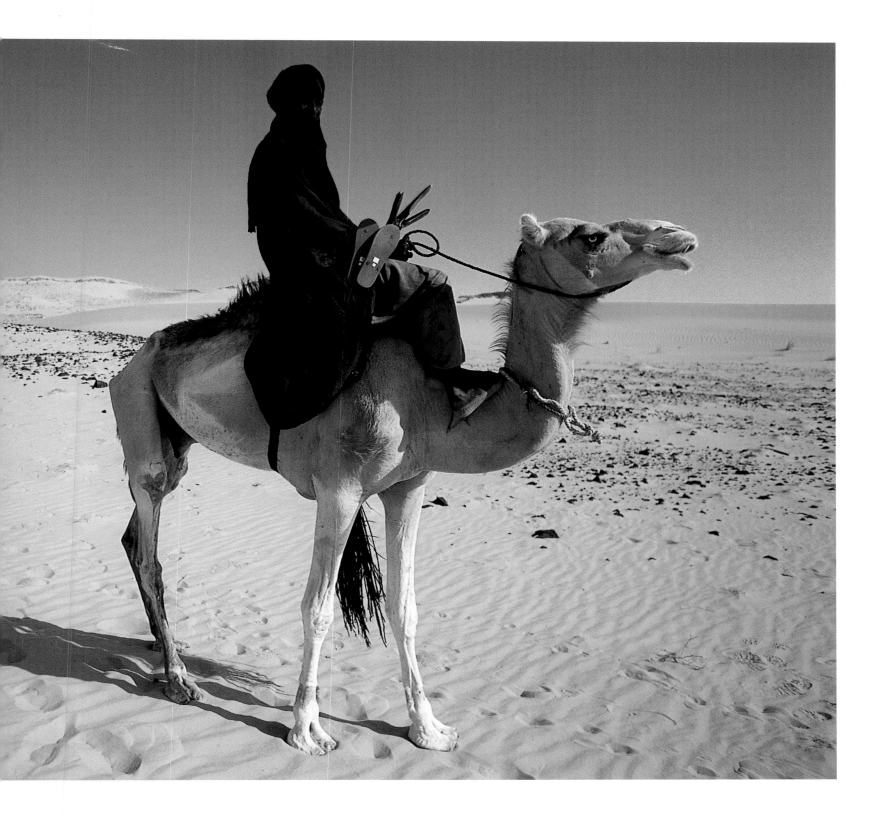

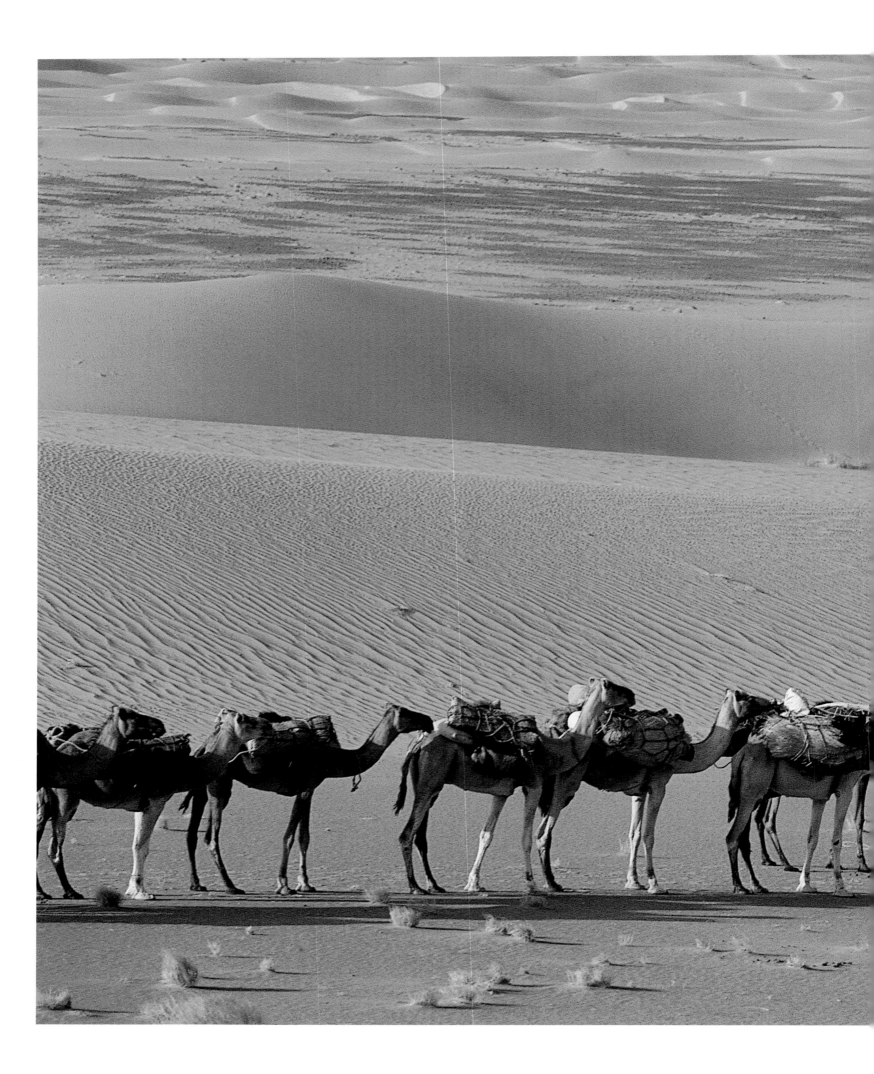

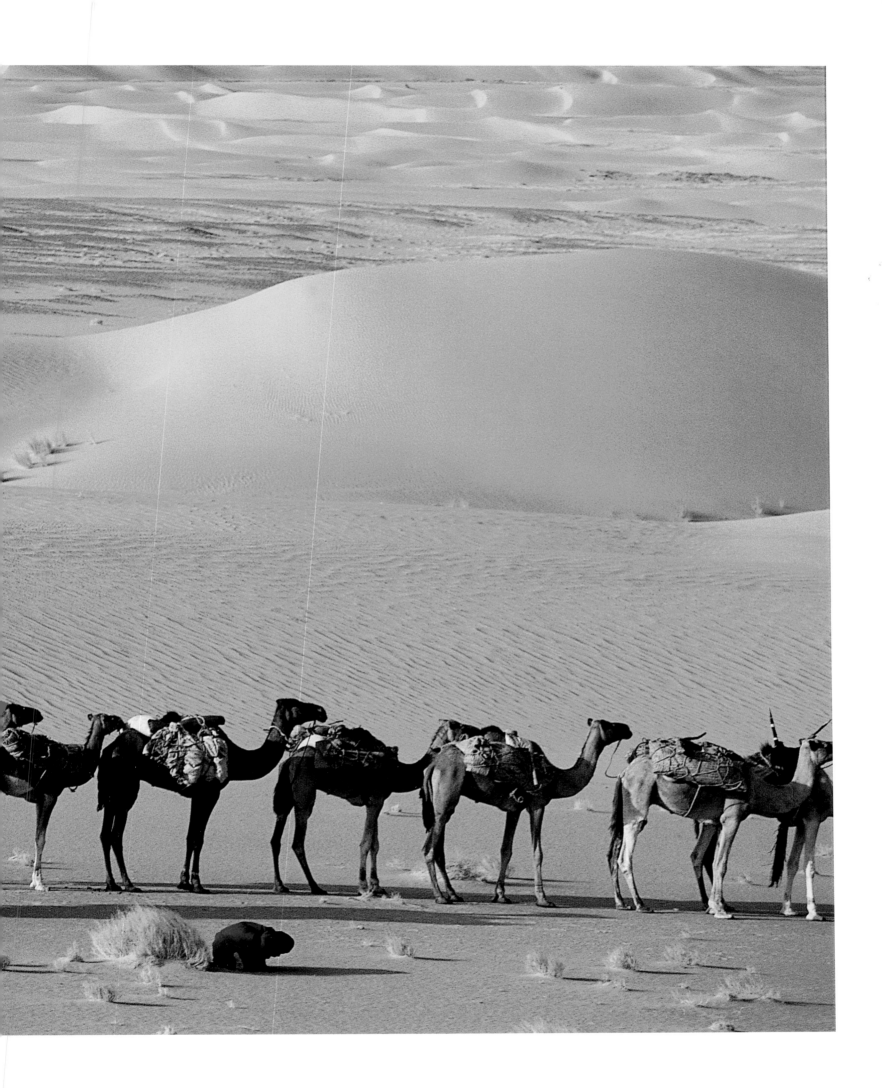

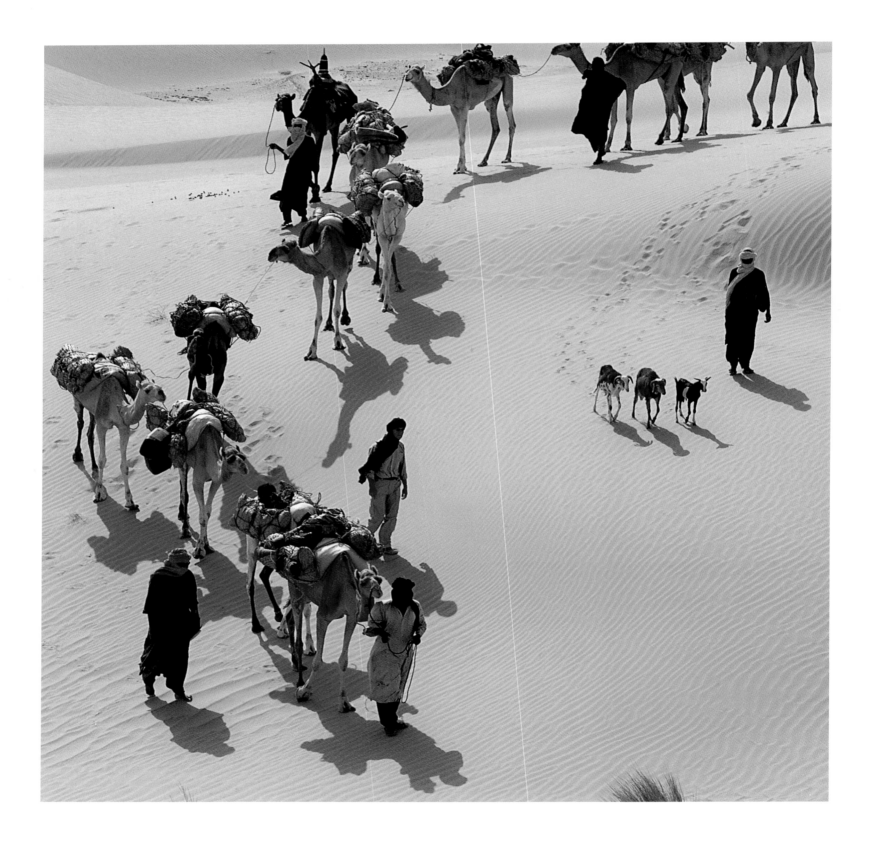

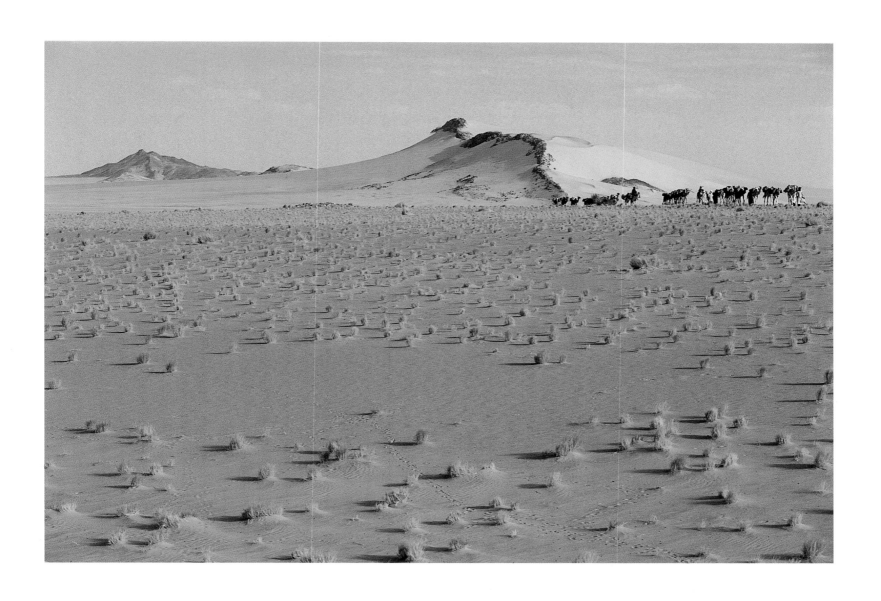

A DIFFICULT TREK through the Ténéré Desert. **(LEFT)** Men and beasts tread gently downhill along the edge of the soft dunes. **(ABOVE)** By evening, the caravan had reached the place where they would camp for the night, shielded from the desert wind by the mountains just beyond the 'Dragon's Spine'.

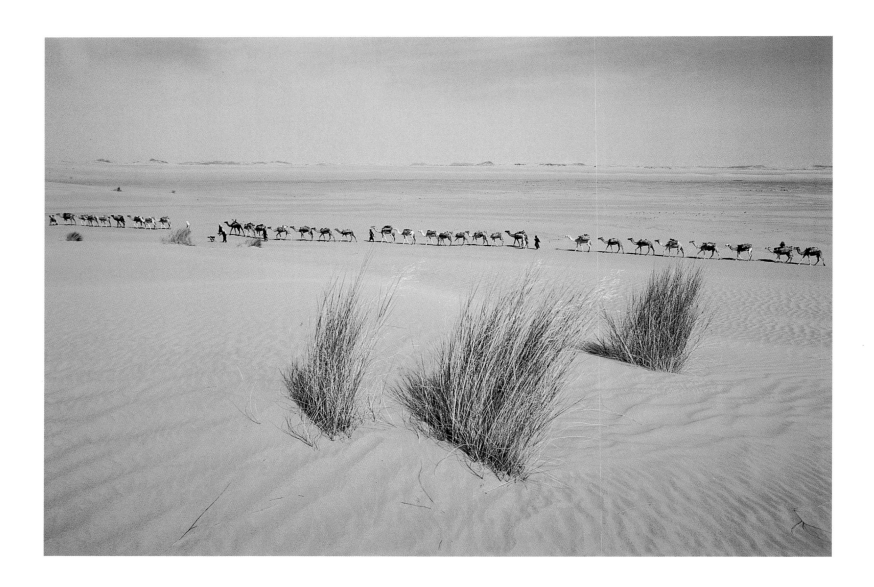

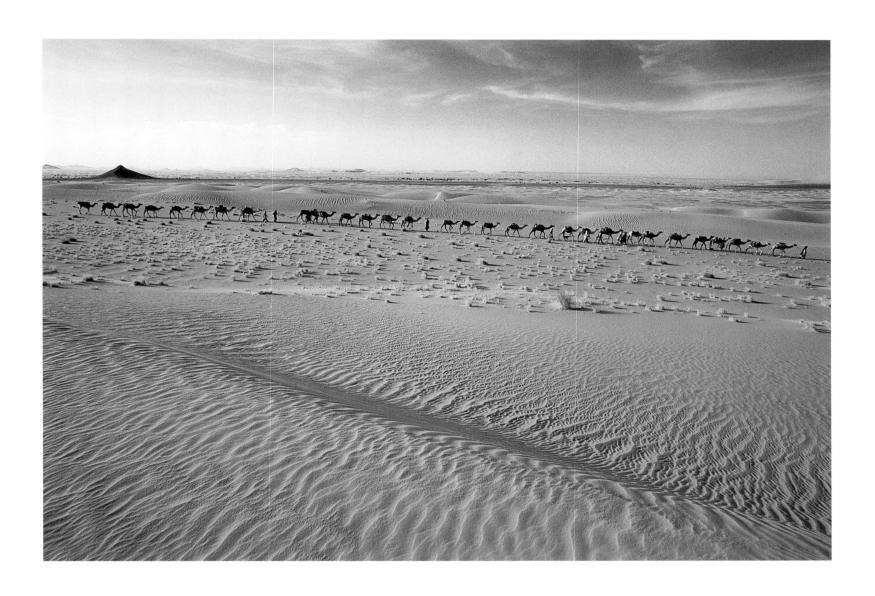

DESPITE THE STARK BEAUTY and a sense of lightness of being that came with the immensity of the open space, I felt relieved by the fact that we were not going all the way to Bilma with the caravan. The salt pans were at least another 200 miles and ten days further on, through some pretty nasty bits of the Sahara. Of course, Nigel, Mr 'been there, done that, got the T-shirt', had done the Bilma journey before for another television programme and had won an award for it, so you'd *expect* him to say that it was a doddle.

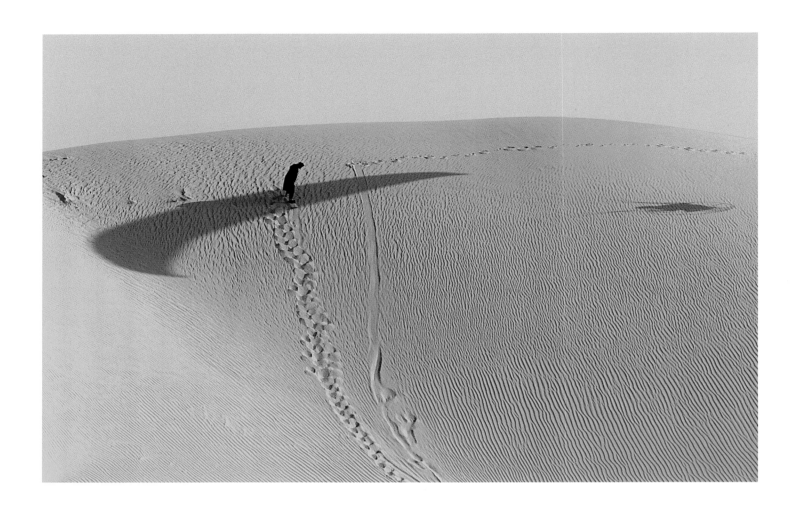

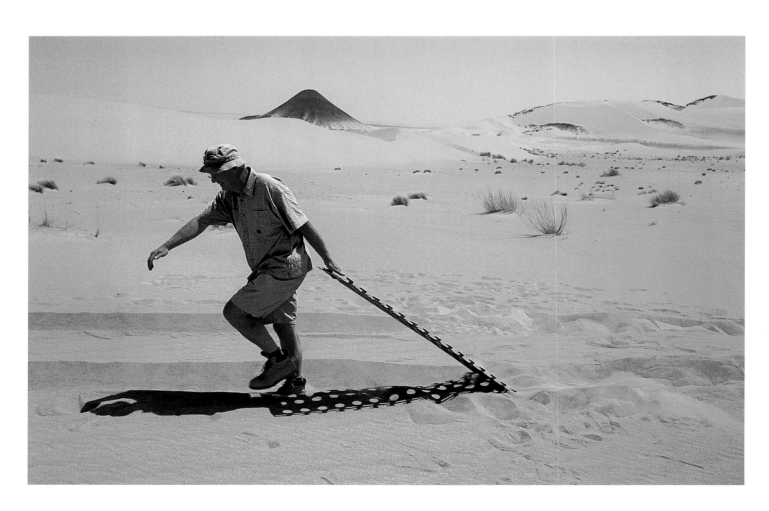

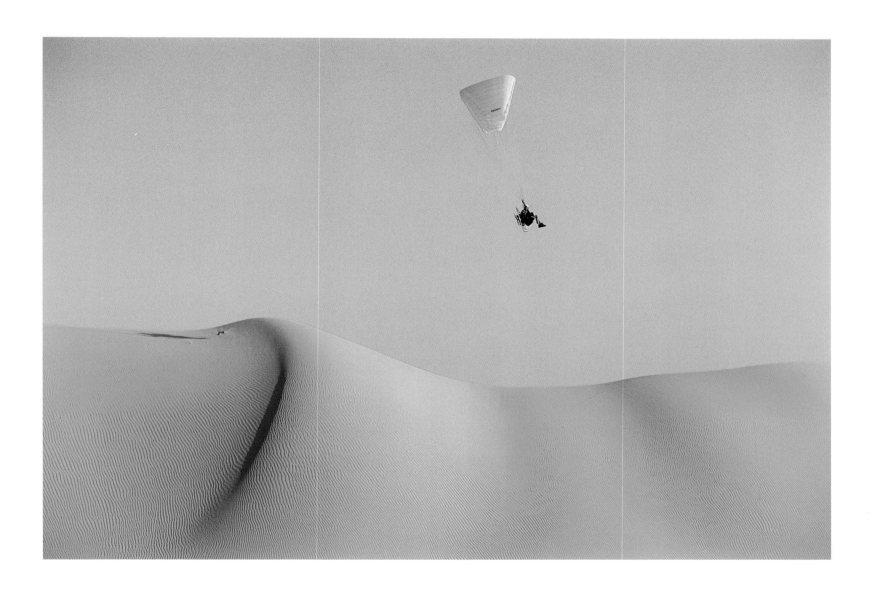

THE PARAGLIDER arrived in total darkness, guided by a single oil lamp in our camp. At JP's invitation, French flyers François and Renaud spent the next day buzzing around overhead like 'blue-ass flies', attempting to get some aerial shots of the camel train with Peter's camcorder. Some of the camels were unnerved and refused to move. It was a day of incongruities in the Ténéré desert. While the latest toy of twenty-first-century adventure was challenging the most ancient mode of desert transport from above, Mr Danger **(TOP LEFT)** was trying out his snowboard on the sand in its shadow. **(BOTTOM LEFT)** Earlier, John 'tidied up' the desert, removing the sand ladders after they had successfully dug their vehicle out of a soft dune.

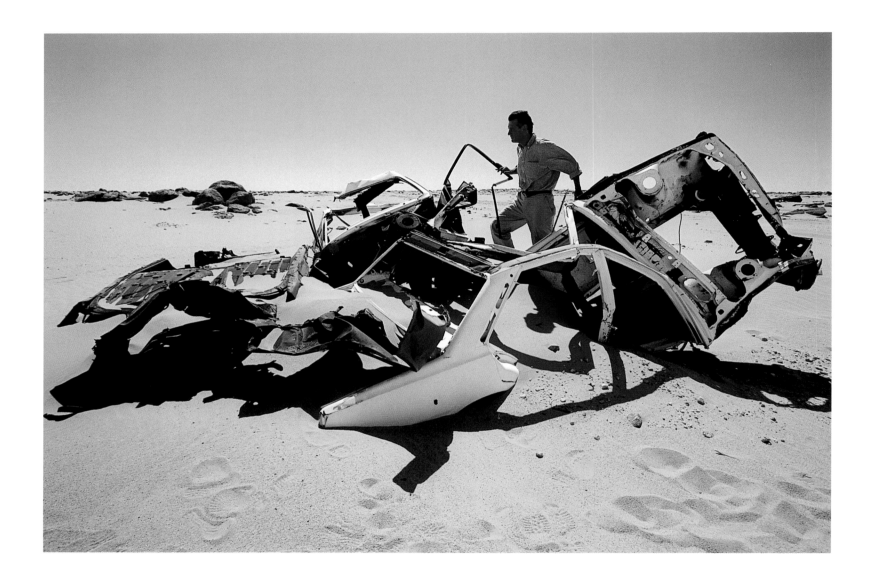

SOMEWHERE ALONG THE WAY, between the Niger-Algerian border at I-n-Guezzam and the southern city of Tamanrasset, we came across this place **(ABOVE)**, known as the 'Cemetery'. Apparently, driving second-hand cars through the Sahara and selling them in the south, in countries like Nigeria, is not only good sport but also good business. Many Europeans, young or just plain nuts, make the trip. Some never get through. Exactly why so many cars choose

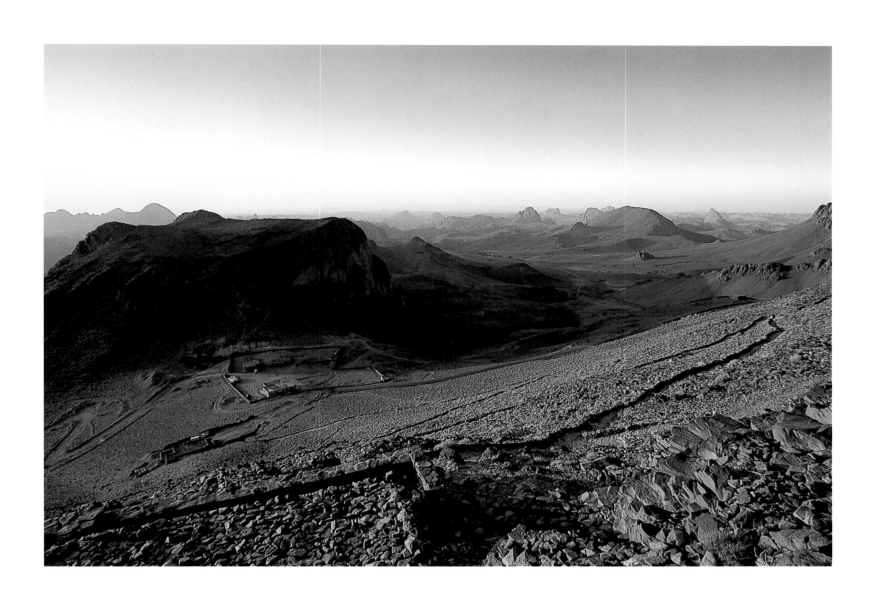

to die here together remains a mystery. And how their drivers get out is another. Six hours after leaving the tidy streets of Tamanrasset for the wretched lava-strewn tracks which twist crazily up and down through the spectacular scenery of the Hoggar Mountains, we arrived in Assekrem. One heart-thumping climb up a precipitous path later **(ABOVE)** we reached the top of the plateau, over 9000 feet above the sea.

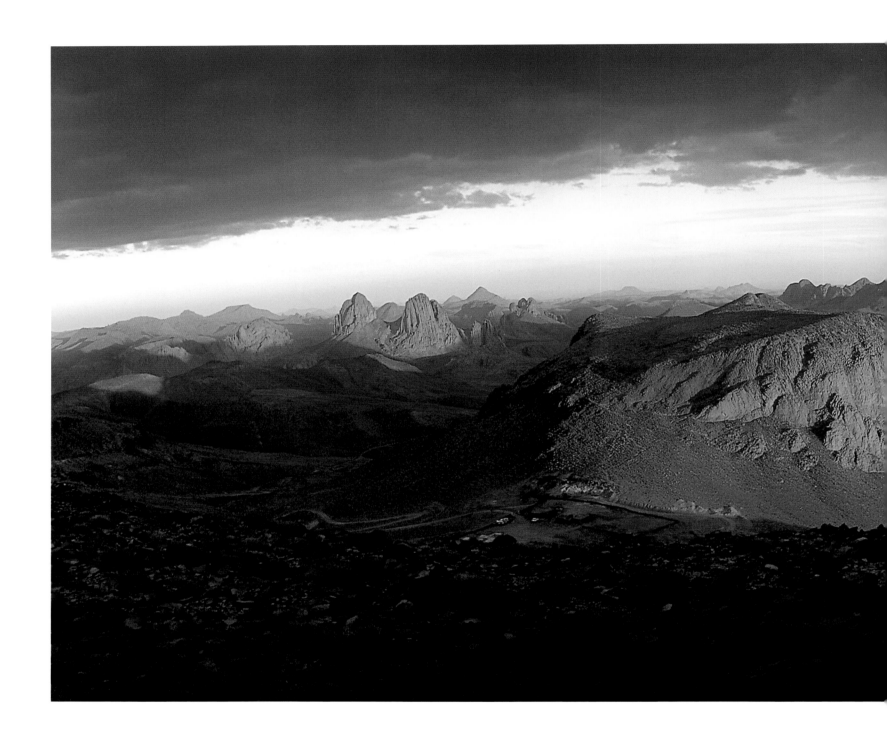

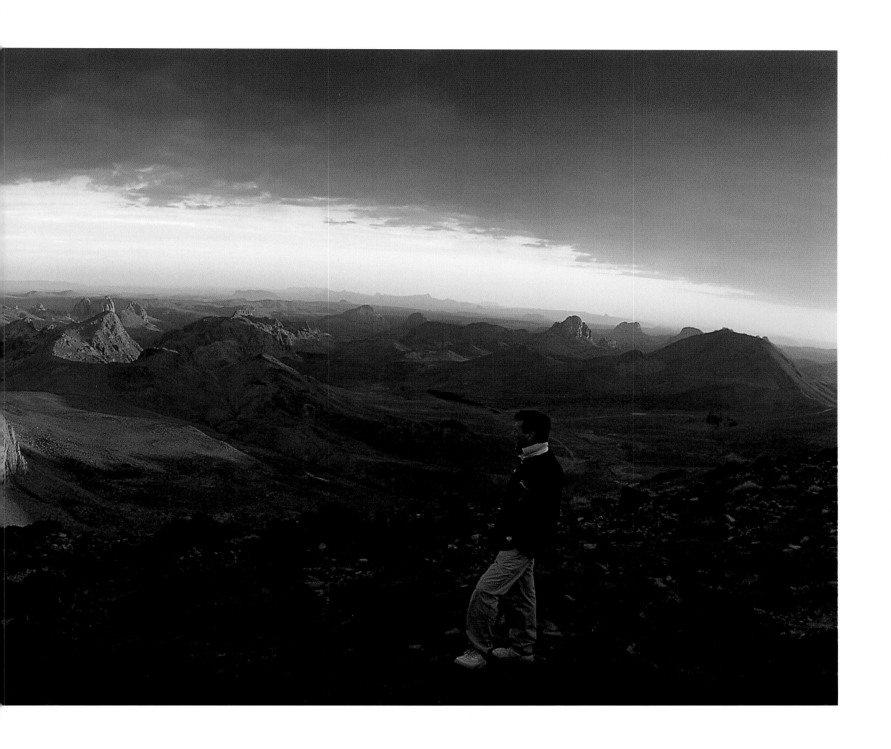

SUNSET OVER THE HOGGAR MOUNTAINS. In 1911, the ascetic French missionary Charles de Foucauld built a refuge at Assekrem. He had a close relationship with the Touaregs of the Hoggar Mountains, and produced the first French-Tamahaq dictionary. He lived in isolation and looked out on this view for five years, until the day he was murdered in Tamanrasset. **(ABOVE)** On his way to the hermitage, Michael pauses to contemplate the splendid silence.

SUNRISE OVER THE HOGGAR MOUNTAINS. At 5.30 am, the crew planted their cameras right outside the small stone chapel on top of the plateau, waiting for the sun to rise while being pounded by a freezing wind. I moved away from the peak, searching in vain for a sheltered camera position. Dawn broke and the sun burned through the frozen mist. Suddenly, the peaks of the Hoggars, some of the highest in the Sahara, seemed weightless, and I recalled the words of José Martí: 'Should you see a hill of foam / It is my poetry you see / My poems are mountains / And feather fans.'

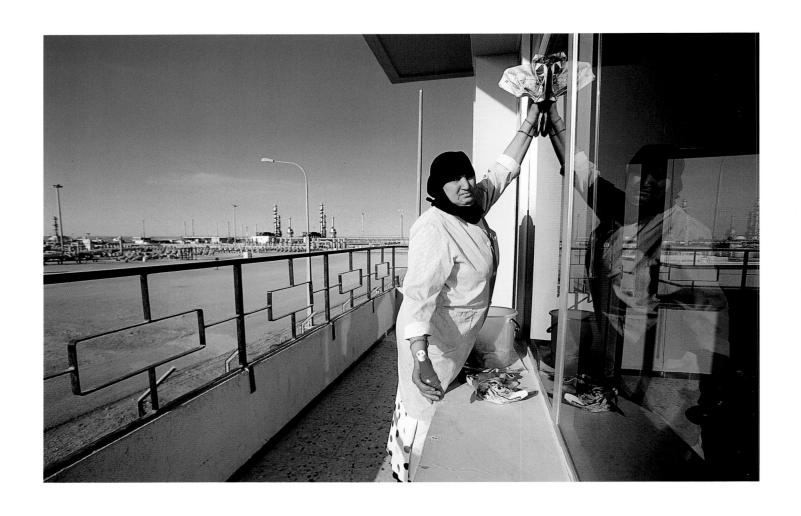

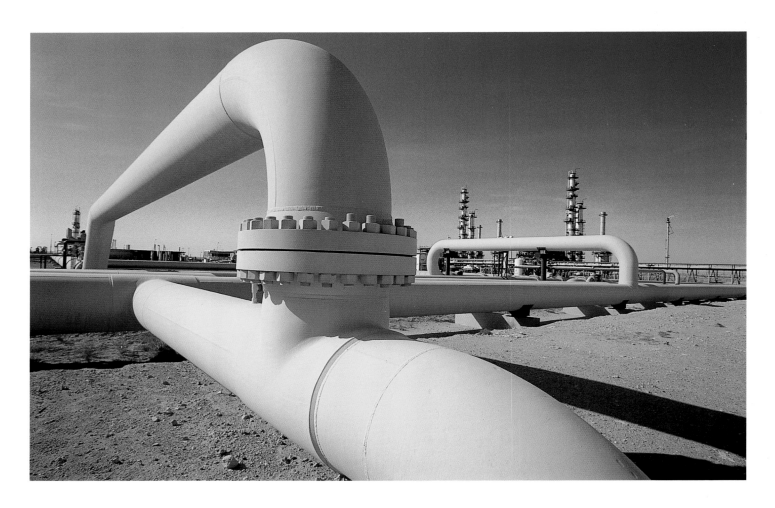

OIL AND GAS exports make Algeria the third richest country in the Sahara. The facilities at Hassi-R'Mel **(LEFT)** process the natural gas from the desert and send it across to Europe through pipelines under the Mediterranean in the form of liquid nitrogen. **(ABOVE)** At In Aménas, near the Libyan border, I observed BP workers dismantling the drill site bit by bit from under a 200-foot derrick which was lying on its side.

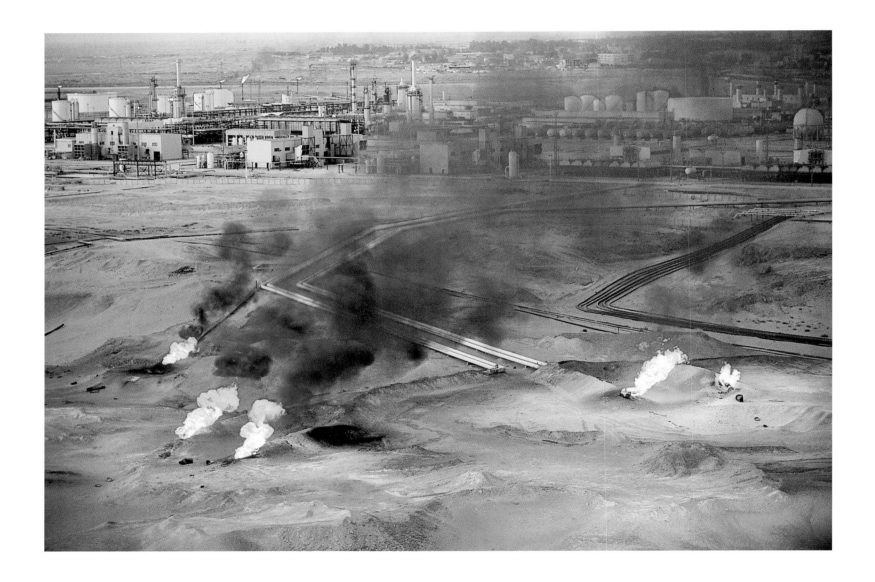

THESE VISIONS of the dark side of the Sahara were made possible by the generosity of our hosts at Sonatrach, the Algerian state oil and gas corporation. They kindly provided us with a helicopter for some aerials over Hassi-Messaoud, so I mustn't even think about using the term 'Visions of Hell'. It was an extraordinary experience, at once exhilarating and depressing. And I found myself remembering the last time I shot over Nigel's shoulder through a gaping hole of the missing door in an aircraft; it was above the sand seas of Chinguetti at sunrise, all the way back in Mauritania.

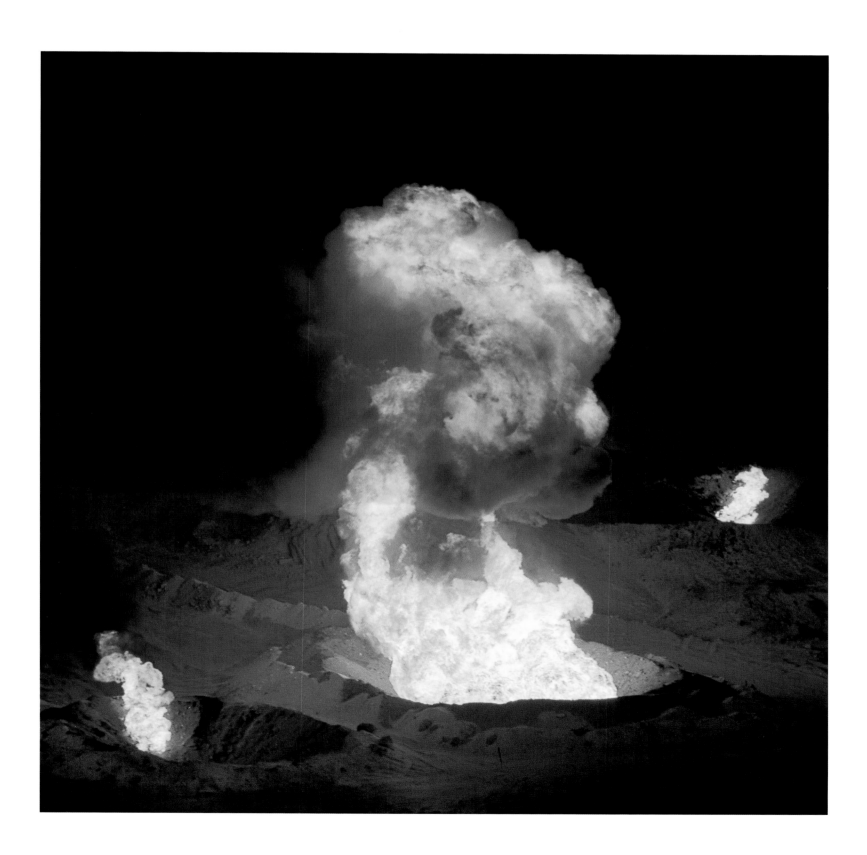

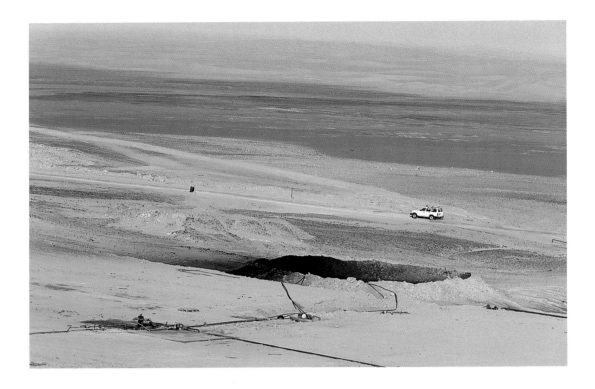

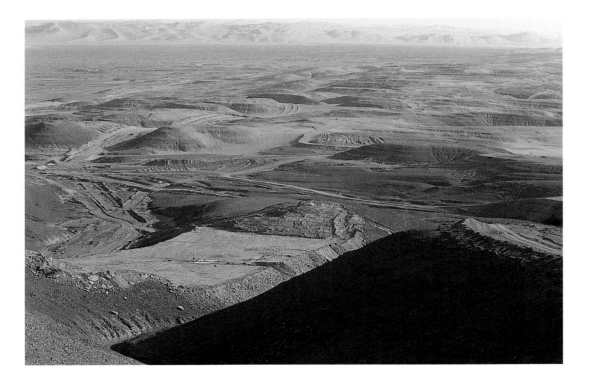

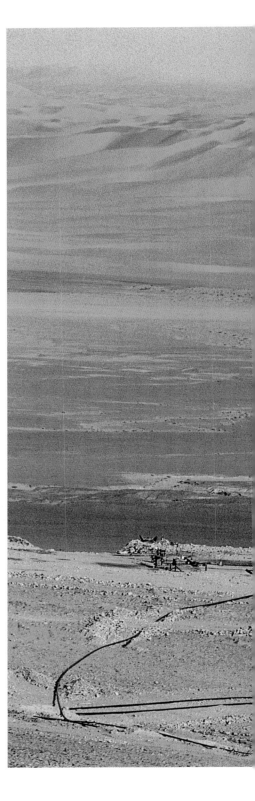

A SINGLE ACACIA TREE (RIGHT) marks the border between Algeria and Libya. **(ABOVE)** All along the border route from In Aménas, the desert has been ravaged by oil and gas exploration. But as I looked into the distance, beyond the tree, at the majestic terracotta dunes in Libya that stretch to infinity, I was reminded of my favourite *Sufi* saying, 'This too will pass'. Long after the last whisper of gas has been squeezed from the ground, the desert will still be here, and its sand will surely reclaim the burnt-out craters left behind by men in blue overalls.

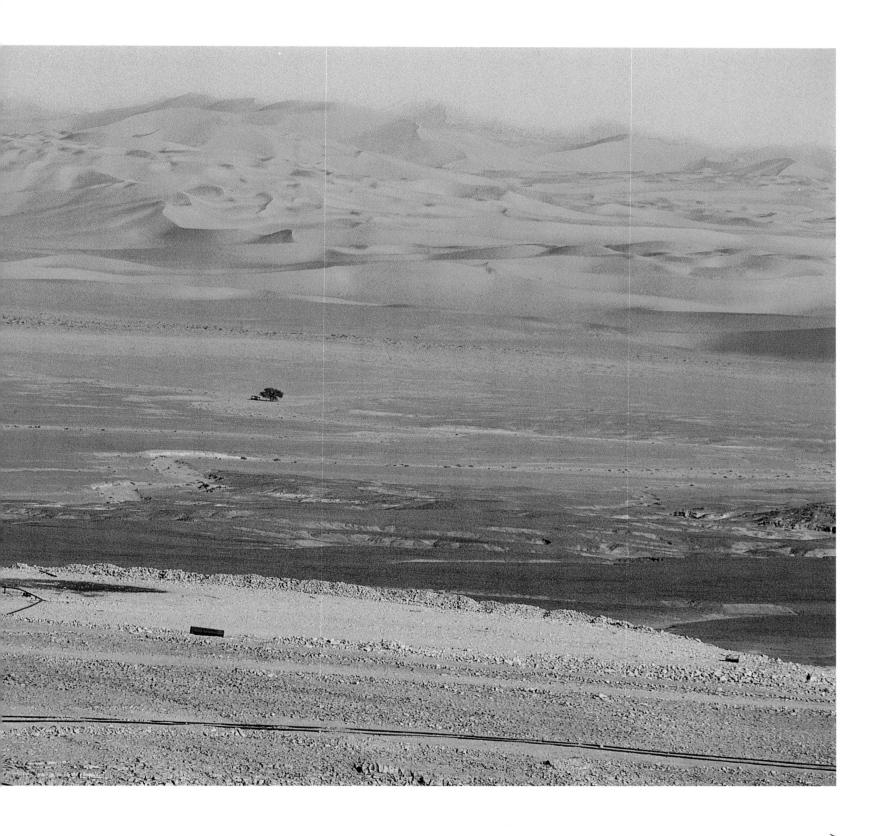

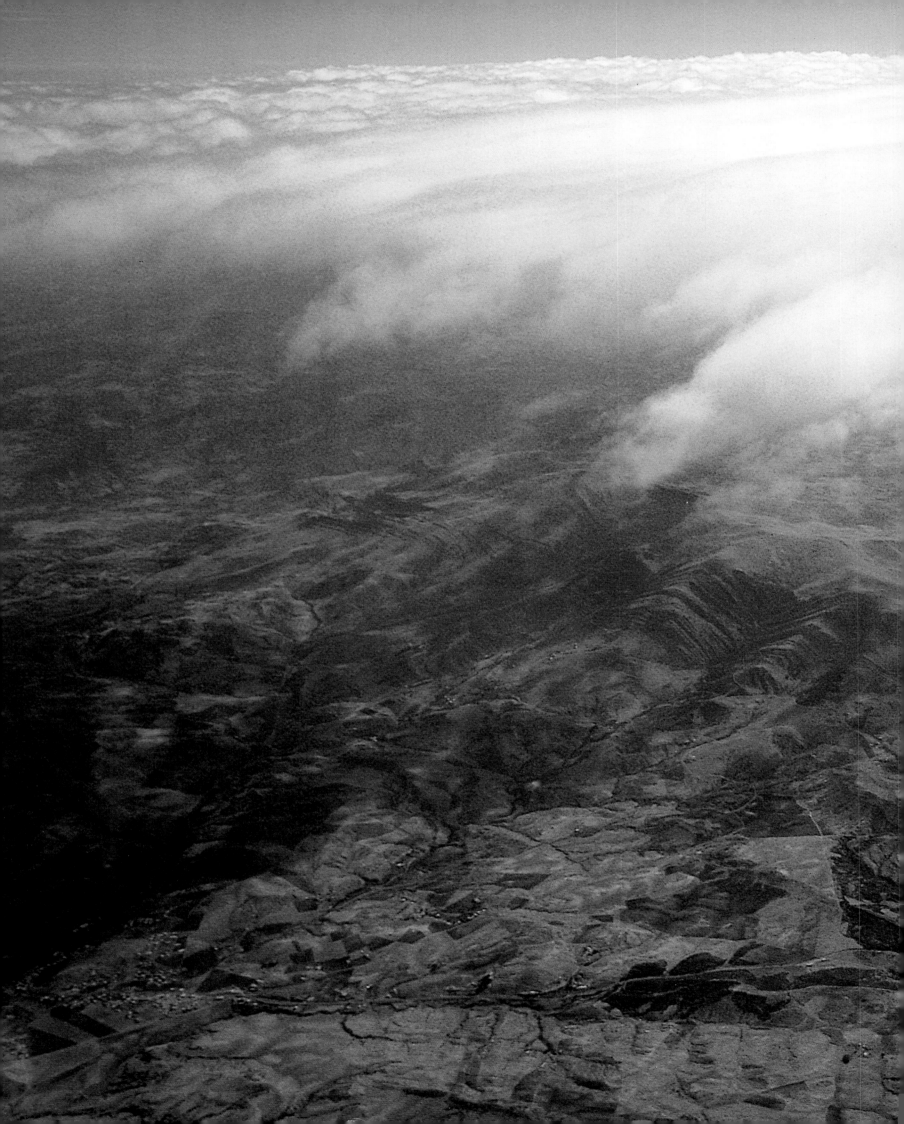

THE**NORTH**

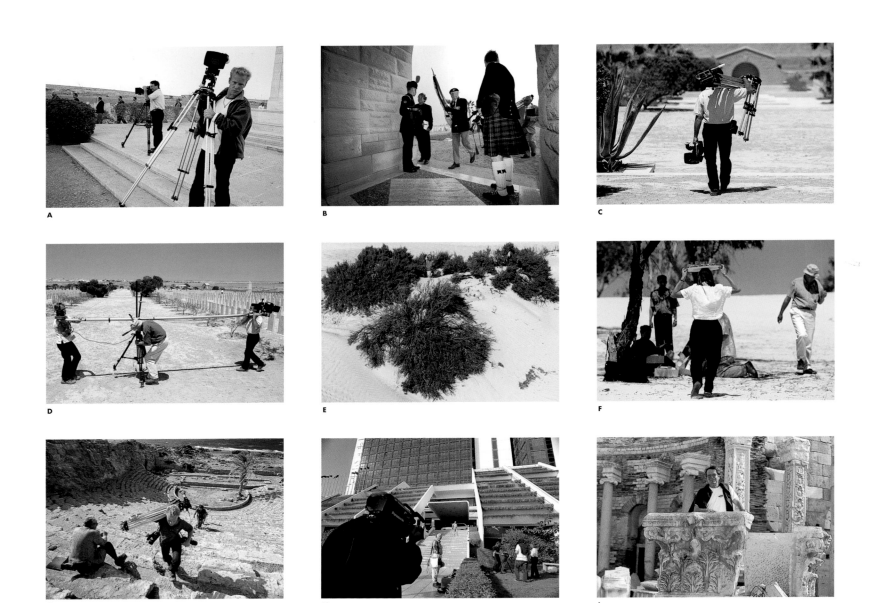

A

B

C

D

E

F

G

H

I

LIBYA (A) Multi-camera fiasco at the Acroma-Knightsbridge Cemetery in Tobruk. There were so many cameras around that it became impossible for any of us to get a shot without another cameraman wandering through frame. (B) Roger chatting up the bugler after the memorial service for the Desert Rats. (C) Nigel demonstrating the art of tripod removal. (D) The bored crew takes the crane for a walk. (E) John finds a picturesque spot to hide in the Libyan desert.

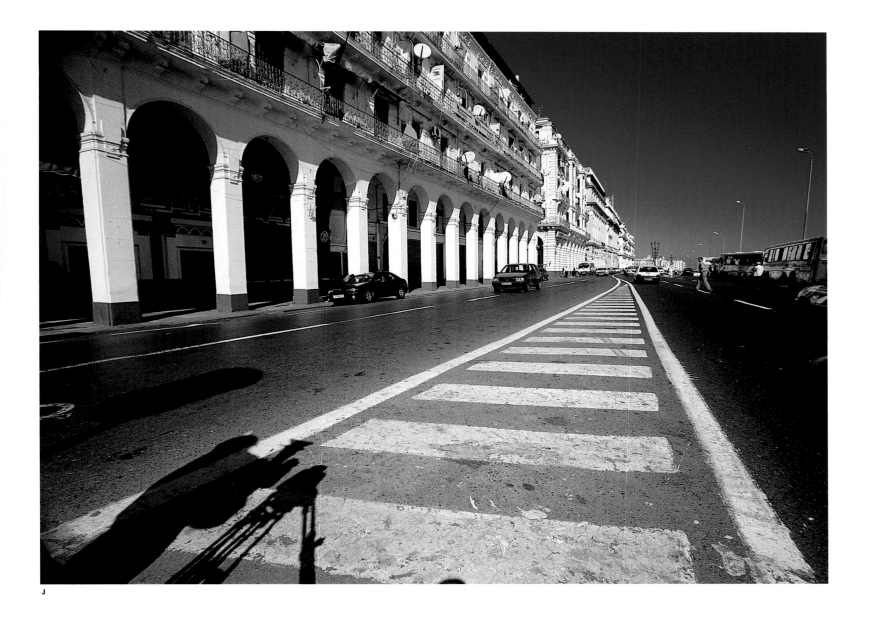

J

(F) Madame Chardonnay aka Vanessa, demonstrating her skills as a hostess. (G) 'It's a wrap' for the Palin-as-Julius Caesar sequence at the theatre in Apollonia. (H) Outside the hotel in Benghazi, John is clearly not at all happy about having his every movement video-taped. (I) Generalissimo Roger Edwin Mills – Portrait of Power, at Leptis Magna. **ALGERIA** (J) Nigel's shadow sets up a shot in Alger La Blanche, the white city of Algiers.

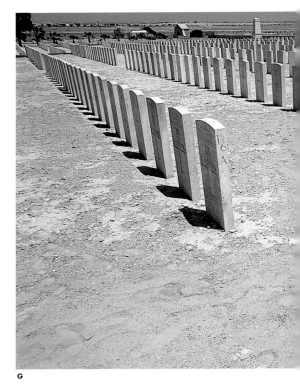

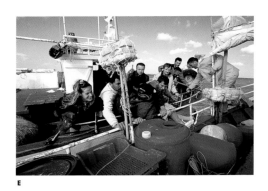

A

B

C

D

E

F

G

H

TUNISIA (A) Pete, who is perpetually hungry, eyes the hard-boiled eggs while on reflector duty in the troglodyte caves. (B) Photographic evidence for why Claire was voted 'Miss Popular' by the members of the crew. (C) John takes notes with his Dictaphone while… (D) Junior loads yet another magazine inside the souk in Djerba. (E) JP almost ends up swimming with the octopus, when he doesn't quite make it from one heaving boat onto another. (F) On the way back to port after octopus fishing, the Meakins happily pose for this boat-to-boat portrait, while JP is clearly in a slightly less agreeable mood. (G) Back in Tobruk, due to bad picture editing, Pete sets up a crane shot at the cemetery. (H) Claire finds a new friend in Sidi

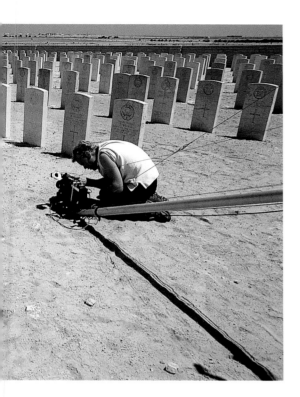

J

K

L

M

I

N

O

Bou Said... (I) while the Meakins have a very different idea about what you're supposed to do with a pussy cat. (J) 'The crew that goes to the loo together, stays together.' The gang in the Roman ruins at Dougga. **ALGERIA** (K) Nigel and John with Eamon on the roof of Villa Suzini, notorious as the torture chamber during the war for independence. (L) The Meakins take their morning's work at the Central Station in Algiers very seriously. (M) Michael listens to a play-back of his 'piece to camera' with Roger and John on the beach at Sidi Ferruch, where the French first came ashore in Algeria in 1830. (N) Pete 'tidying up' the window on the Algiers to Oran train. (O) Generalissimo Roger Edwin Mills – Portrait of Power, outside Tarifa, Spain.

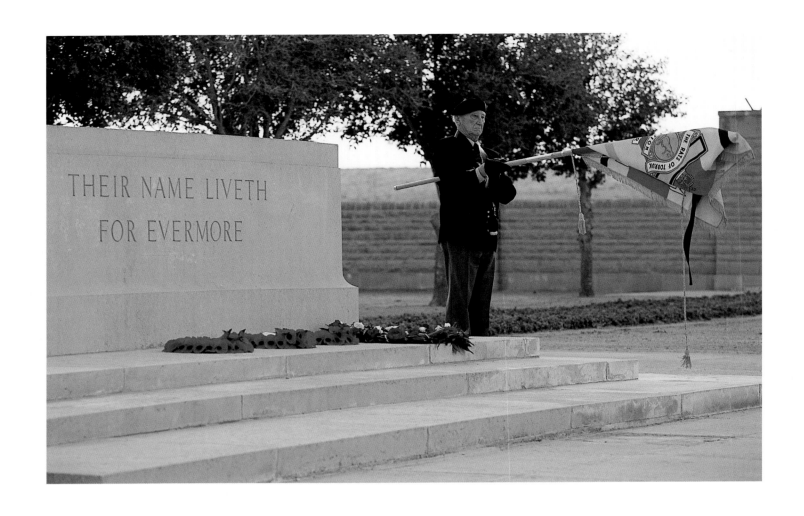

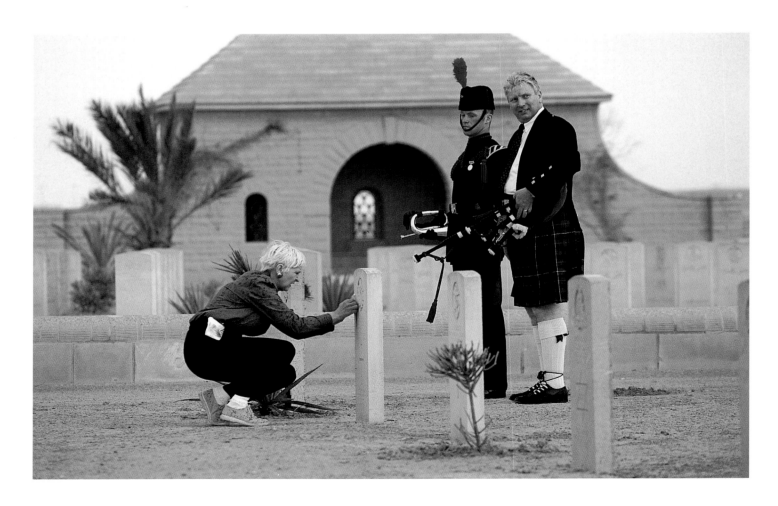

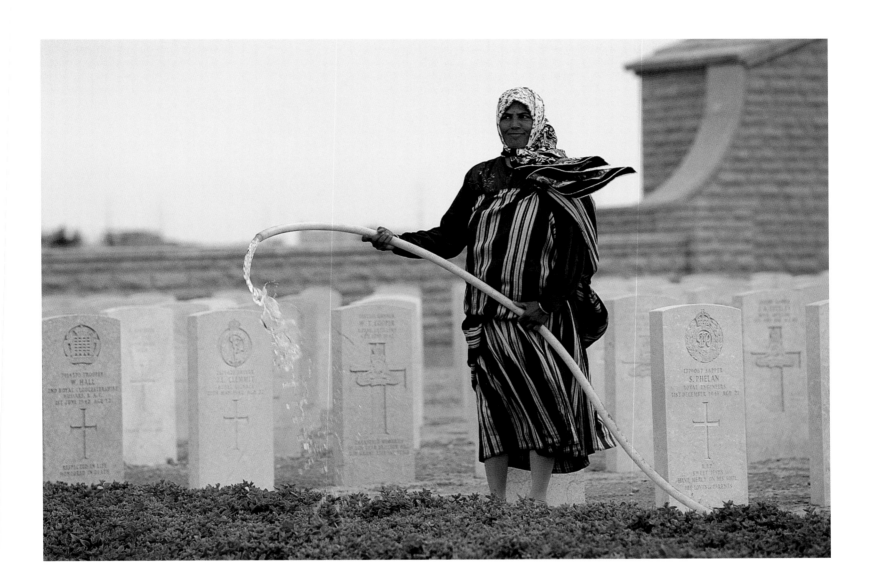

FOR EIGHT MONTHS, between April and December 1941, the Desert Rats clung on to the port of Tobruk despite overwhelming odds, keeping open a vital supply line for the Allies in their struggle for control of Egypt and the Suez Canal. Sixty years later, the few survivors of the epic battle still well enough to travel returned one last time for a memorial service (TOP LEFT) at the Acroma-Knightsbridge Cemetery. The organiser of the reunion, Lady Avril Randell (BOTTOM LEFT), attaches tributes to the headstones on behalf of the families unable to attend. The cemetery is immaculately maintained by the Libyan Mohamed Hafji and his wife (ABOVE). He 'inherited' the responsibility eighteen years ago from his father, who took care of the graves for over thirty years before he himself gave up the ghost.

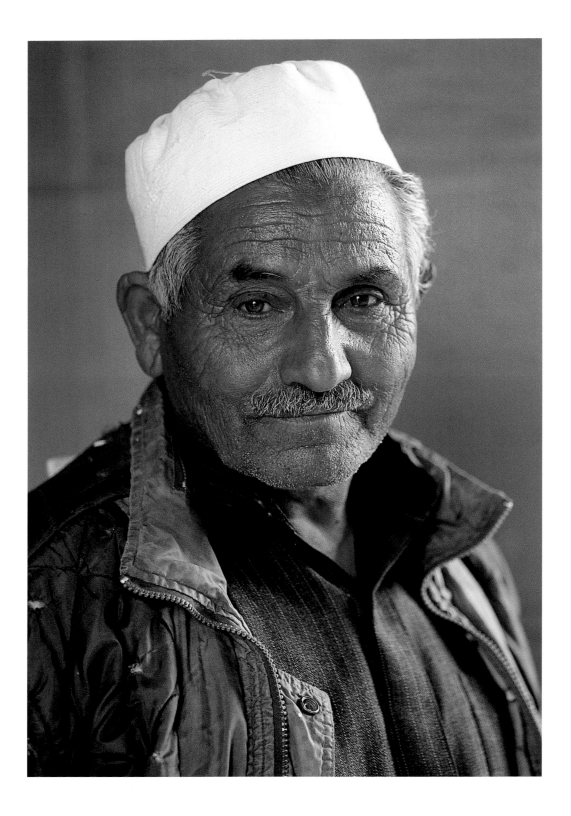

OUR TIME IN LIBYA was spent mostly on empty highways, confined inside an enormous pink coach, under the watchful eyes of our minders, while a video camera recorded our every move – getting on the bus, getting off the bus etc., etc. So, meeting local people, though not officially discouraged, was difficult. Here are two of them who slipped through the net. **(LEFT)** A caretaker in Tobruk and **(RIGHT)** a taxi driver outside our hotel in Benghazi.

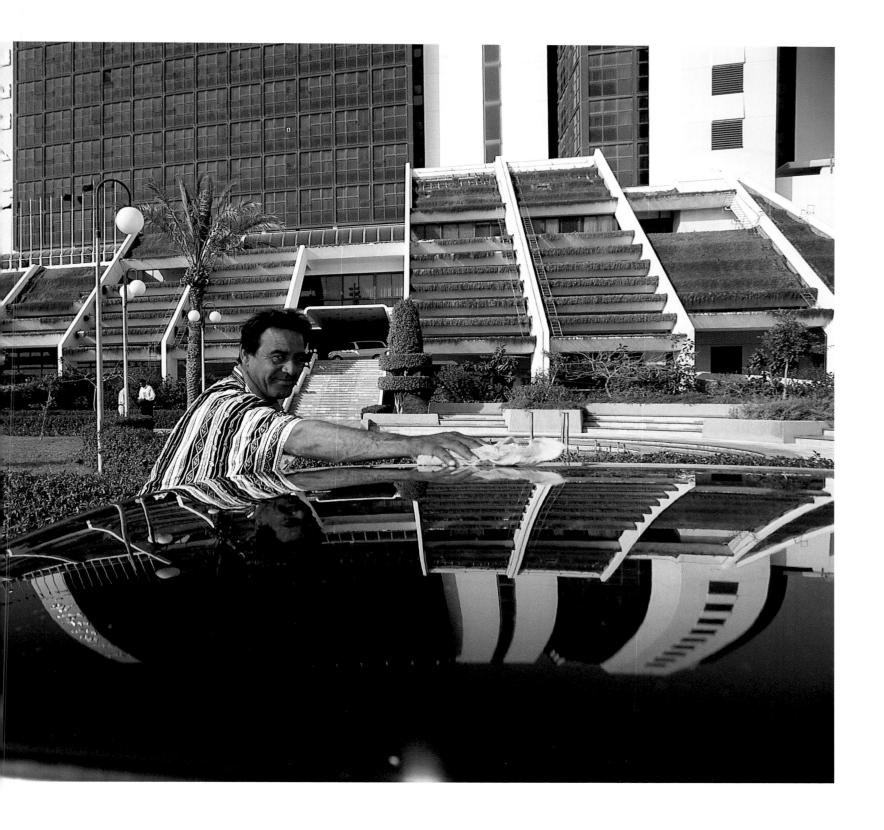

(OVERLEAF) View of a small section of the enormous slab of concrete outside my hotel window in Benghazi, vaguely reminiscent of Tiananmen Square in Beijing. I didn't know what it was meant to be, nor its exact function – it was way too big to be just a heliport. But I did think at the time that it would make a monumental drive-in theatre, one that could accommodate all the cars in Benghazi.

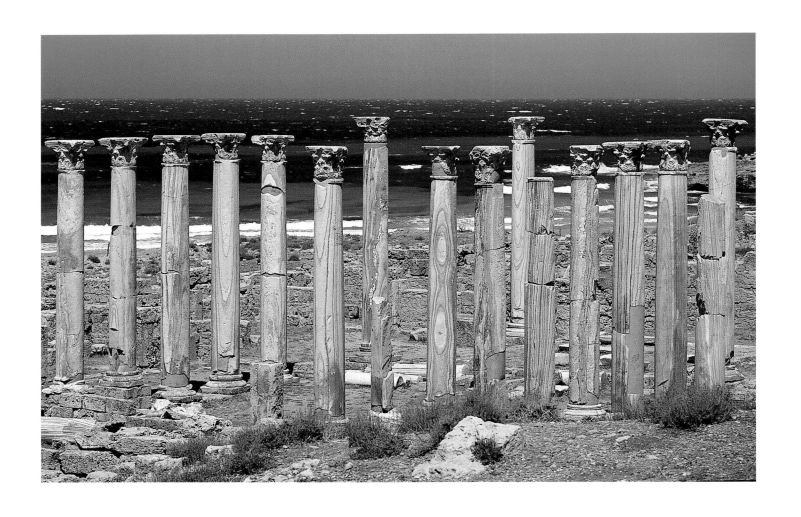

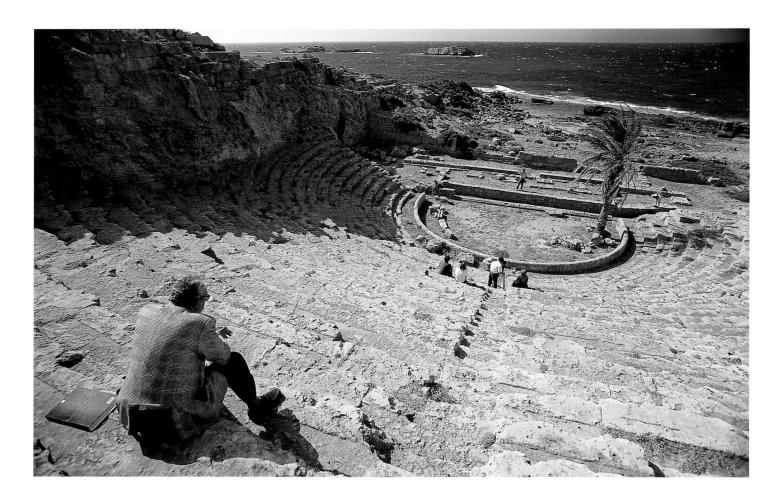

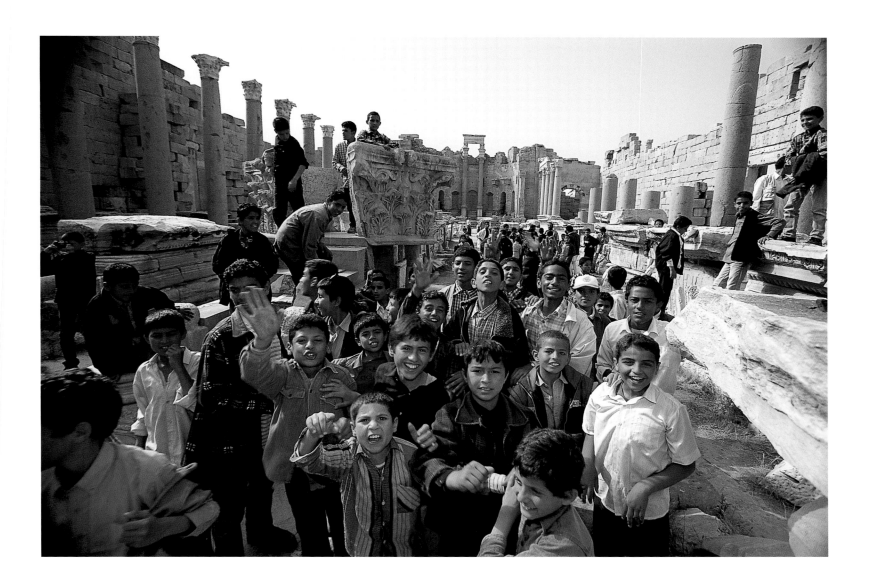

LIBYA WAS ONCE KNOWN AS the breadbasket of Rome, and dotted all along the coast between Tobruk and Tripoli are some of the most spectacular and unspoiled Roman ruins in the world. **(TOP LEFT)** We found these impressive marble columns of the Eastern Basilica at Apollonia, seaport for the city of Cyrene, first settled by the Greeks around 630 BC. **(BOTTOM LEFT)** Michael was so moved by the beautiful theatre by the Mediterranean that he decided to recite *Julius Caesar* on stage, under the uncomprehending gaze of our government minder. **(ABOVE)** Boisterous school children at Leptis Magna, once the richest Roman city in Africa, where grain, slaves and other treasures of the continent were assembled and shipped north.

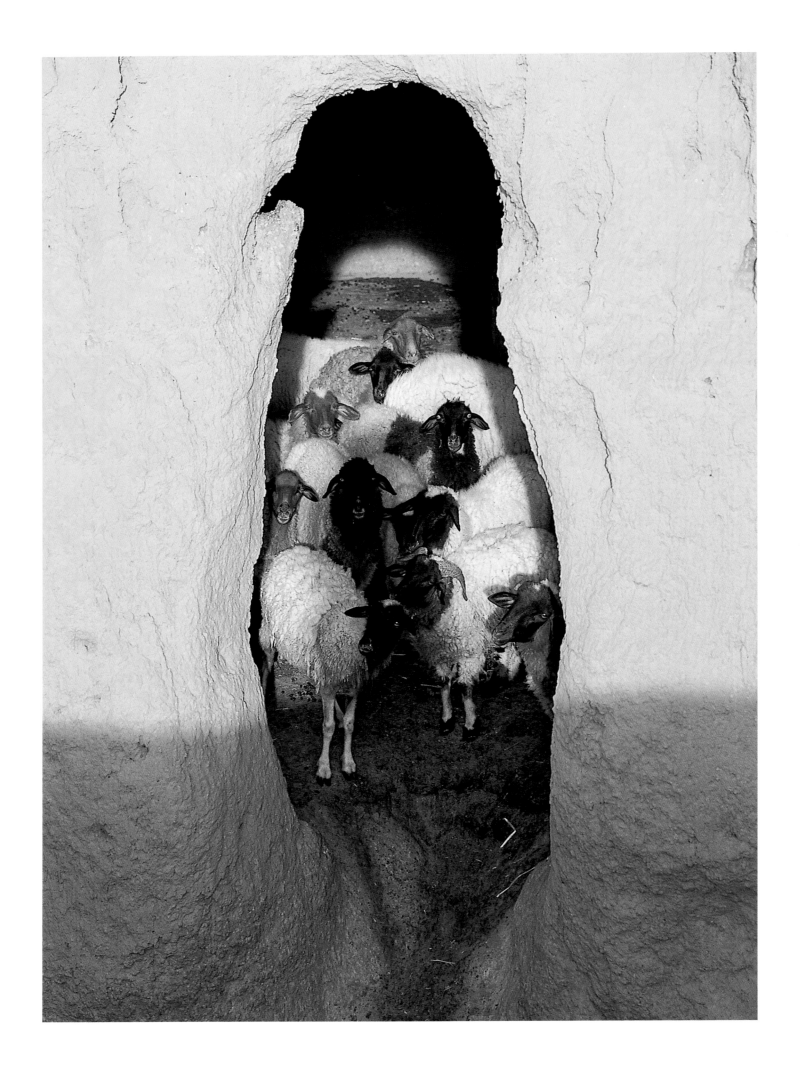

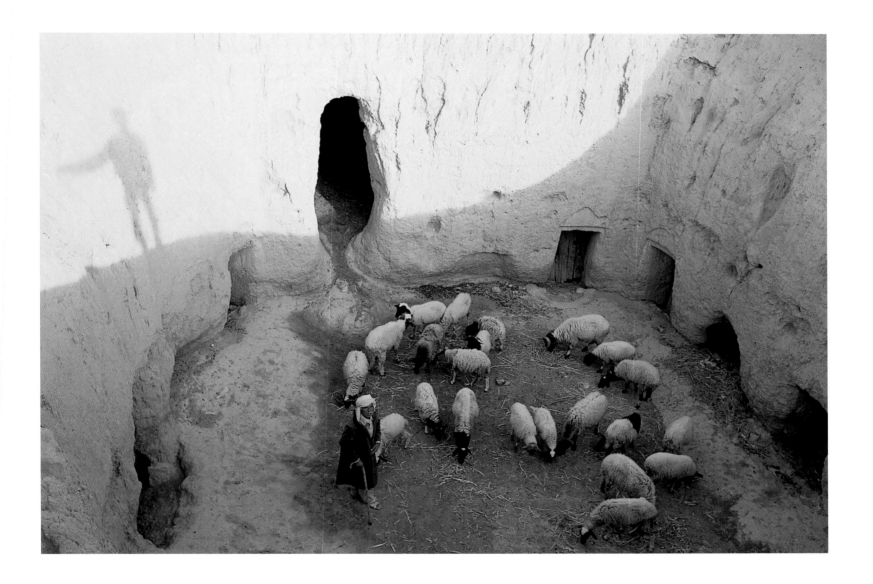

MICHAEL TOOK US BACK to where he and the rest of the Pythons were crucified over twenty years ago in *Life of Brian*. El Haddej is also home to the troglodytes of the Matmata region; their Berber ancestors settled in the underground caves here over 2000 years ago. The sheep have their own caves **(LEFT & ABOVE)**, which are sometimes connected by tunnels to their owner's living quarters.

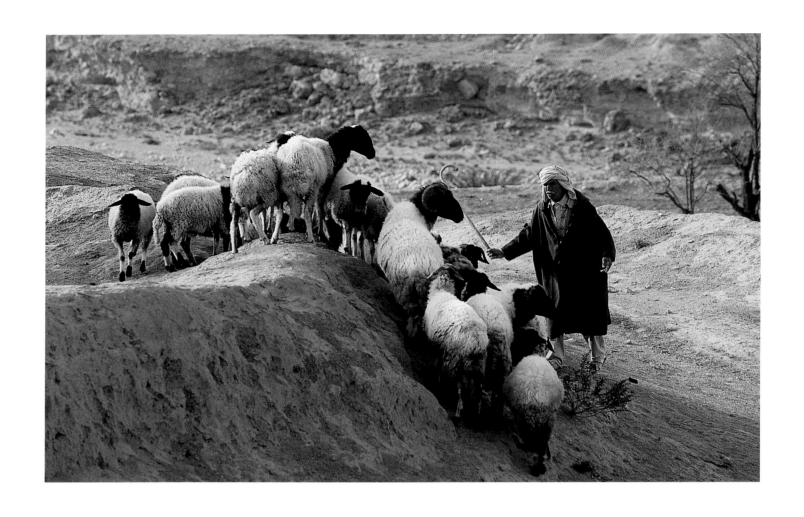

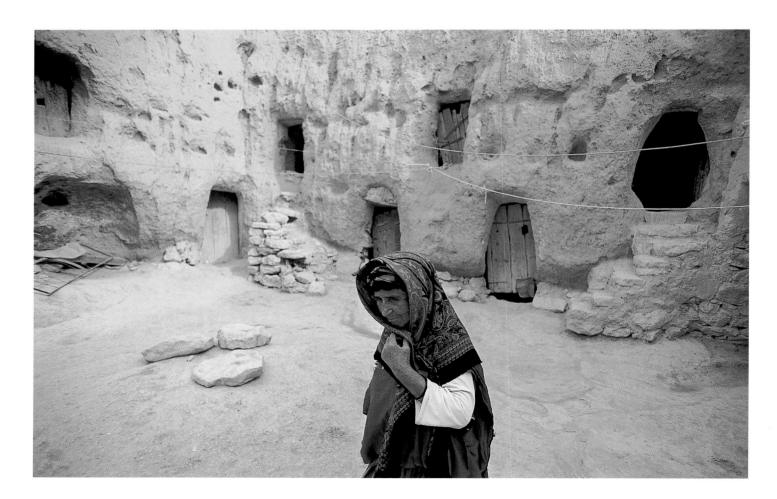

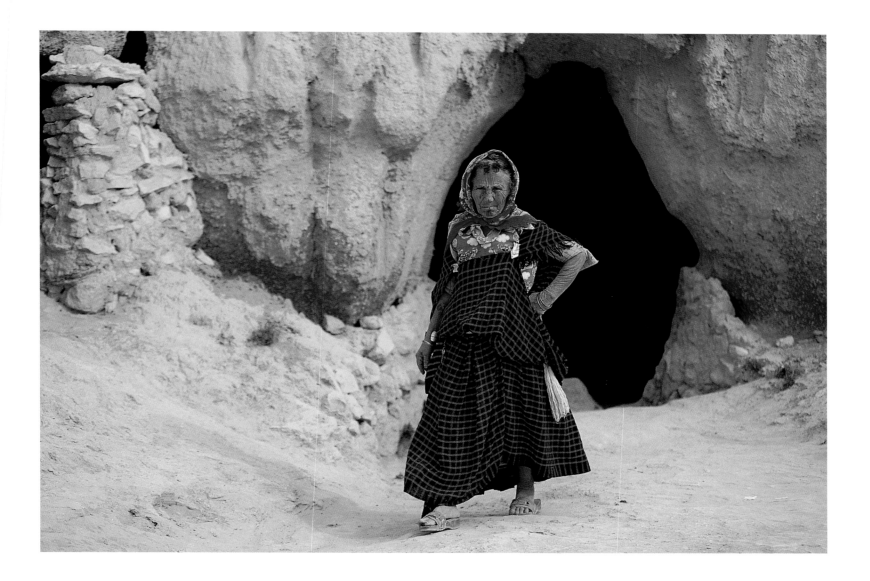

OUR HOSTS in El Haddej were Bilgessou and his wife Manoubia, seen here **(TOP LEFT)** herding his flock and **(BOTTOM LEFT)** hiding her face from the camera. Though the young people are increasingly moving away to the cities to seek their fortunes in tourism, the older generation stubbornly persevere with their troglodyte way of life. This little old lady **(ABOVE)** has never even been to the town 5 miles away and has no desire to do so any time soon. She also validated Mike's theory that I had very bad 'little old Berber ladies' karma, screaming at me like a mad woman soon after I took this picture.

TUNISIA

171

QUITE ABRUPTLY, we were thrown back onto the tourist trail on the north shore of the island of Djerba, where busloads of tour groups from Europe are deposited into dozens of 'Buffet Heavens' all along the coast. However, the old town on the other side of the island, largely painted in blue and white, definitely has a certain charm. Djerba has a reputation for being an ethnically diverse and tolerant island, and at the market in the Jewish quarter, Palestinians and Jews mingle easily. At a small corner grocery shop **(ABOVE & BOTTOM RIGHT)**, a lady waits for her bread while the man who has already got his 'revs-up' his motorised bike. **(TOP RIGHT)** A crafts-man's workshop inside the souk.

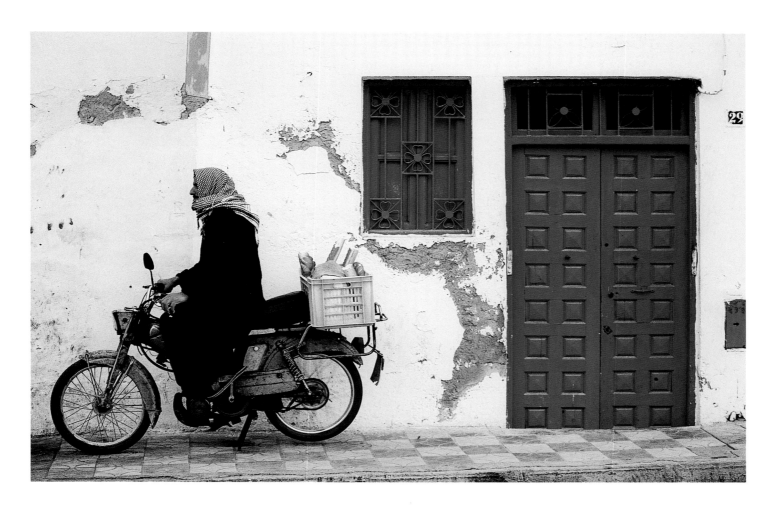

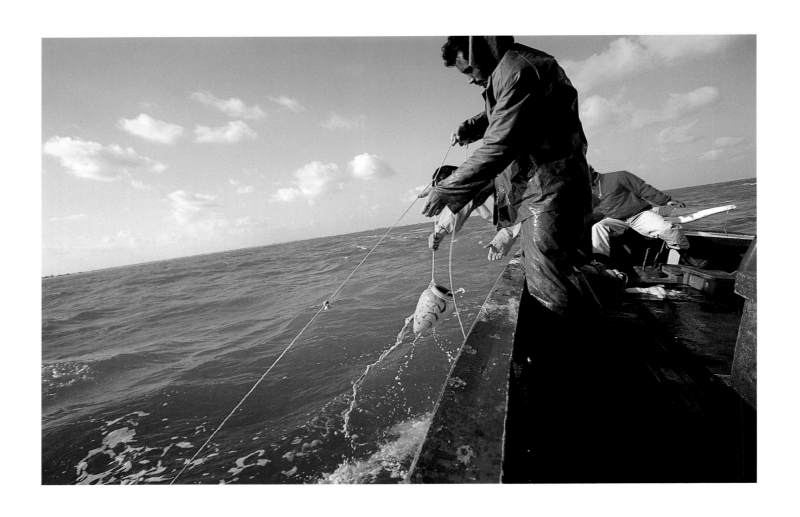

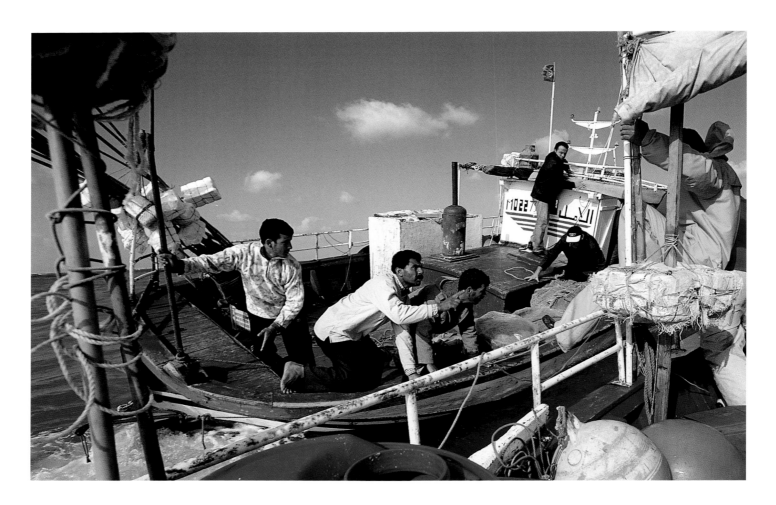

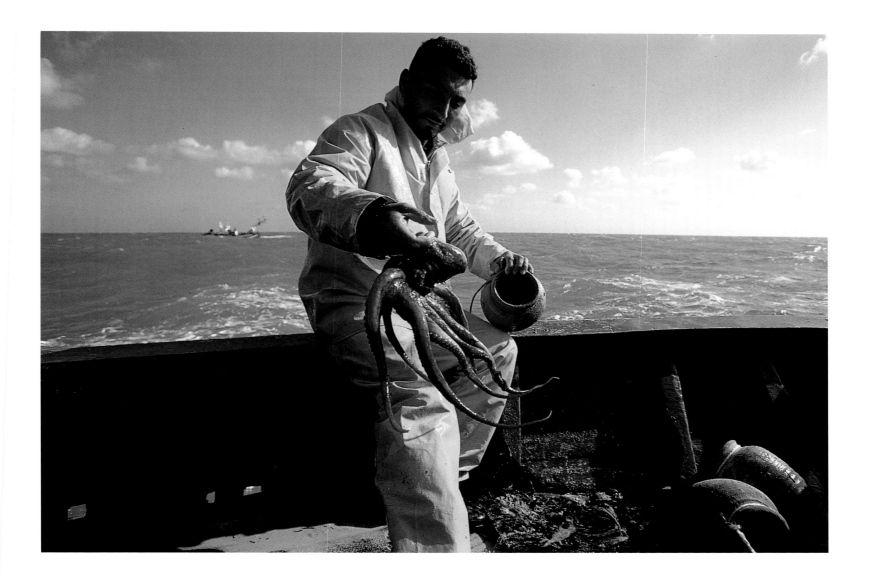

OCTOPUS FISHING with terracotta pots has a long tradition here in Djerba **(TOP LEFT)**, dating back 3000 years to when the Phoenicians first visited these coasts, presumably in more substantial crafts than the oversized bathtub we went out in. The sea was rough, to put it politely, and when the crew attempted a boat-to-boat transfer **(BOTTOM LEFT)**, JP slipped and almost went in to join the quarry. **(ABOVE)** Fresh out of the pot, the creature that evolution has completely forgotten; it is difficult to comprehend why they still crawl into these pots after thirty centuries.

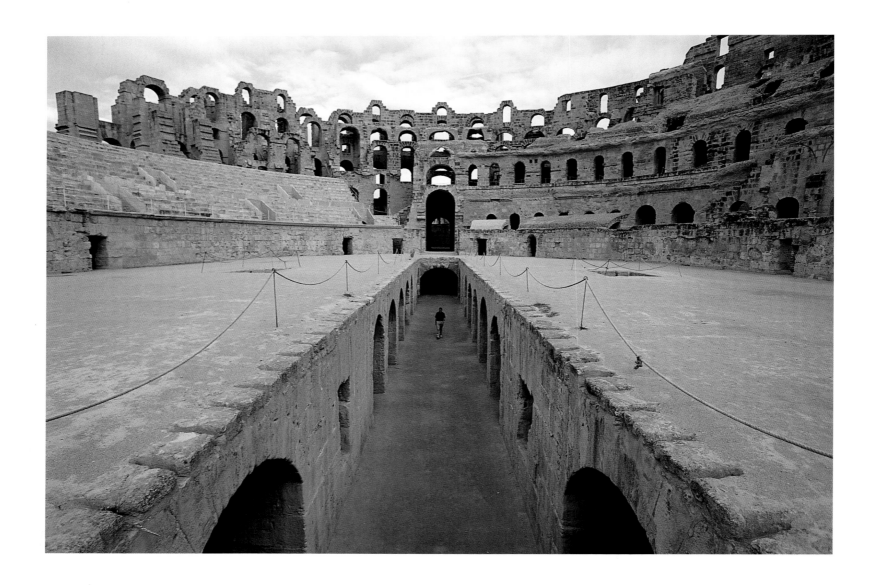

ON OUR WAY NORTH towards Monastir and Sousse, where many of the exteriors for *Life of Brian* were shot, we stopped for lunch in El Jem. **(ABOVE)** Mike wanders through the backstage area of the impressive 30,000-seat amphitheatre, where gladiators and wild animals, locked in cells on either side of the passageway, got themselves ready to be hoisted up to the arena by

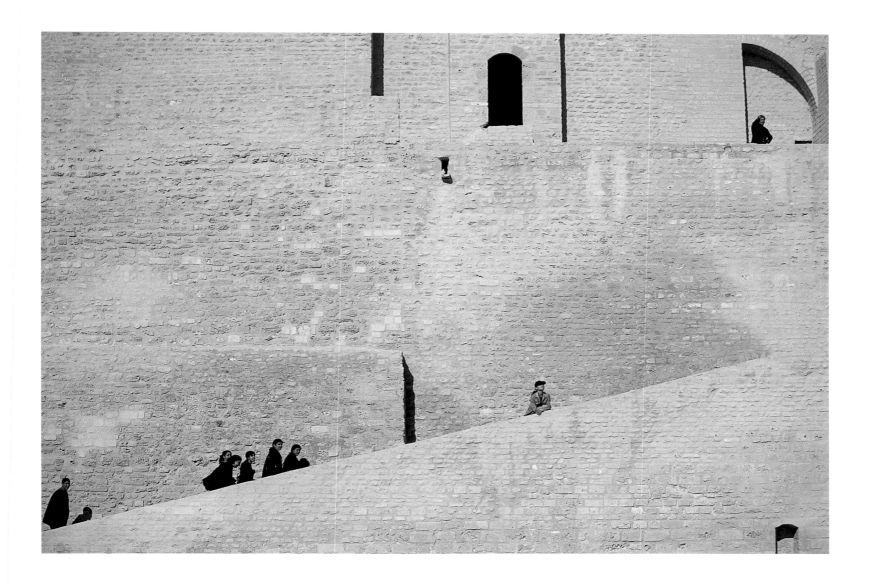

elevators and kill each other in the name of popular entertainment. **(ABOVE)** On top of this wall in the Ribat of Harthouma in Monastir, Mike revisited his role as Pilate and performed the 'Biggus Dickus' scene for everyone in the courtyard, including the stragglers from this school tour. It was one of the funniest moments of the journey.

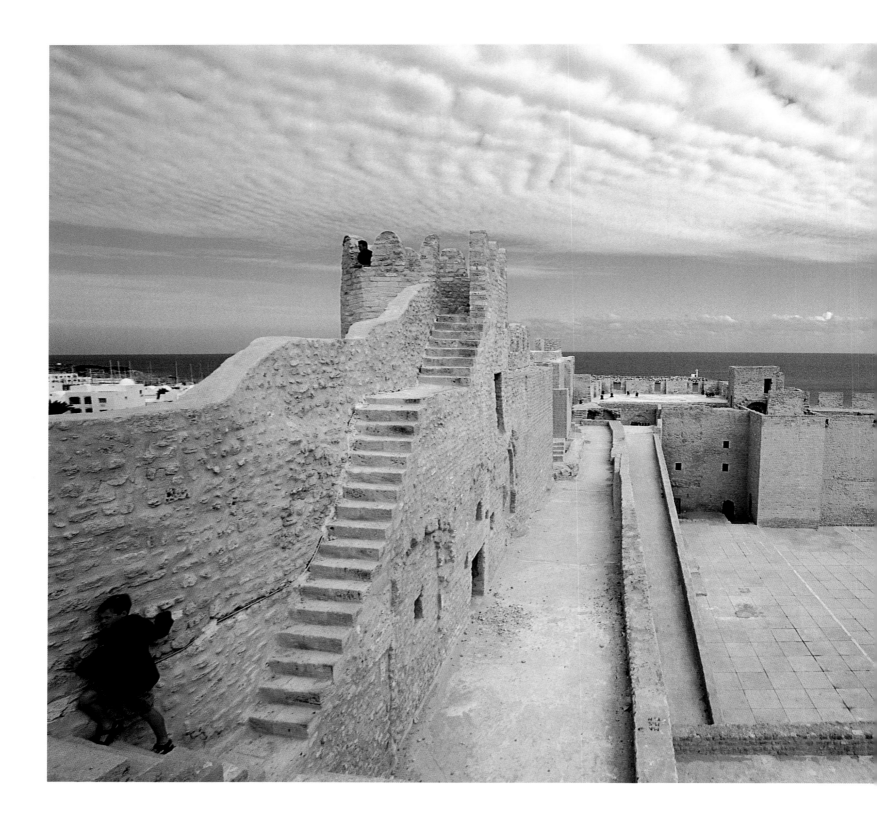

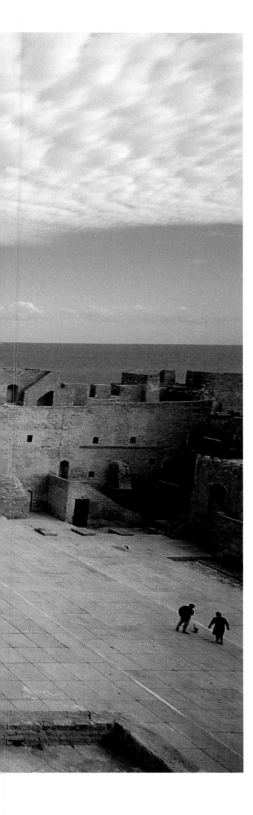

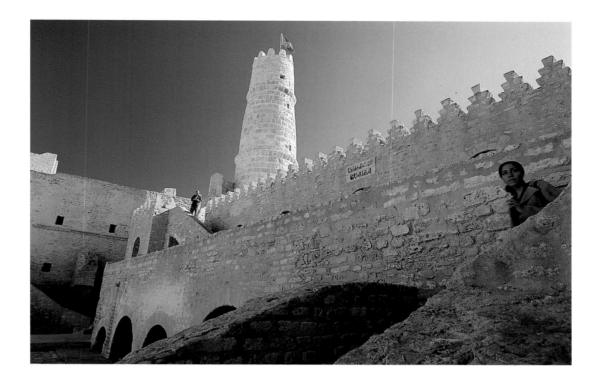

THE RIBAT OF HARTHOUMA was one of the best-preserved Arab fortresses in North Africa before the Pythons' invasion of 1978 AD. It has been through major renovations since, and on the day of our visit **(LEFT & TOP RIGHT)**, there was not even a trace of the damage inflicted by Gilliam the Terrible and his infamous art department. In fact, it was all a bit too tidy, more like a Disney set than a real-life castle. **(BOTTOM RIGHT)** Through an embrasure in the north wall, the white domes of the marabouts – tombs of holy men – can be seen rising from the Sidi El Mezeri Cemetery.

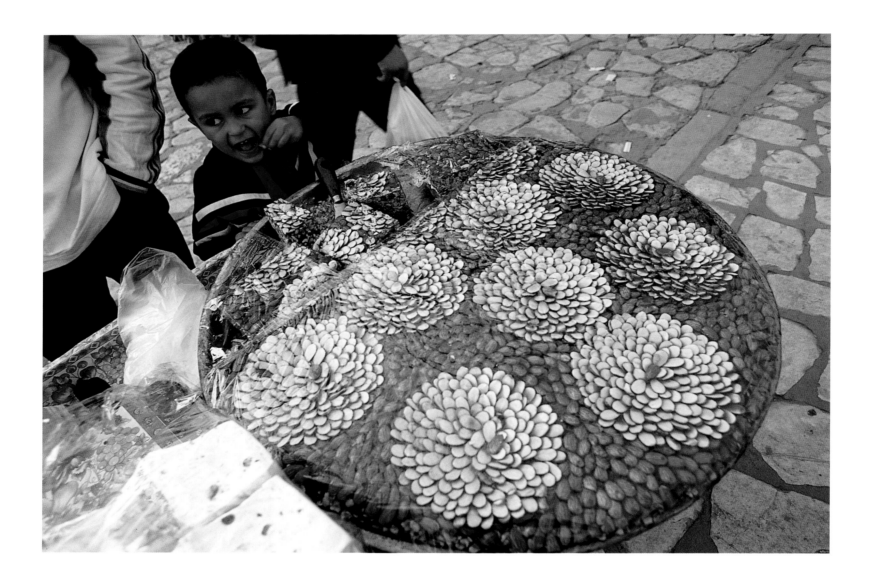

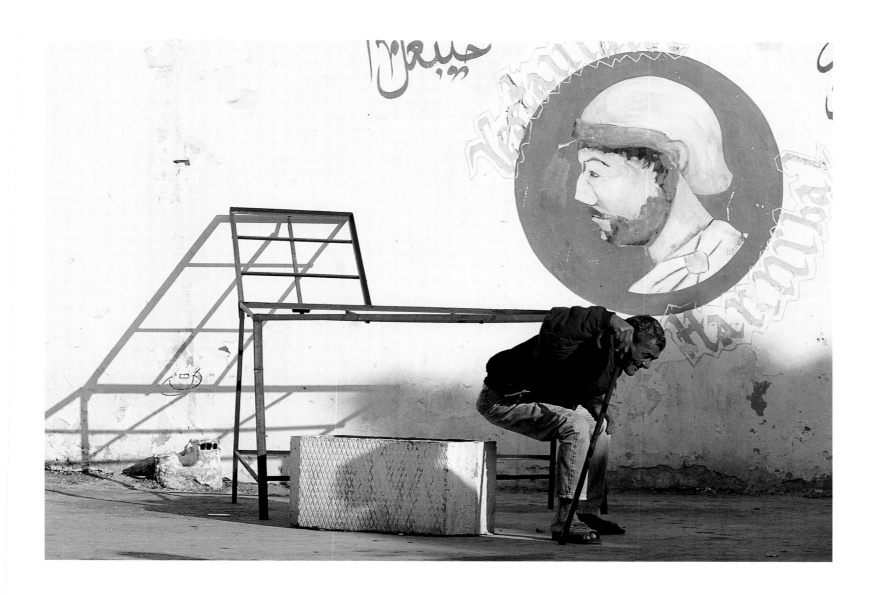

INSIDE THE OLD SOUK in Sousse during Ramadan **(LEFT)**, this boy, probably the hawker's son, was picking bits of almonds off of his father's festive nougat at the end of a day of fasting. Earlier, outside the Hannibal Restaurant, this old man **(ABOVE)** behaved just like a small child when he played a game of hide-and-seek with my camera. First he hid his face with his hand, then he turned around and flashed a huge grin at me, when he discovered that I was still there on my knees, pointing the big lens at him. After about ten minutes, he finally grew tired of the game, got off his pedestal and left.

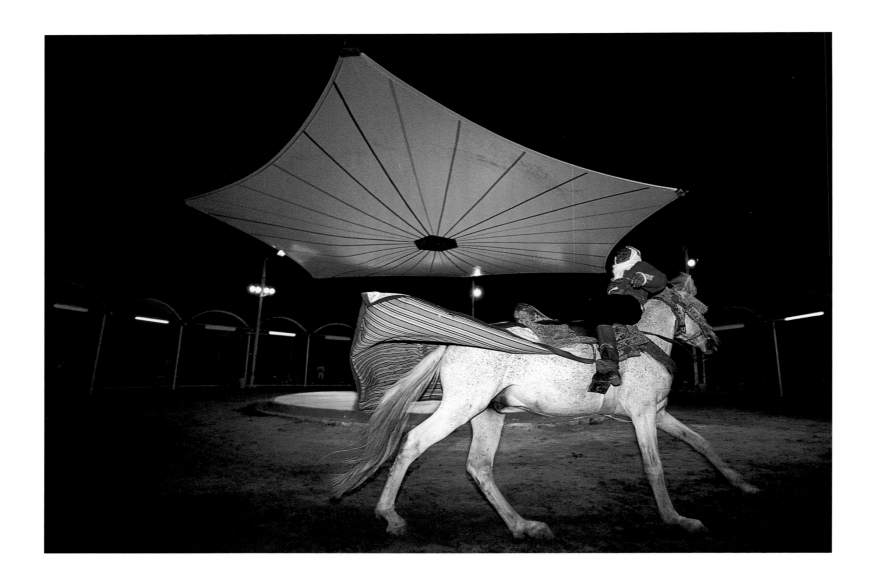

THOUGH I'M NOT A BIG FAN of flash photography, I nonetheless found my small speedlites almost indispensable on this journey, because the severe shadows cast by the desert light often required a little fill-flash. They also came in handy whenever JP decided to drag us out of bed to do night shoots, one of his specialties, usually in places that were either extremely dark or had no light at all. We have a few examples here of those no-light, no-win situations. **(ABOVE)** The equestrian show at the *faux* Berber wedding for tourists outside of Sousse. The 'Bride' of the wedding **(TOP RIGHT)** tidying up the alley behind the dressing room. **(BOTTOM RIGHT)** A waiter at Café des Nattes in Sidi Bou Said, preparing a *chicha*.

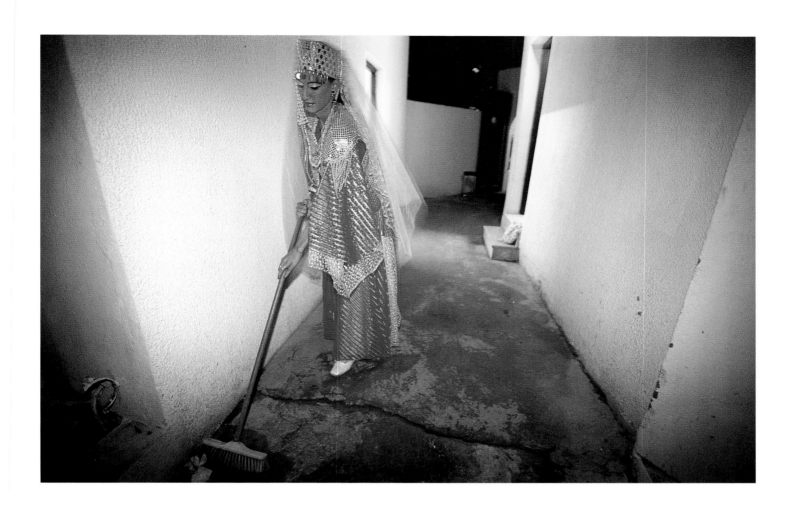

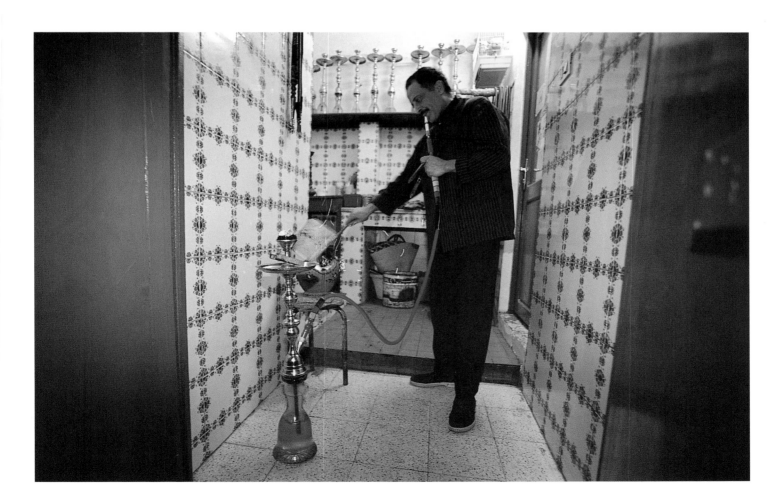

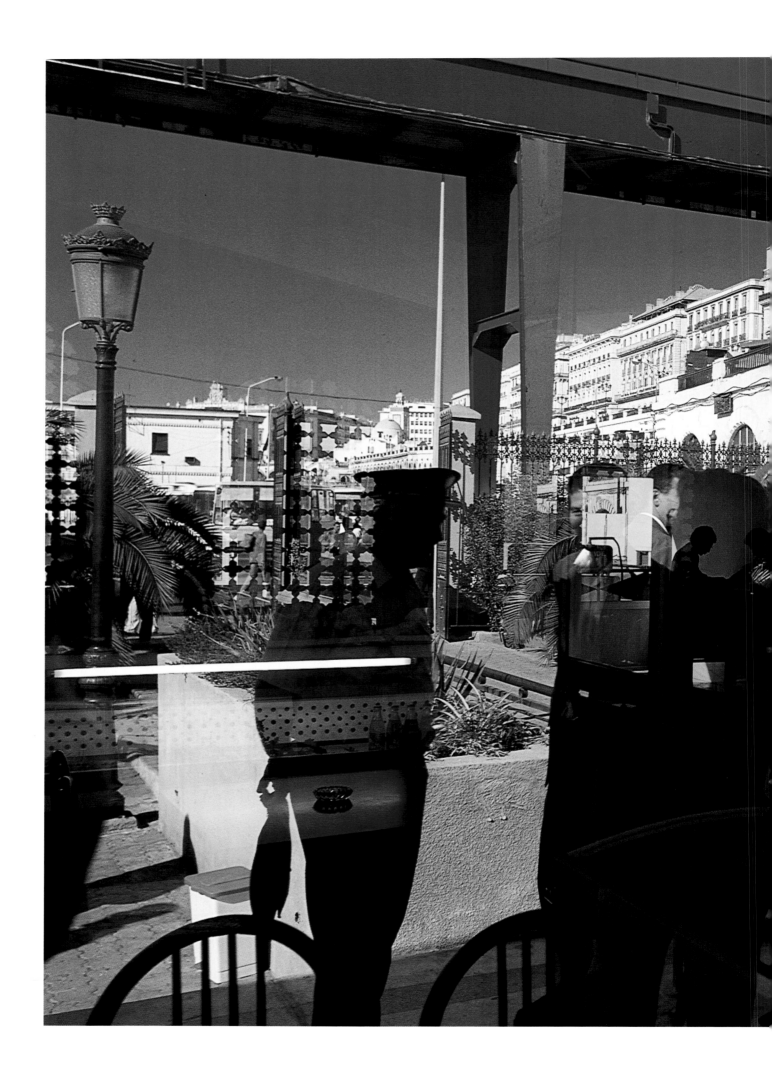

(PRECEDING PAGES) The terraces of Alger La Blanche, the white city modelled on Marseille in France, reflected in the glass front of the café at Central Station.

ALGIERS was, in many ways, the most interesting city we visited on the journey. It was also an impossible place to work in. With a fatwah out on all foreigners, we were constantly surrounded by SPS (Service de Protection Spéciale) agents, and were warned in no uncertain terms never

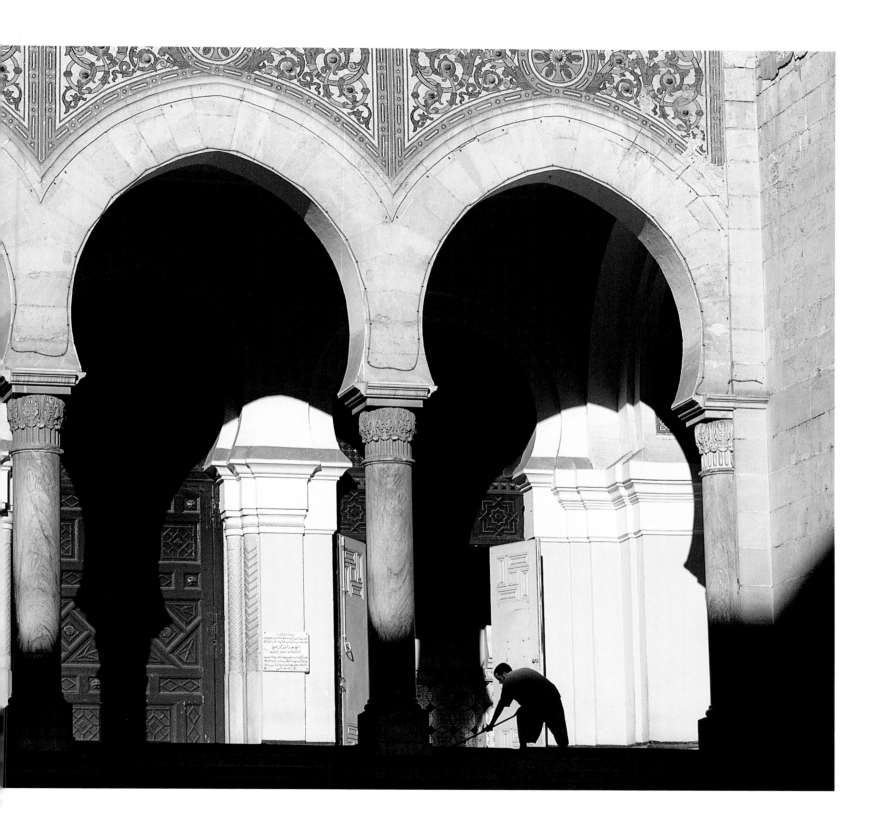

to point a camera in their direction. Since they were all over us like cheap suits, the wide-angle lens was basically made obsolete, and I was reduced to hunting with the telephoto, very much like on a safari. **(LEFT)** These imposing colonnades on Boulevard Zirout Youcef on the waterfront, such a potent reminder of the colonial era, are only a short stroll away from **(ABOVE)** the Grand Mosque on the edge of the casbah.

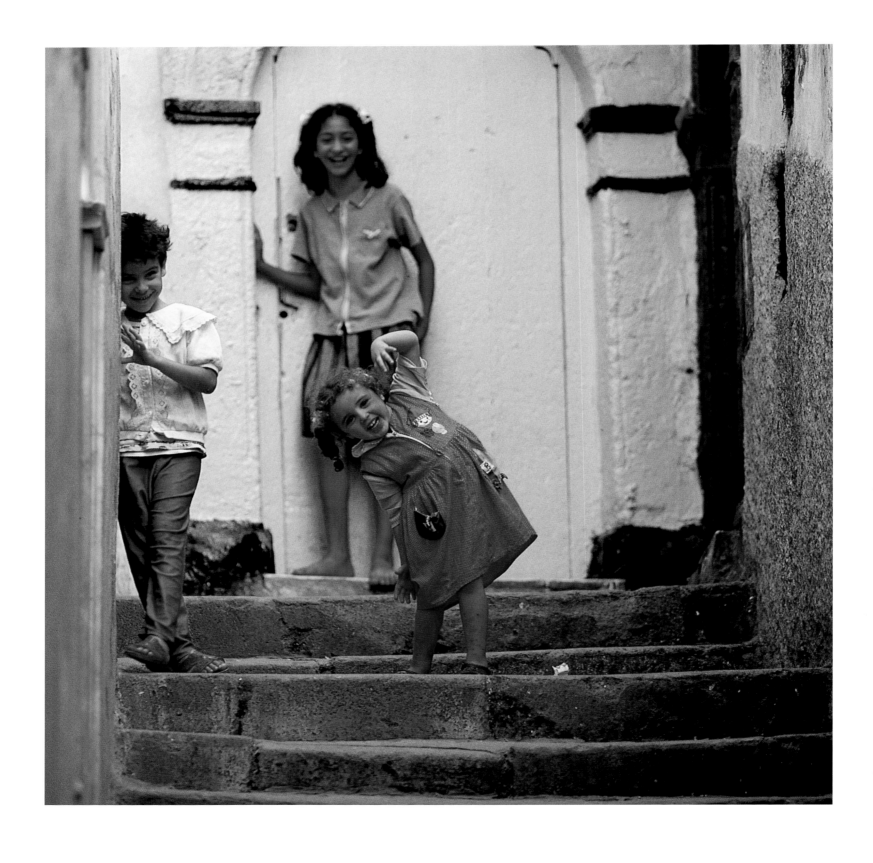

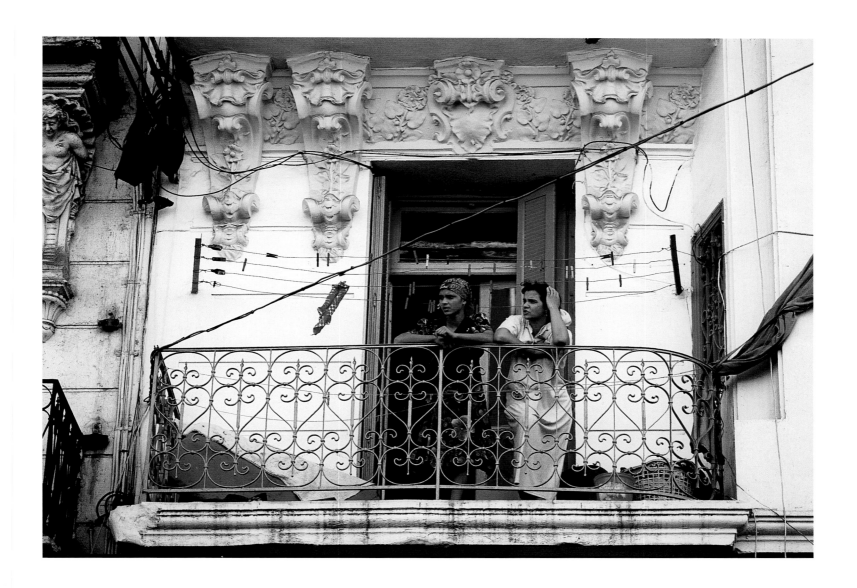

VISITING THE CASBAH was a long-held dream, ever since I saw *The Battle of Algiers* in Film Aesthetics 101 when I was in art college. So it was a thrill and a privilege to be allowed in there, finally, where Ali La Pointe and three of his men had chosen death over surrender. The bad news was that not only had our security detail grown to include six casbah SPS agents, but also a special uniformed-police unit with semiautomatic rifles was on hand at every street corner along our route. Their presence turned the overpopulated casbah into a ghost town. So these children up an alleyway **(LEFT)**, defying the authorities in all innocence, was about all I had to show from the experience. **(ABOVE)** Once outside the old town, life was visibly more relaxed.

THE LIGHT was stunning the morning we left Algiers for Oran. This young lady **(LEFT)** was on the opposite platform at the Central Station, waiting for the commuter train. At Sidi Ferruch, where the French first landed in 1830, young lovers strolled on the empty beaches outside empty tourist resorts, while this local fisherman **(RIGHT)** busied himself with his catch of squids in the glorious evening light. The paranoia seemed less palpable out there, but our security detail assured us that danger was just lurking behind the lapping waves.

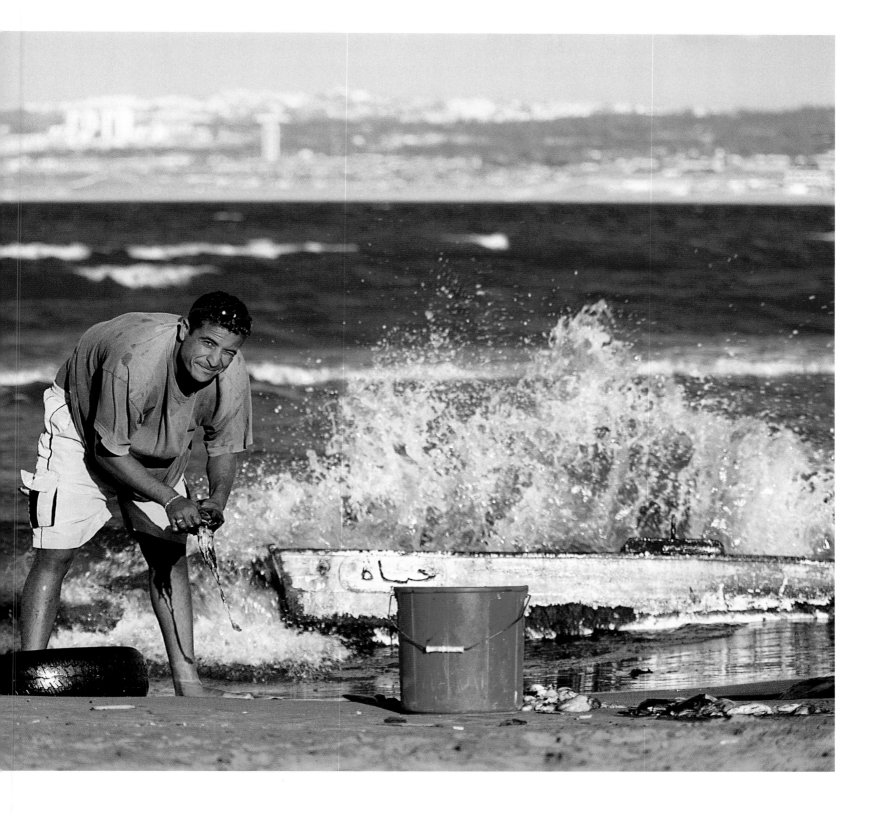

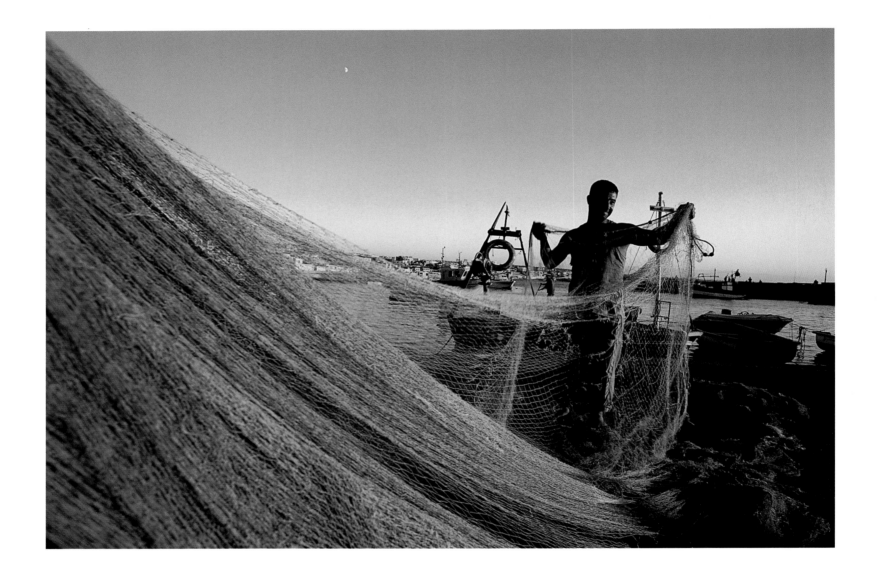

IN A SMALL FISHING VILLAGE outside Ain Benian **(ABOVE & RIGHT)**, the local people spend their early evening hours much like they do in any other such place on the Mediterranean. The unbearable tension of the previous few days melted away with a few beers at the Poseidon Restaurant by the water; even our security team seemed to finally relax a bit, and ate a huge meal of seafood at the next table. Perhaps secure in the knowledge that we would no longer be their responsibility the next day, when another team of heavily armed men would escort us on the train through the 'Triangle of Death' to Oran.

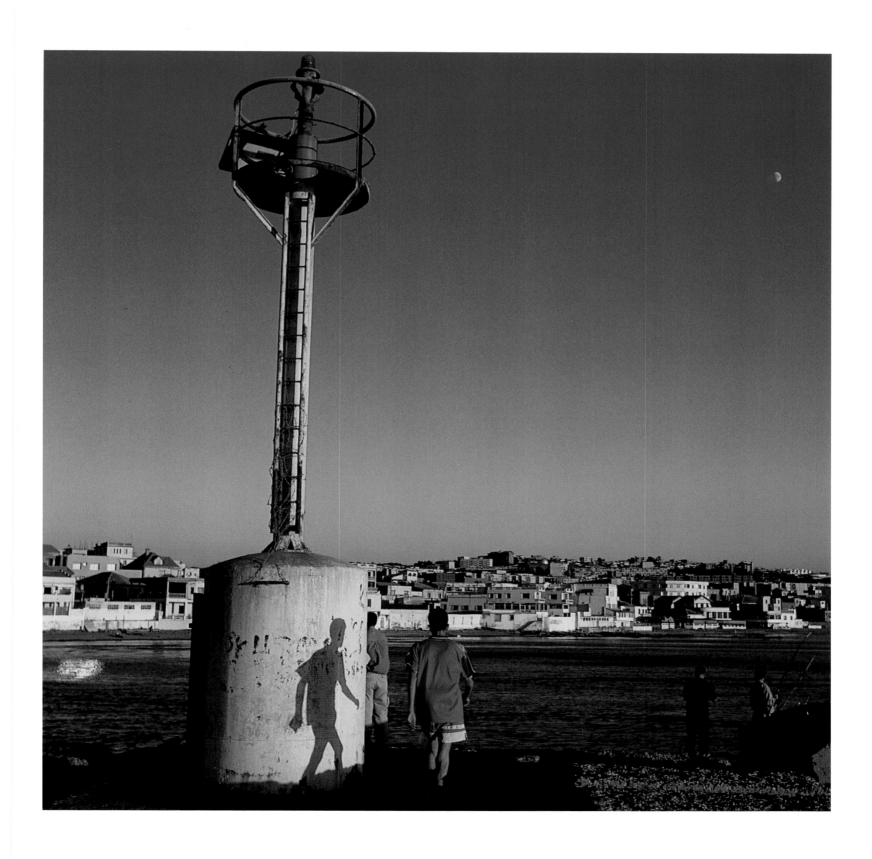

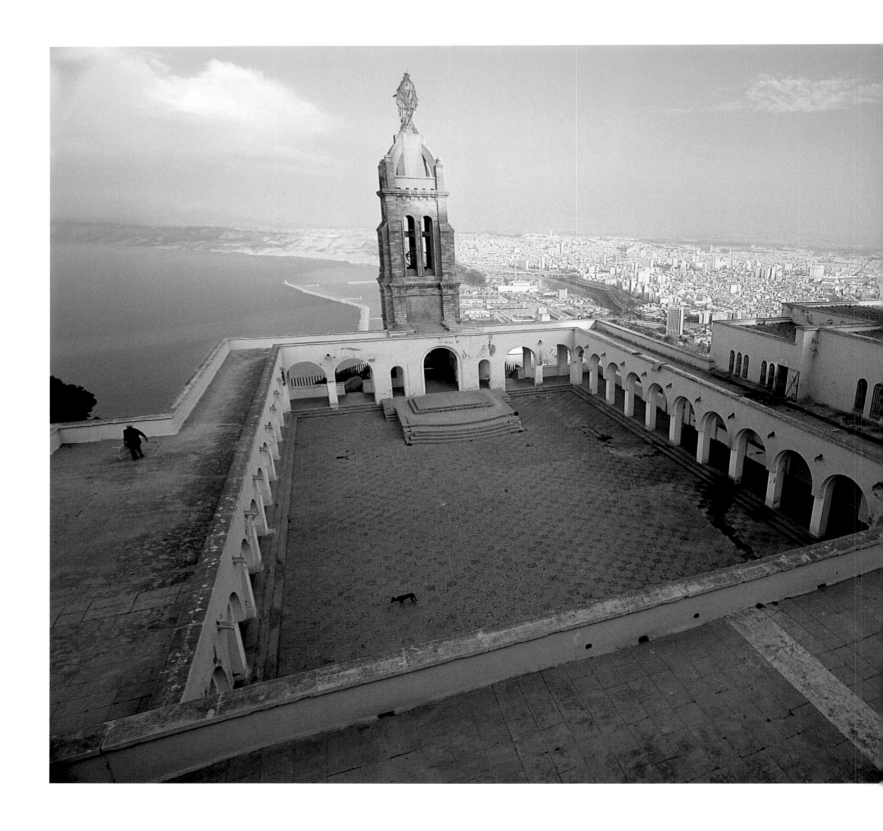

AFTER SURVIVING A JOURNEY on 'the most bombed railway line in the world', we arrived in Oran, less than 400 miles from Ceuta and a short ferry ride from the end of our journey. **(LEFT)** From the mountain-top Basilica of Santa Cruz, the city looks majestic. But all the way up, the hillsides are littered with shantytowns and covered with the refuse they produce, an odd reminder

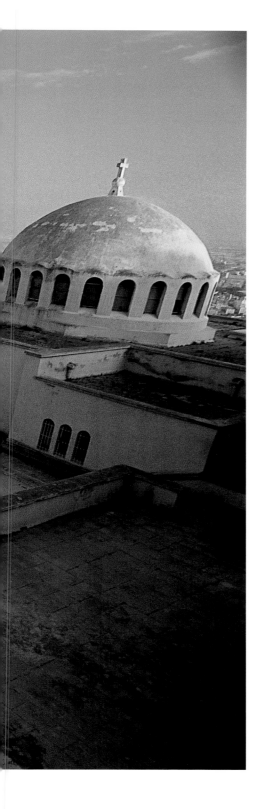

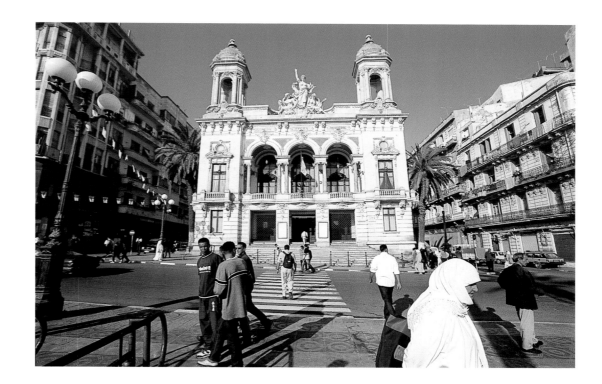

that Camus' classic *The Plague* was set here. (TOP RIGHT) Pieces of its prosperous past remain intact like this replica of the Paris Opera House, but the city evokes the same sadness one feels watching a beautiful woman growing old and dying in despair. (BOTTOM RIGHT) A more recent architectural wonder, the segmental paving below my hotel balcony.

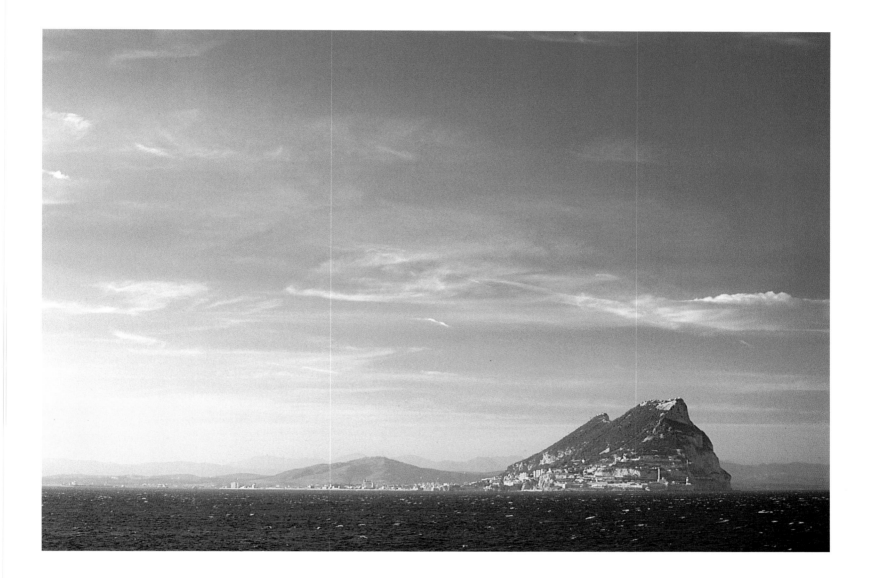

WE CAUGHT THE FERRY from the Spanish colony of Ceuta on the north coast of Morocco, back to Gibraltar where we began. We were not the only people who were looking to cross the Strait from there. Just in front of this wall **(LEFT)** is the Plaza de Africa, where prospective illegal immigrants from all the countries we visited, and many more beyond, gather to sniff out a way to reach Europe. All of them endure unbelievable hardships on epic journeys across or around the Sahara, often only to find their way blocked just before the finish line and end up trapped here in a UN detention camp with no way out. **(ABOVE)** Approaching the promised land.